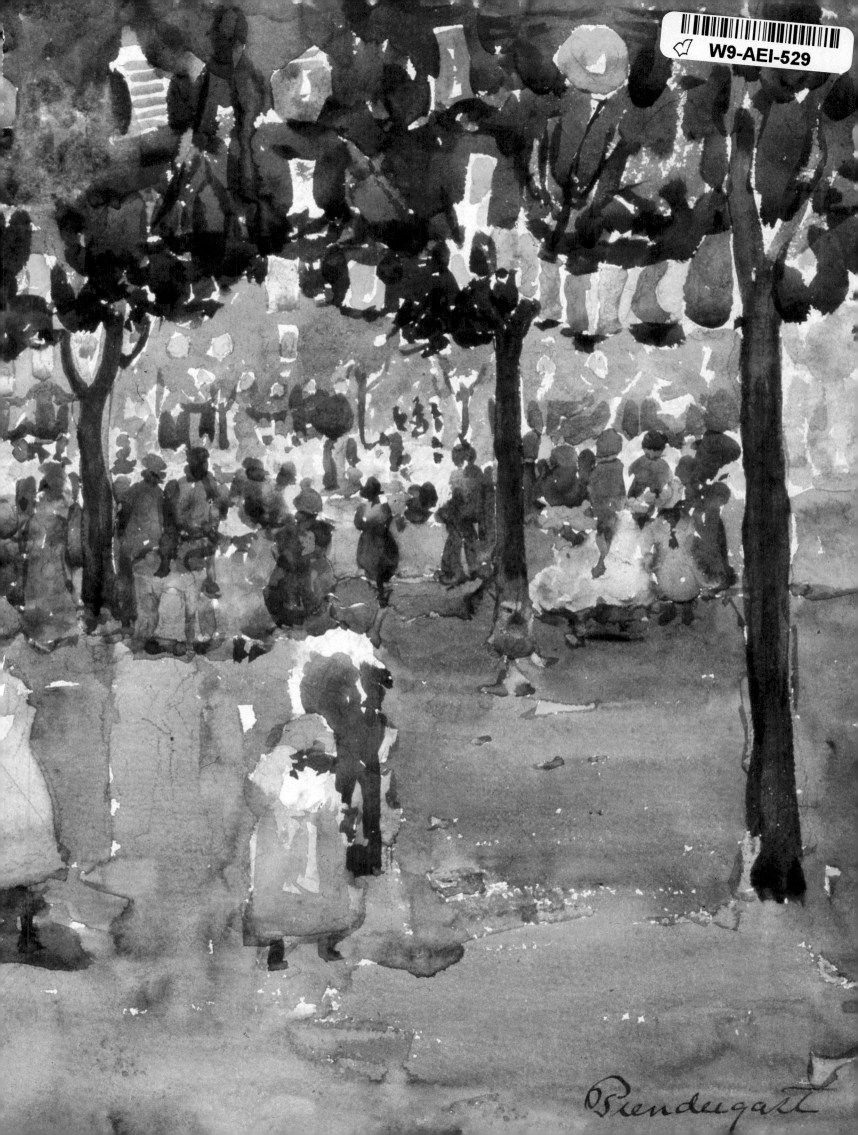

Prendergast

PAINTING CENTRAL PARK

THE VENDOME PRESS

NEW YORK

PAINTING CENTRAL PARK

ROGER F. PASQUIER

FOREWORD BY AMANDA M. BURDEN

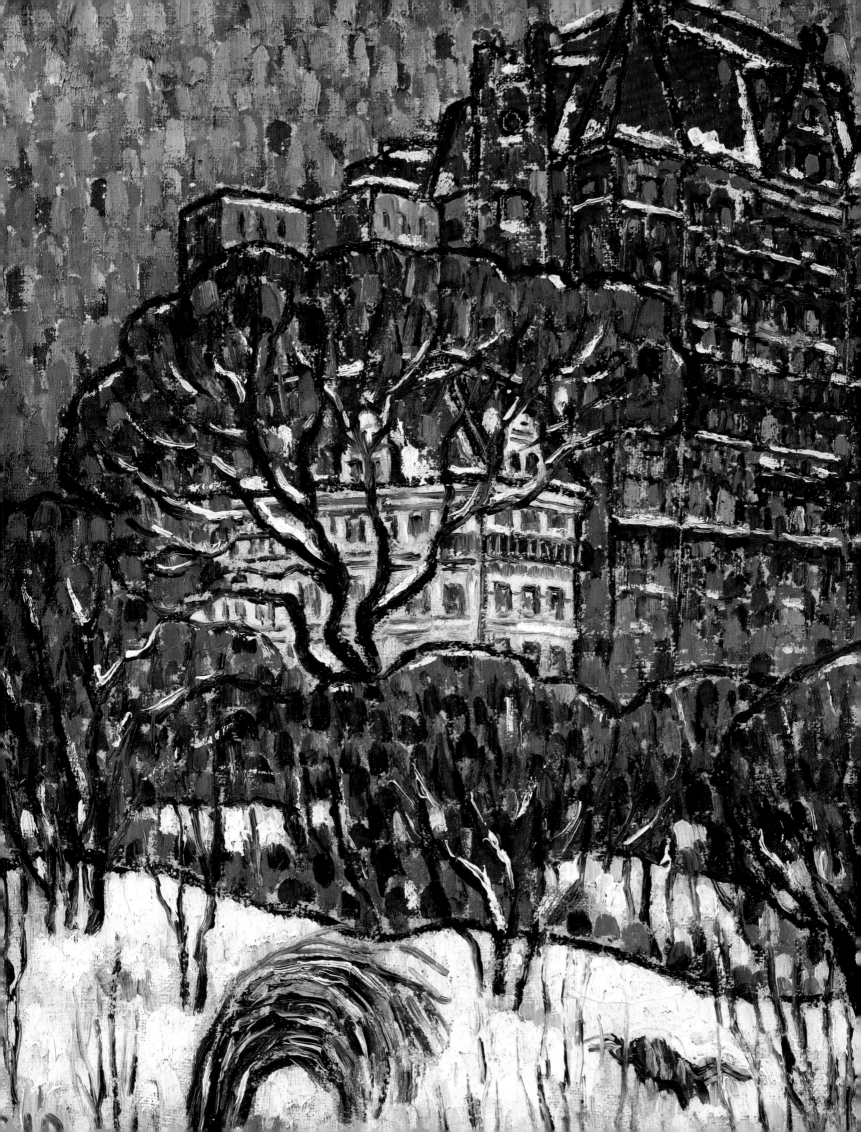

CONTENTS

In memory of

Peter F. Cannell and Nathaniel G. Gerhart—

not nearly enough time in the park

ACKNOWLEDGMENTS

Acknowledgements—surely the section of a book every author most enjoys writing, when the text is set and the mechanics of printing are to begin. I reached this stage thanks to the interest and expertise of many friends, some new acquaintances, and a few distinguished institutions.

First, *Painting Central Park* would not have attained material form without the generous support of the Furthermore program of the J. M. Kaplan Fund, the Arthur Ross Foundation, and the Sansom Foundation, as well as the assistance of the Foundation for Landscape Studies. I am very grateful to the officers and staff of each.

Research was a pleasure, thanks to the rich resources and helpful staff of the New York Society Library and the Nolen and Thomas J. Watson libraries of the Metropolitan Museum of Art.

The museums, galleries, artists, and collectors—named and anonymous— that allowed works in their possession to be reproduced in this book all have my thanks.

Friends, new acquaintances, and email contacts who helped locate paintings include Bob Alcorn, Molly Ott Ambler, Fred Baker, Jonathan Boos, Betty Cunningham, Richard Estes, Alice Cooney Frelinghuysen, Barbara Gallati, Gerd M. Grace, Halley K. Harrisburg, Ashton Hawkins, Jonathan Henery, Jason Herrick, Ellen Iseman, Edith McBean, Deborah Pesci, Paul Provost, Maureen St. Onge, Thayer Tolles, Eric Widing, and Wray Williams. Peter P. Blanchard, my godson Isaac E. W. Perkins, and Roxana Robinson sent me to a number of writers who, unbeknown to me, had set a fictional foot in Central Park. Christopher Gray shared his knowledge of the buildings surrounding it. Errors of fact or judgment are mine.

At the Vendome Press, this book was enthusiastically supported by Alexis Gregory and Mark Magowan and scrupulously and knowledgeably edited by Jacqueline Decter. Irene Convey, Alecia Reddick, and Jim Spivey efficiently undertook the big job of securing all the images. Patricia Fabricant's design has made the book a work of art.

I am grateful to all of these people, and even to the occasional gallerista, museum curator, and collector who did not respond to phone calls or written requests; they forced me to be more inventive in reaching my goal and reminded me that there are usually at least two ways to achieve it. That lesson I can carry forward to future projects.

ROGER F. PASQUIER

Childe Hassam
Across the Park, 1904
Oil on canvas, 27¾ x 24¾ in.
(70.5 x 62.9 cm)
Private collection

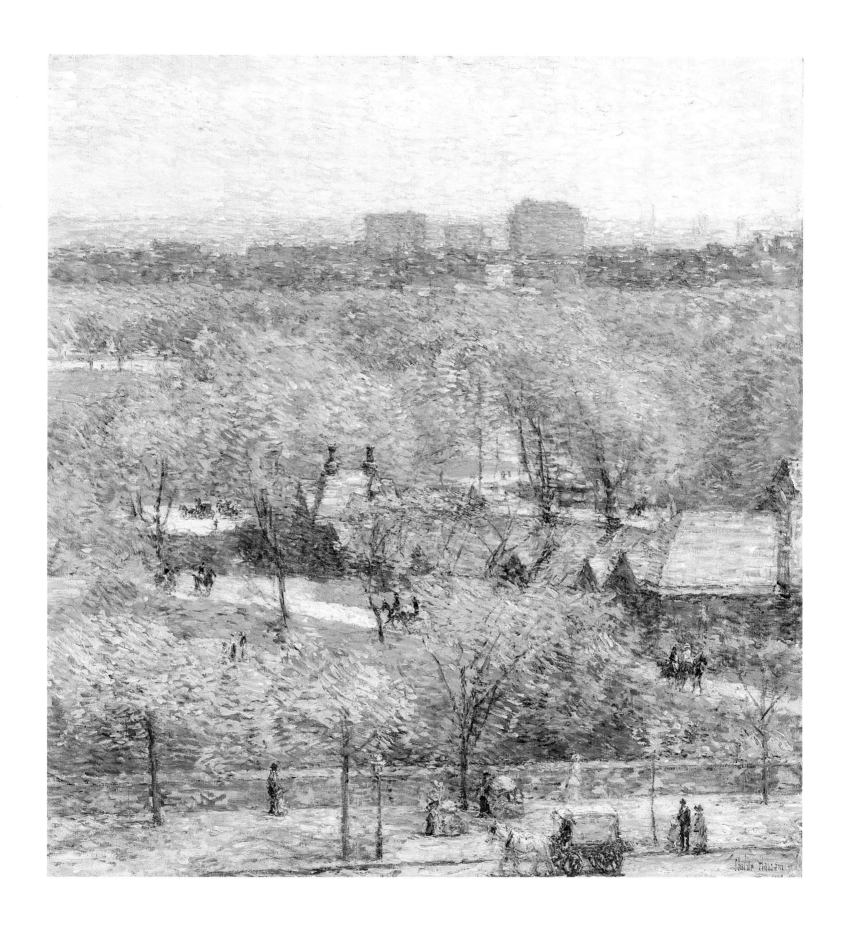

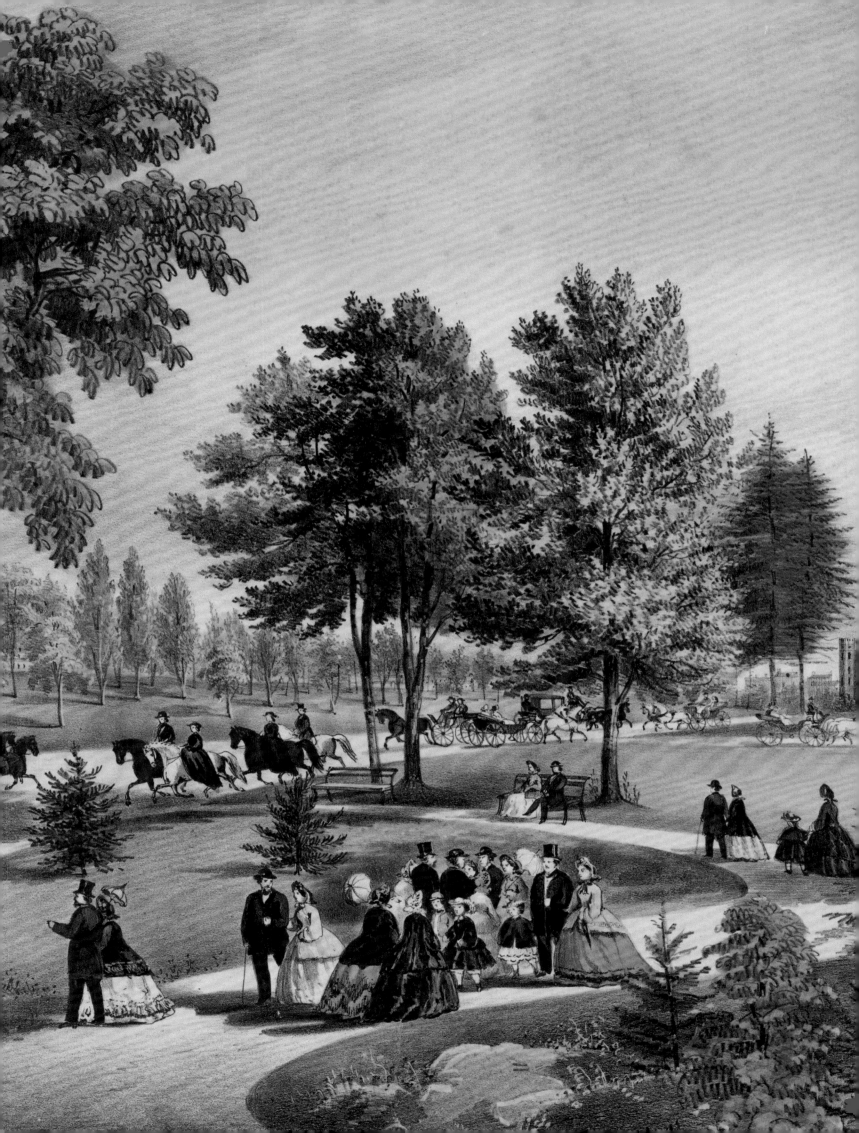

FOREWORD

Parks are a fundamental necessity for a healthy urban life. They satisfy the human need to connect with nature, while providing opportunities for recreation, socialization, and reflection. As a city planner, I believe deeply in the importance of green space in a dense urban environment. But I also have come to know that the success of a public open space is inextricably linked to how well it is designed. In fact, designing public spaces for public use is an art, and there is probably no grander work of public art in America than Central Park. Its designers, Olmsted and Vaux, together fashioned a complex and intricate greensward that, while sweepingly gorgeous, has been able to bring pleasure to individuals of every age, class, and interest, providing, in the words of Henry James, "something for everybody . . . and everything at once." For more than 150 years, Central Park has contributed immeasurably to the quality of life and public pleasure in New York City. Indeed, it was expressly created for people's use and enjoyment, embracing the democratic principle that the benefits of fresh air and uplifting scenery should be free to all.

For most of my life, Central Park has been both my backyard and a constant source of renewal. Whatever I crave is usually near at hand: the quiet wilds of the Ramble, the chaotic social antics on the Mall, a head-clearing run around the reservoir, the familiar comfort of a park bench. But I never would have guessed that Central Park had inspired so many artists until I read this magical book. The extraordinary works collected here show how, from the days of its creation to the present, this park has captivated painters and other artists. In a myriad of styles, they illustrate the many ways New Yorkers and visitors from all over the world have made use of the park, for socializing, recreation, or contemplation.

I am not surprised that Roger Pasquier has been the person to have so ingeniously and artfully arranged these works into a compelling historical narrative and graceful guide to the park itself. I have known Roger since 1970, spending many an early spring morning benefiting from his exceptionally keen ear and eye; he is an expert on all birdlife, fauna, and flora. Roger's deep appreciation for all aspects of the park—its creation, its evolution, and what it has meant to the people of the City of New York—underlies the beauty and wonder of this extraordinary volume. Through each painter's creation, he lets us see in a fresh way places known and loved. By enabling us to view the park through the eyes of the artists, Roger has given us a new way to understand both the history of the park and the artists who were so fascinated by it. He skillfully interweaves the schools of painting and individual artists with the changing nature of the park and the buildings along its edges. Anyone who cares about Central Park will delight in this book and certainly look at the park in a new way, seeing afresh what captured the artists' attention and how each tried to bring it alive in a different way.

AMANDA M. BURDEN

Currier & Ives
Central Park, The Drive,
1862 (detail)
See page 32

INTRODUCTION

Since it was created, Central Park has often been called one of the greatest works of art in America. And from its earliest days, the park, in turn, has inspired the work of many of America's greatest painters. Has any place of comparable size in America, in fact, been painted by so many artists over so many years? From Impressionists and members of the Ashcan School to Abstract Expressionists and Photorealists, painters have depicted the park in some of their most iconic work. My hope in this book is to provide a fresh look at Central Park through the eyes of the painters (with a few pictures in words from novelists), and a new appreciation of how public spaces can inspire great art.

Christo
The Gates, Project for Central Park, New York City,
2003 (detail)
See page 93

The first paintings of Central Park were landscapes of the site before construction began, followed by views of its major landmarks—the Bethesda Terrace, the Conservatory Water, and the like—and depictions of crowds at play or people in solitary contemplation. As the city advanced northward to surround the park, artists documented the evolving cityscape that frames this urban oasis. Park paintings also provide a rich and varied visual history, reflecting much of the American social experience. Because New York has always been a magnet for artists, the body of art celebrating the contribution of its parks to urban life is unparalleled. Happily, today as in the past, artists are inspired by America's most popular, most visited park.

The mid-nineteenth-century movement to create large city parks arose at about the same time as painters in Europe and America began exploring new ways of capturing everyday life. Public parks—in Paris, London, and other major cities, as well as New York—provided these artists with perfect settings and countless subjects. Leisure pursuits such as horseback riding, ice skating, driving in carriages, and sailing miniature boats were especially popular themes. For many of the promising young American painters who came to New York after studying in Paris and other European cities, the elegant, romantic landscape of Central Park, with its promenades, fountains, bridges, and other man-made features, proved an ideal background for paintings of genteel, well-dressed women astride their mounts, well-behaved children rolling hoops or launching toy boats on the Conservatory Water, and gentlemen showing off their skill on the ice.

The next generation of painters saw Central Park not only as a sylvan retreat for the prosperous but also as the lungs and jostling playground of the masses, who lolled on the grass rather than sitting decorously on benches and whose children cavorted at May Day celebrations. The riders on fine horses had to sidestep the new automobiles, and the ladies in open-air limousines had to endure the envious stares of the carless. The painters treated these juxtapositions of young and old, rich and poor with humor and sympathy.

Many mid-twentieth-century artists presented a quieter, more introspective view of the park, showing people reading or lounging on the grass in solitude. Scenes are often laced with ambiguity, prompting the viewer to ponder the dynamic among the people portrayed. Even when New York emerged as the global center of Abstract Expressionism, Pop Art, Op Art, and Minimalism, a few painters depicted the park, its popular activities, and the continually evolving palisade of cliff-like buildings that frame it. Today, as always, the park attracts talented painters lured by the ever-changing sky, the shifts of the seasons, and the myriad pleasures it offers to the millions of people who enter it every year. The original concept of the park—its vistas, architectural landmarks, and sculpture—as a work of art was reinforced and enhanced in 2005 with the installation of Christo's *The Gates.*

The fascinating story of Central Park's creation and management since 1858 has been thoroughly covered in a number of books (see the Selected Bibliography). In *Painting Central Park*, I have focused on the aspects of the park's history that most directly affected how it was depicted by artists. But no twenty-first-century book about the park can omit mentioning the impact of the Central Park Conservancy. It was created in 1980, when the park was at its

nadir—eroded, littered, alternately overcrowded and deserted—lagging behind the recovery from the financial crisis of the 1970s. The conservancy pioneered a model of public-private partnership to restore, support, and maintain one of the city's most iconic features. How New Yorkers saw their parks was how they saw their entire city and its future. How visitors from around the nation and the world saw Central Park colored their view of America. Returning the park to its green, welcoming persona was imperative. The conservancy concept has now been replicated for many other New York City parks and for parks all over the country.

Henry James, visiting Central Park in the spring of 1905, fully grasped the challenges facing a park in the heart of New York at a time when there were few public amenities in the city:

> To the Park, accordingly, and to the Park only, hitherto, the aesthetic appetite has had to address itself, and the place has therefore born the brunt of many a peremptory call, acting out year after year the character of the cheerful, capable, bustling, even if overworked hostess of the one inn, somewhere, who has to take all the travel, who is often at her wits' end to know how to deal with it, but who, none the less, has, for the honour of the house, never once failed of hospitality. This is how we see Central Park, utterly overdone by the "run" on its resources, yet also never having had to make an excuse.

Elizabeth Barlow Rogers, a founder of the Central Park Conservancy and its first administrator, appointed by Mayor Edward Koch in 1979, acknowledges that she often felt like this overworked hostess herself. But under her leadership and that of her successors, the park has reached a state that would make its original designers, Frederick Law Olmsted and Calvert Vaux, proud. They would be gratified to see how much of their original vision has attained maturity and withstood many challenges. As Olmsted foresaw in a letter to the park's commissioners in 1858:

> The time will come when New York will be built up, when all the grading and filling will be done, and when the picturesquely-varied, rocky formations of the Island will have been converted into foundations for rows of monotonous straight streets, and piles of erect, angular buildings. There will be no suggestion left of its present varied surface, with the single exception of the few acres contained in the Park. Then the priceless value of the present picturesque outlines of the ground will be more distinctly perceived, and its adaptability for its purpose more fully recognized. It therefore seems desirable to interfere with its easy, undulating outlines, and picturesque, rocky scenery as little as possible, and, on the other hand, to endeavor rapidly, and by every legitimate means, to increase and judiciously develop these particularly individual and characteristic sources of landscape effects.

I have spent much of my life in Central Park, first as an infant in a perambulator, then as a child climbing on the rock outcrops and roller skating around the Conservatory Water, later exploring the Ramble when I was old enough to be allowed to go alone, and watching birds throughout the park ever since my early teens. Having studied art history in college and graduate school, I have long wanted to explore Central Park through the lens of art. But I first thought seriously of the possibilities during the few years I lived far from it, in Washington, D.C. There, nothing made me more homesick than looking at George Bellows's *Bethesda Fountain* (right and see page 66) at the Hirshhorn Museum. When I finally found the time to take up the subject, I first wondered whether there were in fact enough really good paintings of the park, by enough artists, throughout the years since the park was created in the 1860s. To my happy amazement, I rapidly found more than eighty well-known painters who have depicted Central Park. (And what fun it was to discover their depictions of the stages of my own park life—as an infant with a nursemaid, as a child climbing the rocks and watching the model boats on the Conservatory Water, even as a birdwatcher.)

Not all of the painters I found are included here—some, in fact, did much better work elsewhere—and I have featured some less familiar artists whose paintings have historic value documenting the park's evolving landscape and popular activities. I took photocopies of many paintings into Central Park, in the hope of finding precisely where the artists stood. I enjoyed thinking of myself as following, on a small scale, the advice of the author of *The Oregon Trail,* Francis Parkman, who said that the historian must always see firsthand the places in his narrative. I was surprised at how often I could quite literally put myself in the painter's place. And I enjoyed discovering how some artists deliberately rearranged pieces of the landscape for their own expressive purposes.

The whole process of searching for the artists, their paintings, and the places they painted, and then looking for the broader patterns or historic interest the paintings may reveal, has given me a new appreciation for the park I thought I knew so well. I hope that this book will likewise bring the pleasure of a fresh way to see a place known and loved or newly discovered.

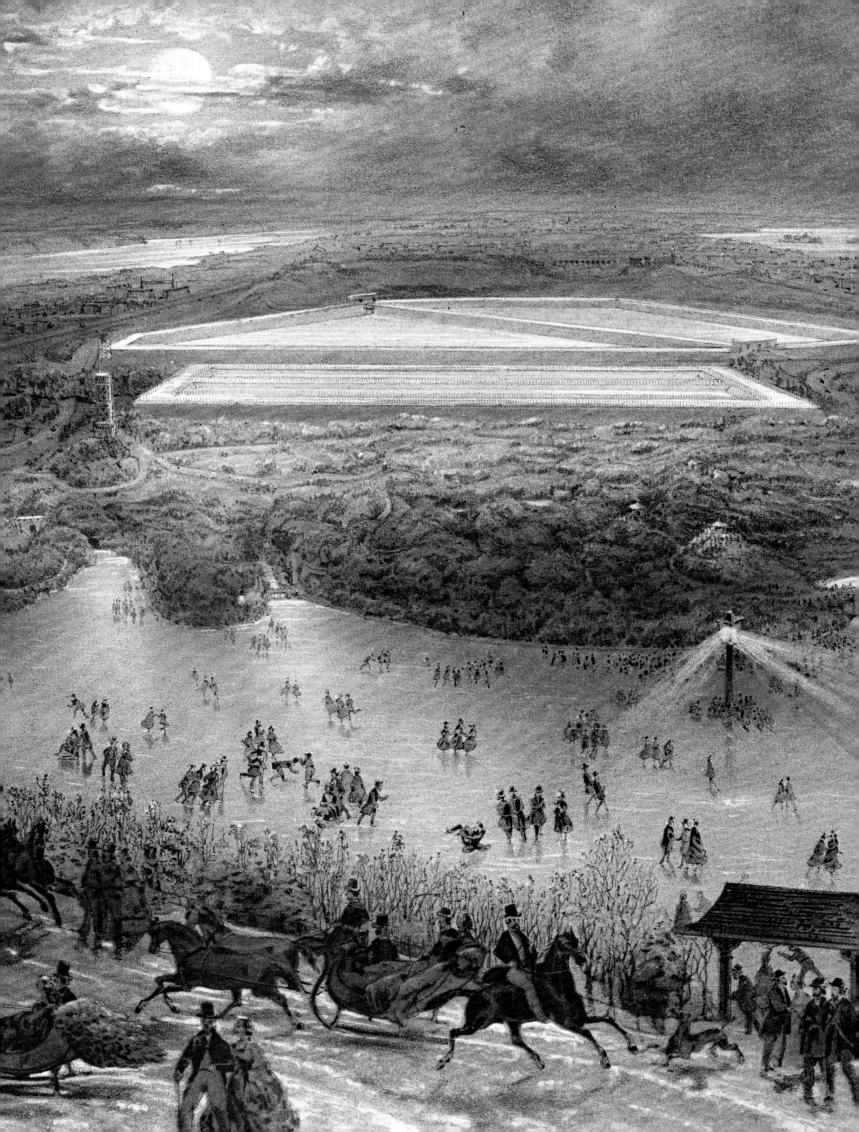

THE PARK'S
FIRST ARTISTS

The first declaration that Central Park was a masterpiece came in 1862, soon after it opened to the public. *Harper's Monthly* boldly proclaimed the park "the finest work of art ever executed in this country . . . the exquisite forms of the ground in every direction—the perfection of the roadwork and gardening—the picturesque and beautiful bridges—the lovely sweeps of water contrasted with lawn banks—the pictorial effect of the terrace upon the water, so that you drive out of the city into the landscape . . ." *Harper's* cited many of the features that for generations ahead would attract painters. Artists were among the park's first visitors, and their work did much to make the park better known to the public and, in turn, to other artists.

Julius Bien, after John
Bachmann
Central Park (Winter),
1865 (detail)
See page 34

Painters had every reason to be enthusiastic. The park offered subjects not readily encountered in America: the vistas across meadows and lakes evoked English estates; the elegant parade of carriages and riders rivaled any in Paris or London; the fountains and pavilions were reminiscent of those in Rome. All in a public space uniquely American, dedicated to the democratic ideal that the benefits of fresh air and uplifting scenery should be free to all.

We owe much of our insight into the park's transformation from a scrubby wasteland into a maturing landscape to the very first generation of artists. But we owe the park itself to a few artistic visionaries—a poet, landscape designers, and architects.

By 1800 it was clear that New York had an advantage over the other Atlantic coast cities as a hub of trade and commerce—both across the Atlantic and into the American heartland—thanks to its enormous protected harbor and the Hudson River, the reach of which was extended west to the Great Lakes and beyond by the Erie Canal in 1825. Within the burgeoning city—at that time just the narrow island of Manhattan—the only direction for growth was north. To regularize this expansion, in 1807 a rectilinear grid of streets and avenues was imposed on the entire island, most of which was still unbuilt territory.

As development marched uptown, the need to preserve some open space became evident. In the 1830s, a few public squares were created in the lower portions of the grid. But these hardly met the needs of the then or future city, and by the 1840s there were calls for a major public park. William Cullen Bryant, the romantic poet and long-time editor of the *New-York Evening Post*, had been privately promoting the idea for years when he wrote an editorial in July 1844 urging that the area called Jones Wood—between 66th and 75th Streets from Third Avenue to the East River—be made into a park. His plea was echoed by Andrew Jackson Downing, an influential landscape gardener in Newburgh, New York, who also designed country houses and estates for some of the city's leaders. Downing edited *The Horticulturist* and wrote a series of public letters between 1848 and 1851 bemoaning the lack of parks in American cities.

Both the city and the state government considered the Jones Wood site but, at 153 acres, it was ultimately determined to be too small and less than ideally located. A more attractive proposal came from the Croton Aqueduct Board for a park anchored by the city's receiving reservoir, which since 1842 sat between Sixth and Seventh Avenues from 79th to 86th Street. Anticipating New York's increasing need for water, the board was already planning an additional, larger reservoir just to the north. Park advocates, politicians, and the press could see that as the city expanded northward, this piece of land would soon be right at its center and, if no action were taken, it would be swallowed up by development.

Downing seized on the idea. His vision of a future park, published in the August 1850 issue of *The Horticulturist*, beautifully anticipated what artists would later paint there: "In such a park, the citizens who would take excursions in carriages or on horseback, could have the substantial delights of country roads and country scenery, and forget, for a time, the rattle of the pavements and the glare of brick walls. Pedestrians would find quiet and secluded walks when they wished to be solitary, and broad alleys filled with thousands of happy faces, when they would be gay."

The legislative and budgetary process to secure the land was completed in 1853, and the park's boundaries were set between Fifth and Eighth Avenues from 59th to 106th Street. The unbuildable rocky and swampy land between 106th and 110th Streets was added in 1863, bringing the total acreage to 843. None of the land that became Central Park suggested its potential as a great work of art. In the 1850s, the original forest was long gone; the tract was a mix of scrubland, swamp, grazing land for goats, and small settlements like Seneca Village, a primarily African American community located in an area roughly extending from 82nd to 89th Street between Seventh and Eighth Avenues.

The land called for a grand plan. In 1857, the commission established to make the park happen rejected the design proposed by the topographical engineer hired to map and plan the drainage of the new park. Instead, they announced a competition, with very specific directions on the features and facilities the plans had to include. Working behind the scenes to scuttle the original plan was the competition's ultimate victor—the English architect Calvert Vaux (1824–1895). His clients included members of the commission, whom he persuaded to consider other alternatives. Vaux came to America in 1850, recruited in London by Downing, who needed an architect for his expanding practice. Their joint projects included the grounds around the Capitol and the Smithsonian Institution in Washington, D.C. Downing died in 1852, in an accident on one of the Hudson River steamers, and Vaux moved to New York City in 1857. His partner in the winning design was Frederick Law Olmsted (1822–1903), whom he had known since 1851.

Olmsted, whose name is most closely associated with the creation of Central Park, was in fact always adamant that the credit should be shared equally with Vaux. Olmsted had led a peripatetic life before his commitment to the future park. He had farmed in Connecticut and on Staten Island, traveled through and written books on England, Texas, and the Deep South, and worked for a New York book publisher. In 1857, his friends on the park commission urged him to take the new position of park superintendent. Soon after Olmsted started the job, Vaux persuaded him to partner with him in entering the competition. Together, they produced the winning Greensward Plan (see page 22).

The name says it all. The Olmsted and Vaux design emphasized wide fields and long vistas. They concentrated the architectural and circulation features at the southern end of the park, where they anticipated the most visitors, and treated the land north of the reservoirs in broader strokes of meadows, woodlands, and lakes. Of the thirty-three entries, theirs provided the greatest detail—including the first art of Central Park.

Olmsted and Vaux submitted nine presentation boards showing different sections of the site and how the Greensward Plan would transform them. Vaux executed the drawings. He undoubtedly was familiar with this aspect of the English landscape design tradition developed in the late eighteenth century by Humphry Repton. When Repton was wooing his aristocratic clients, he prepared before-and-after studies to show how he would transform their featureless parks into picturesque landscapes with lakes, bridges, and far-off follies to draw the eye into the distance. Olmsted and Vaux deployed the same method, taking into account, of course, how their landscapes would be used by throngs of public visitors.

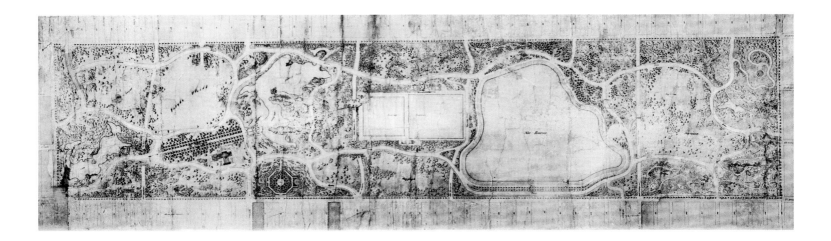

Each pair of drawings presented the "present outlines" in a simple pencil sketch and the "effect proposed" in a more elaborate rendering, with white lead highlights adding depth and drama. The drawings were accompanied by a map indicating where each of the depicted sections was located. Today, one of the most recognizable is *No. 1. From Point A* (opposite) showing the view from the entrance at Fifth Avenue and 59th Street. This is the Pond and the hilly peninsula jutting into it from the north. The island seen in the sketch was not created, but the rest of the outline is close to what it looks like today.

More fanciful is the one full-color rendition, *No. 9. From Point I* (pages 24–25), of Bogardus Hill—today's Great Hill at 106th Street, then the northwest limit of the park. In Repton's day, the "eye-catcher" structure seen in the drawing might have been a pagoda, such as the one at Kew in London. But in 1858 New York, it was a multicolored architectural composite—a harbinger of Olmsted and Vaux's plan to include buildings in styles from different eras and regions of the world. This tower was never built, and when the park was extended to 110th Street in 1863, an extant local landmark was incorporated into the park—a block-house built during the War of 1812 as a fortification against the British. It still dominates the hill at the northwestern end of the park.

Pulling out all the stops, Olmsted and Vaux included yet another painting in their submission. In 1854, Vaux had married Mary McEntee, and in 1858 he asked her artist brother, Jervis, to paint a view of the park site as it was then. McEntee (1828–1891), who studied with the landscape painter Frederic Church in 1850–51, had moved to the city in 1858. His *View in Central Park* (pages 26–27) shows the area that would become the Lake, with the future Ramble on the higher ground beyond.

Attractive as a landscape in its own right, the painting also conveys what a tremendous undertaking it would be to transform the site into the "effect proposed" by Olmsted and Vaux. As Olmsted once said, "It would have been difficult to find another body of land of six hundred acres upon the island which possessed less of . . . the most desirable characteristics of a park, or upon which more time, labor, and expense would be required to establish them." McEntee may have felt the same lack of promise in city landscapes. His preferred subject was the Catskills. He spent part of each year in Richard Morris Hunt's Tenth Street Studio Building, where he worked on his mountain scenes. Neighbors in

ABOVE
Frederick Law Olmsted and Calvert Vaux
Central Park Competition Entry No. 33: The Greensward Plan of Central Park, 1858
Brown ink on paper
Parks and Recreation Department, City of New York

OPPOSITE
Calvert Vaux
Greensward Plan presentation board
No. 1. From Point A: Present Outlines [above];
Effect Proposed [below], 1858
Graphite, wash, and white lead on paper
New York Municipal Archives, New York

NO. 1.

FROM POINT A.

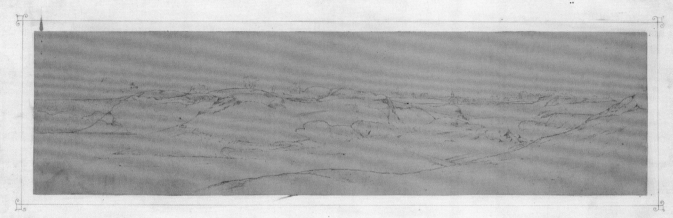

PRESENT OUTLINES.

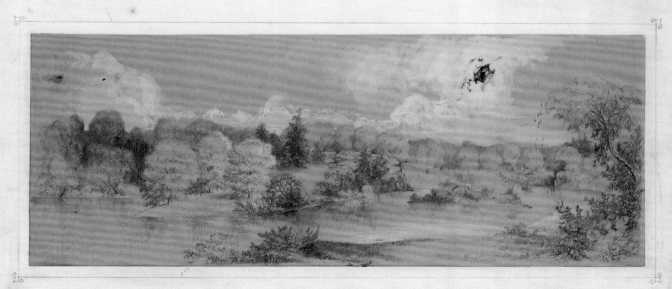

EFFECT PROPOSED.

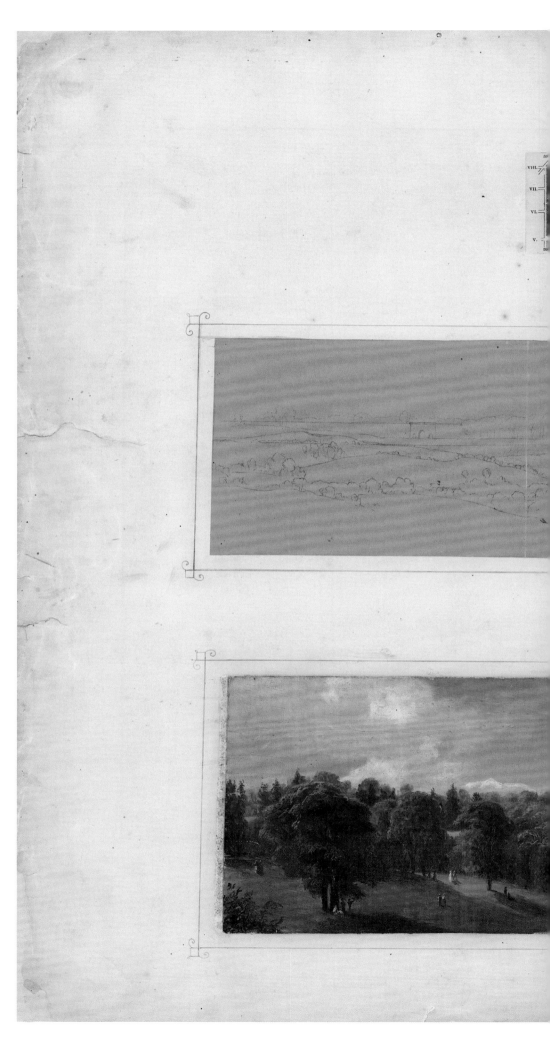

TOP
Calvert Vaux, ca. 1860
Historic New England

ABOVE
Frederick Law Olmsted, ca. 1860
Frederick Law Olmsted Historic Site

RIGHT
Calvert Vaux
Greensward Plan presentation board
No. 9. From Point I: Present Outlines [above];
Effects Proposed [below], 1858
Graphite and oil on paper
New York Municipal Archives, New York

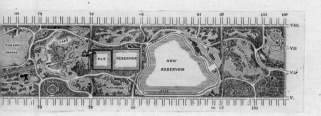

PRESENT OUTLINES.

EFFECT PROPOSED.

the building included a number of the era's greatest American landscape and genre painters—Sanford Robinson Gifford, Eastman Johnson, John Kensett, and Worthington Whittredge—who all favored rural scenes.

The final creative member of the Central Park team was another English architect, Jacob Wrey Mould (1825–1886), who came to New York in 1853 and was hired by Olmsted and Vaux in 1858. His greatest contribution was as co-architect with Vaux of some of the major park structures, including the Bethesda Terrace, for which he designed the elaborate carvings, and as solo architect of some of the smaller buildings, such as the Sheepfold and the original Bandstand (no longer extant). Mould later collaborated with Vaux on the original American Museum of Natural History and Metropolitan Museum of Art.

The task of turning the Greensward Plan into reality began in 1858, with as many as 3,800 workers laboring on the site during 1859. The park opened in sections, and by 1861, most of the major work was completed, though decorative elements like Mould's Bethesda Terrace ramp carvings were not finished until 1868. Not surprisingly for a publicly funded project administered by politicians and their appointees, there were delays, budget conflicts, demands for features that the designers fought off or ultimately accepted, resignations, and reappointments.

Olmsted and Vaux had mutual respect for the talents each brought to the project and expected to share recognition equally. Olmsted, the manager and public face of the project, planned the broad landscapes, and Vaux designed the buildings; together, they integrated the two aspects in a complex harmony. The collaboration was recognized in its time, and their firm was retained by the City of New York to design Morningside and Riverside Parks. Brooklyn, then a separate municipality, hired them to create Prospect Park, often considered their joint masterpiece. Each went on to a long career, Olmsted as designer of other major American city parks and Vaux as an architect of houses and institutions.

The first artist to depict Central Park who was not part of the Olmsted and Vaux team was the young Winslow Homer (1836–1910). He was employed by *Harper's Weekly* from 1859 to 1867, when he went to Paris. *Harper's*—in both its weekly and monthly publications—was from the start a booster of the park. The weekly commissioned Homer to draw scenes of the park and featured them as full spreads, much bigger than any other illustrations in the magazine. Homer, not yet a landscape painter, focused on people enjoying the park's recreational facilities.

In *A Drive in Central Park* (opposite), which appeared in the September 15, 1860, issue, Homer depicts a lively crowd of horseback riders and carriage drivers. As horses and carriage wheels kick up the dust on the road near Fifth Avenue and 72nd Street, a pair of riders waits patiently to cross the thoroughfare, and two park keepers monitor the scene. Whatever plantings had been installed by then had not yet grown to any significant height. By the time the park was finished, Olmsted and Vaux had laid out separate roads for carriages, riders, and pedestrians, to avoid the traffic jams and potential for collisions seen in this early view.

The following year, a new scene needed depiction for the readers of *Harper's*—the battlefields and camp life of the Civil War. Homer was sent to the front, where in addition to drawings that were reproduced as engravings in the magazine, he did his first oil paintings. The poignancy of these scenes of soldiers

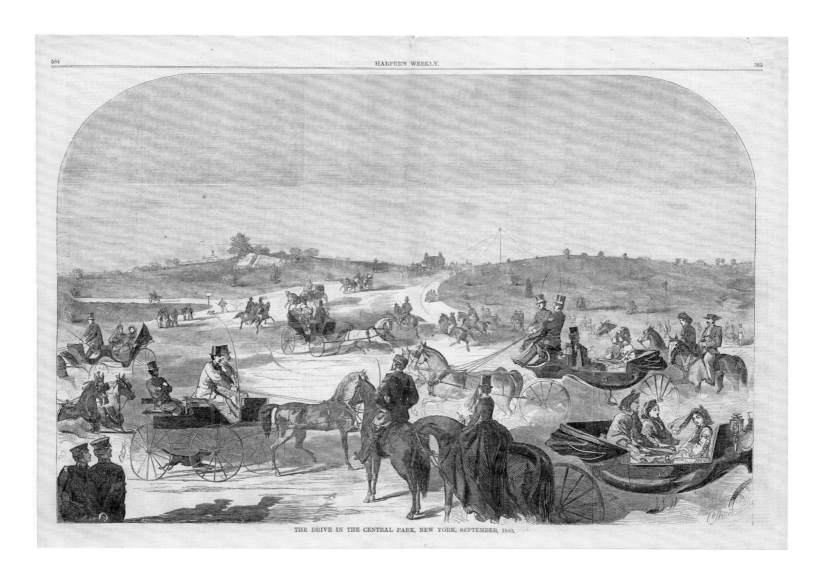

THE DRIVE IN THE CENTRAL PARK, NEW YORK, SEPTEMBER, 1860.

waiting for combat, holding prisoners, and contemplating the graves of their comrades is far from the gaiety of carriage rides or skating parties in the park, and was a major step in Homer's evolution as an artist of private thoughts.

One of the few artists attracted to Central Park in its unfinished state was George Loring Brown (1814–1889). Born in Boston, Brown studied painting in Paris and Florence and then lived in Italy for many years. He so perfected the landscape style developed in the seventeenth century by Claude Lorrain—dark, feathery trees, fields dotted with ruins, and glowing sunset skies—that he became known as "Claude" Brown. Returning to Boston in 1859, he occasionally came to New York for commissions. In Central Park, he found many of the elements of his beloved Italian landscapes, but as though through the looking glass. If Brown's Italian scenes are elegiac evocations of the past, then his *View of Central Park* (1862; pages 30–31) is about the promise of the future. Painted from the Ramble, Brown's landscape includes a glimpse of the Bethesda Terrace and the Bow Bridge, with downtown church spires in the distance. He gives the park the Claudian topography of hills, a few tall trees to one side, and paths leading into the distance under a sky at dusk. But, though the open land correctly suggests years of intense use, it is now about to be transformed into something

ABOVE
Winslow Homer
A Drive in Central Park,
1860
Wood engraving on paper,
13¾ x 20⅛ in.
(34.9 x 51.1 cm)
Clark Institute, Williamstown,
Massachusetts

OVERLEAF
George Loring Brown
View of Central Park, 1862
Oil on canvas, 20 x 42 in.
(50.8 x 106.7 cm)
Museum of the City of
New York, New York

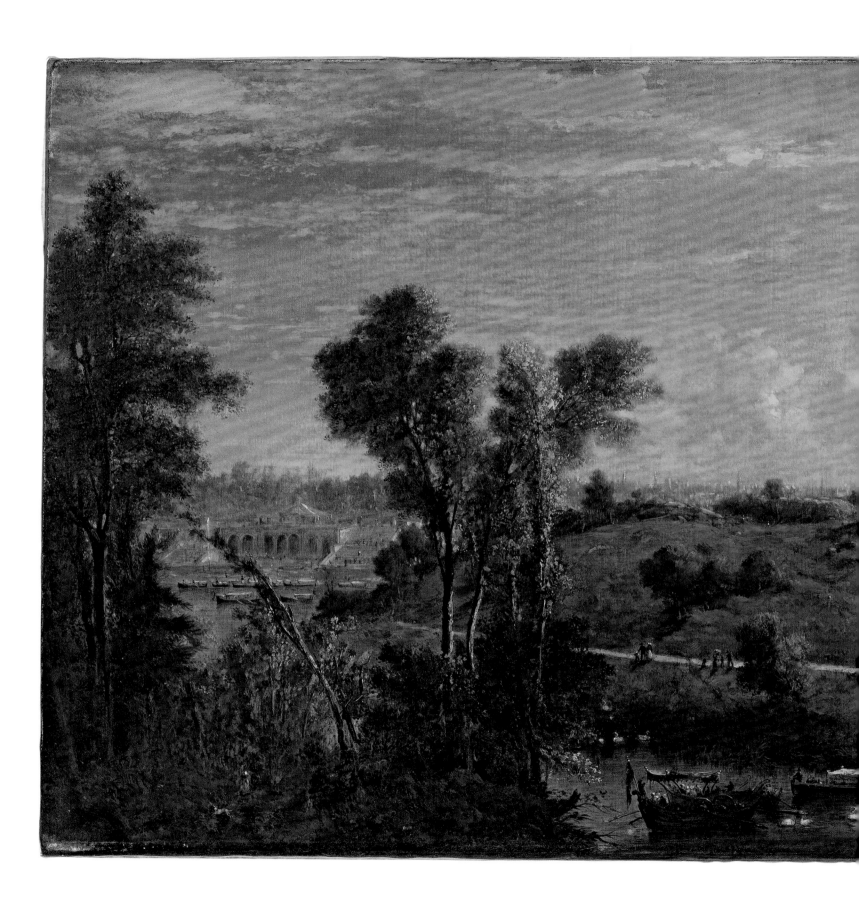

CENTRAL PARK, THE DRIVE.

lush, and the heavy stones on the ground are not fragments of classical temples but rocks that will be dug up and incorporated into a romantic landscape.

Though few painters were attracted to the park while it was a work in progress, illustrations of it in publications like *Harper's*, as well as inexpensive prints, were the major ways that news of Central Park's attractions spread through the city and the country. Currier & Ives, founded in 1834, was for decades America's leading printmaker; it employed a number of artists to make drawings that it reproduced as lithographs. Throughout the Civil War, the firm continued printing images of the idealized American life. Buyers surely found solace in these evocations of innocent pastimes. Currier & Ives had already published many pictures of people riding and skating in rural settings, and the advent of an urban equivalent in Central Park became a popular new subject for the printmakers. Thanks to Currier & Ives and a few other printmakers, images of Central Park hung in thousands of American homes, giving people all across the country a sense of elegant life in a sophisticated city's rural playground.

ABOVE
Currier & Ives
Central Park, The Drive,
1862
Hand-colored print, 12½
x 15½ in. (31.8 x 39.4 cm)
Museum of the City of
New York, New York

OPPOSITE
Currier & Ives
Central Park in Winter,
n.d.
Lithograph, 10 x 14 in.
(25.4 x 35.6 cm)
Museum of the City of
New York, New York

In *Central Park, The Drive* (page 32), most of the trees flanking the carriage road are still saplings. The distant building is the Arsenal. Built in 1851 to store munitions, the Arsenal became office space for the park's administrators—and still serves that function today. It was the first home of the American Museum of Natural History, founded in 1869, until the building designed by Vaux and Mould was completed in 1877. The Arsenal also housed the menagerie that in 1870 moved to new buildings nearby, forming the basis of the Central Park Zoo.

Central Park in Winter (below) shows the delights the park offered skaters and sleigh riders on a cold, moonlit night. In the background, the Bow Bridge, completed in 1862, links the Ramble, opened in 1859, with a path to the still unfinished Bethesda Terrace. The bridge, one of the most admired features and best known of Central Park's twenty-four bridges and arches, was designed by Vaux and Mould; the construction firm supplying the ironwork went on to build the dome of the Capitol in Washington, D.C.

As the Greensward Plan was being realized, and more and more of the park's major facilities opened, the range of prints expanded accordingly. A novelty was aerial perspectives showing the new landmarks. The finest artist of these views was John Bachmann. All that is known of him is what can be traced through the dates of prints he

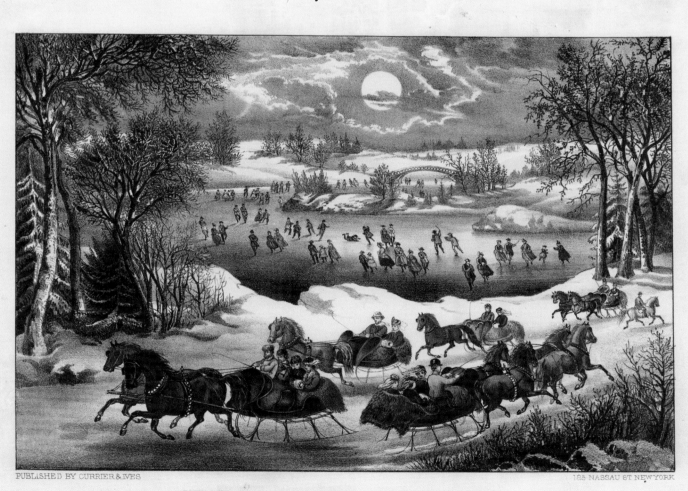

PUBLISHED BY CURRIER & IVES 125 NASSAU ST NEW YORK

CENTRAL PARK IN WINTER.

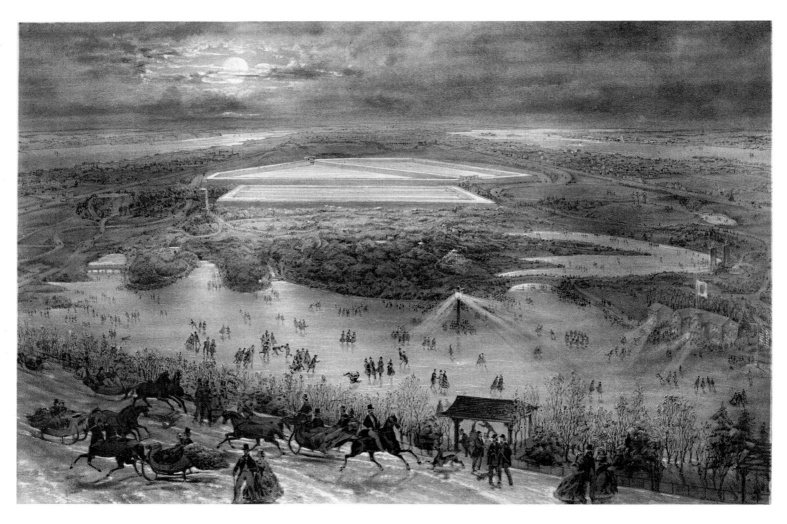

Julius Bien, after
John Bachmann
Central Park (Winter), 1865
Color lithograph on paper,
16¾ x 23⅛ in.
(42.5 x 58.7 cm)
Museum of the City of New
York, New York

did of various American cities between 1847 and 1885. He depicted New York intermittently between 1851 and 1877.

In *Central Park (Winter)* (1865; above), Bachmann's vantage point is not much different from the one in the Currier & Ives print of three years earlier. The Bethesda Terrace, its Venetian banners aflutter, is now visible on the right side of the Lake, with the Conservatory Water beyond. To the north, beyond the still-bare hill of the Ramble, are the two reservoirs, which were so influential in justifying this part of the city as the site for a park.

Bachmann's *Central Park (Summer)* (pages 35, 36–37) of the same year looks south from above the Ramble to the Bethesda Terrace and the Mall, with the Sheep Meadow off to the right. Perhaps Bachmann intended the pair of views as pendants showing the contrast of the seasons in the park, but this one was published by Edmund Foerster & Co, not by Currier & Ives. Various pleasure craft ply the Lake, and a stream of visitors crosses the Bow Bridge to explore the Ramble. The view of the terrace is distinctive for the depiction of the fountain before it was surmounted by the statue of the Angel of the Waters in 1873. The hot-air balloon hovering over the park reminds viewers that this aerial view was in fact feasible for the artist and available to anyone else.

A decade later, Bachmann went aloft again to record how the scene had changed. In this *View of Central Park* (page 38), the Belvedere, designed

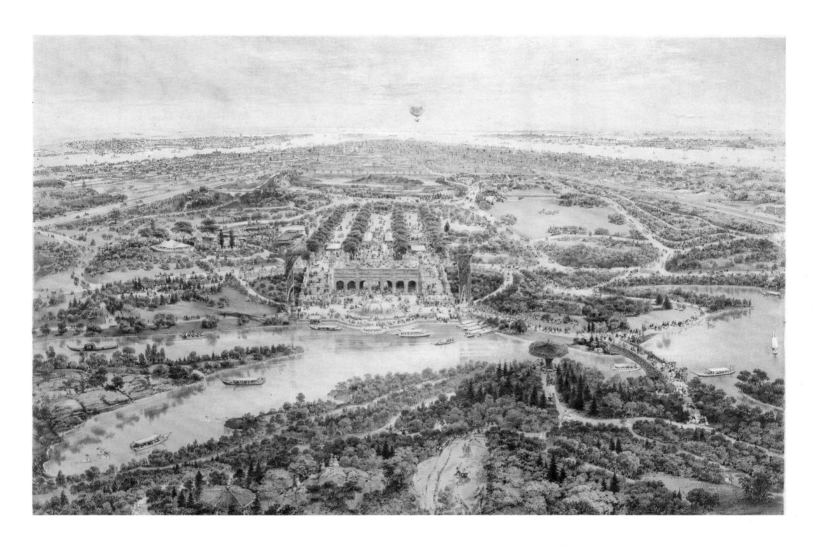

by Vaux and completed in 1871, dominates the foreground. Overlooking the 1842 reservoir, it stands on Vista Rock, the highest point in the park, and was built from the same Manhattan schist. Vaux's boathouse, seen to the left of the Bethesda Terrace on the Lake beyond, was not finished until at least 1875, thereby helping to date this print. In the decade since Bachmann's earlier southward view, buildings have sprung up on previously vacant tracts all around the park's periphery.

Interest in New York's new park was not confined to the United States. Images of it appeared in European newspapers and magazines as well. The French *L'Univers illustré*, for example, printed *New-York: une après-midi au Parc Central* (page 39) in 1877. It shows a crowded day in the Children's Shelter, Vaux's now-vanished, 110-foot-wide rustic octagonal pavilion, built out of cedar logs and branches in 1866. Olmsted and Vaux created this area for children to run about under supervision. Benches divided the shelter into smaller sections of different shapes for various activities. The concept of a "playground" was then a lawn for organized sports like cricket and a new indigenous game, baseball. In the distance are the spires of the Gothic-style Dairy, designed by Vaux in 1871; it was another building in the complex focused on children, called the Kinderberg, or Children's Mountain. The parks known to readers of *L'Univers illustré* had nothing like this.

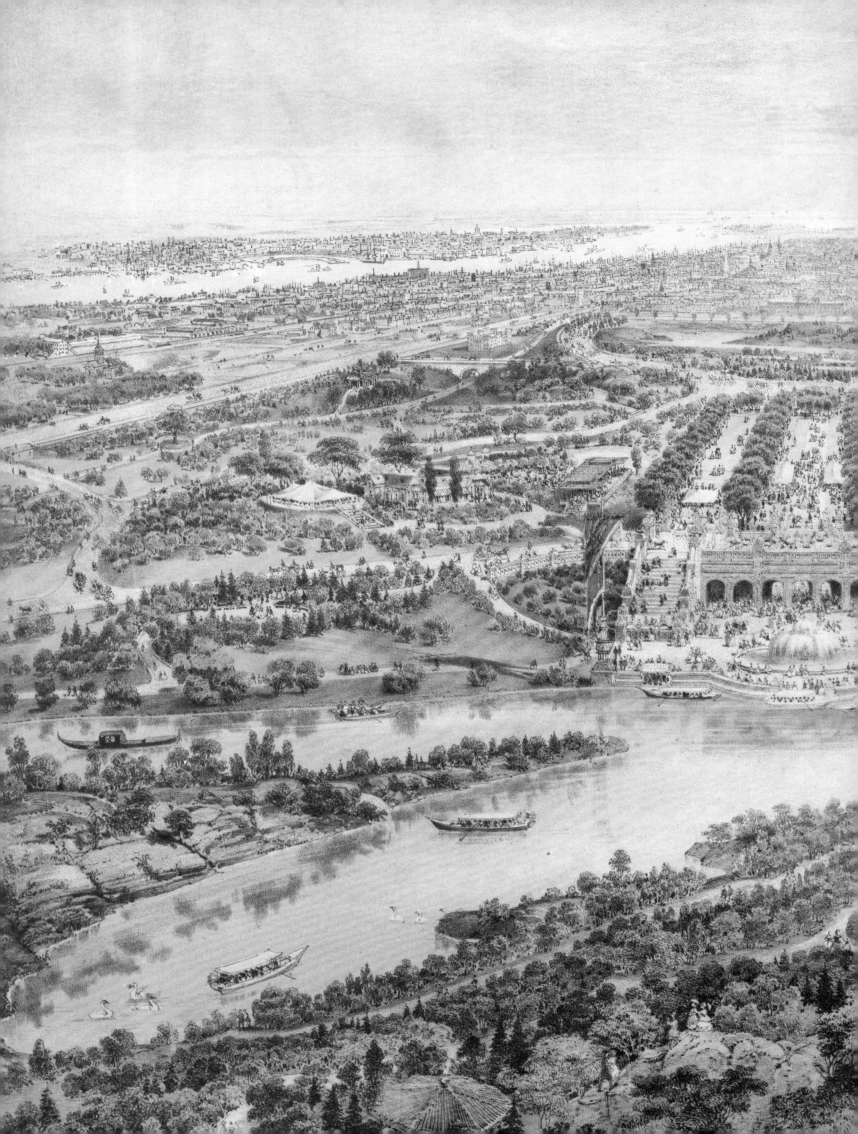

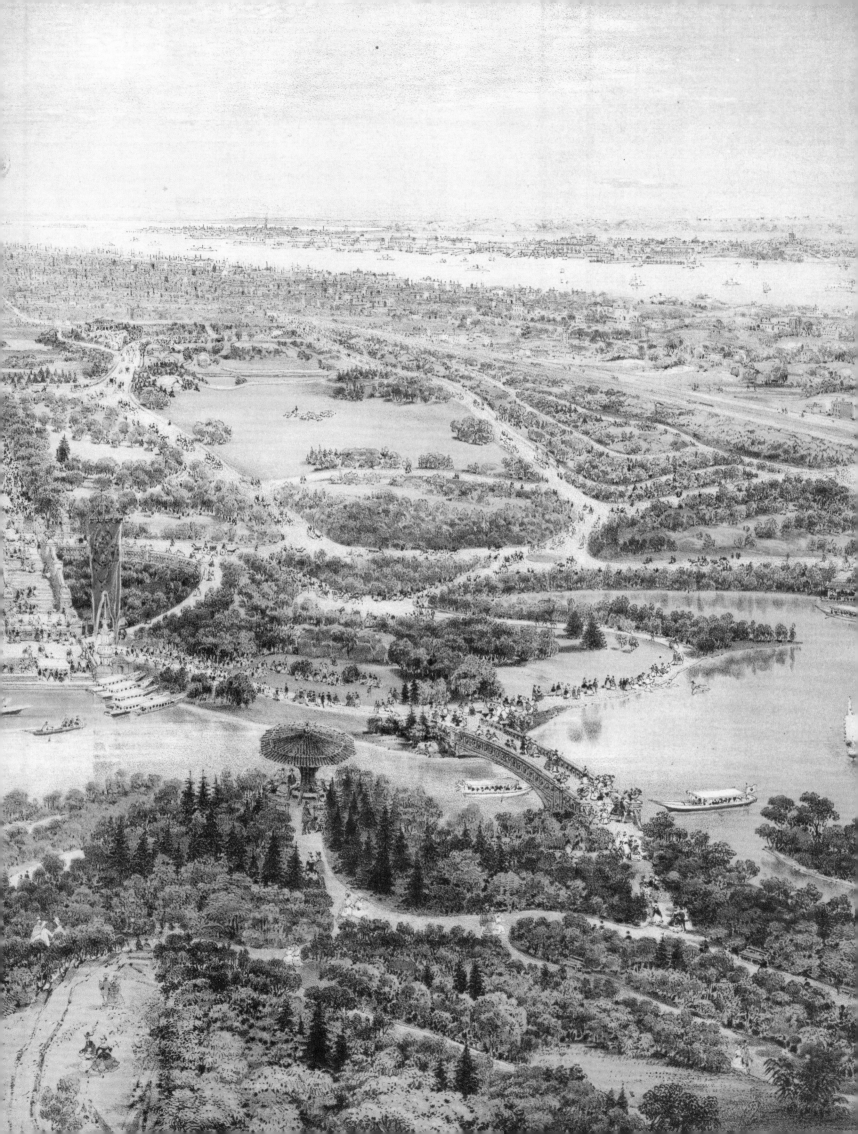

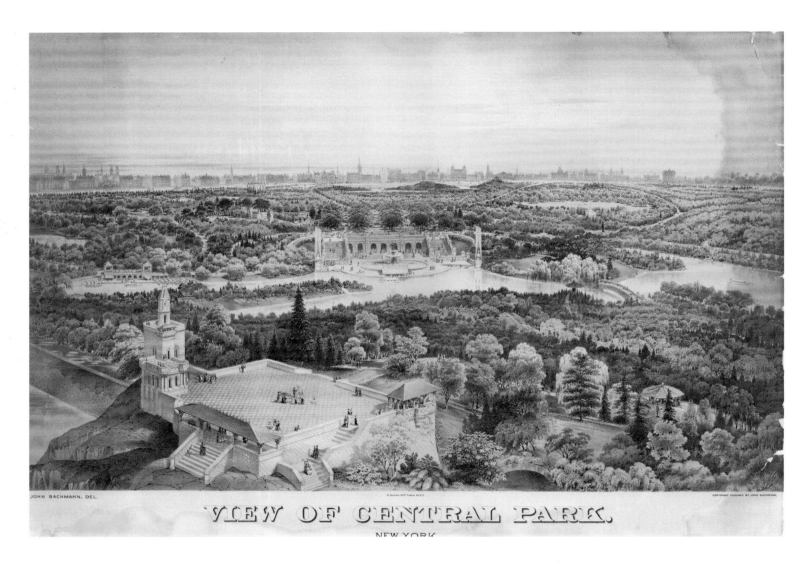

VIEW OF CENTRAL PARK.
NEW YORK

John Bachmann
*View of Central Park,
New York*, ca. 1875
Tinted lithograph on paper,
16¹⁵⁄₁₆ x 26¹⁄₁₆ in.
(43 x 66.2 cm)
I.N.P. Stokes Collection,
New York Public Library,
New York

The importance of prints and journal illustrations of Central Park was especially great in the 1860s and 1870s because a market for paintings of the park had not yet developed. McEntee's 1858 view was done not for sale but to help his brother-in-law secure the contract to build the park. Brown's classical evocation of 1862 did not produce more commissions. McEntee's illustrious fellow renters at the Tenth Street Studio Building earned their living as painters of grander landscapes—the Hudson Valley, Maine coast, Rocky Mountains—and of pastoral scenes on Long Island and around Newport. Few patrons or collectors wanted on their walls a view of an urban development project that would reach maturity only decades later.

Indeed, Central Park still had some growing up to do, as Henry James observed in *The Bostonians* (1886), set in 1875, noting "its rockwork grottoes and tunnels, its pavilions and statues, its too numerous paths and pavements, lakes too big for the landscape and bridges too big for the lakes." The next two decades made the difference. In 1896, James's friend William Dean Howells looked at the same features and wrote in *Impressions and Experiences*, "The Park is in no wise taken away from nature, but is rendered back to her, when

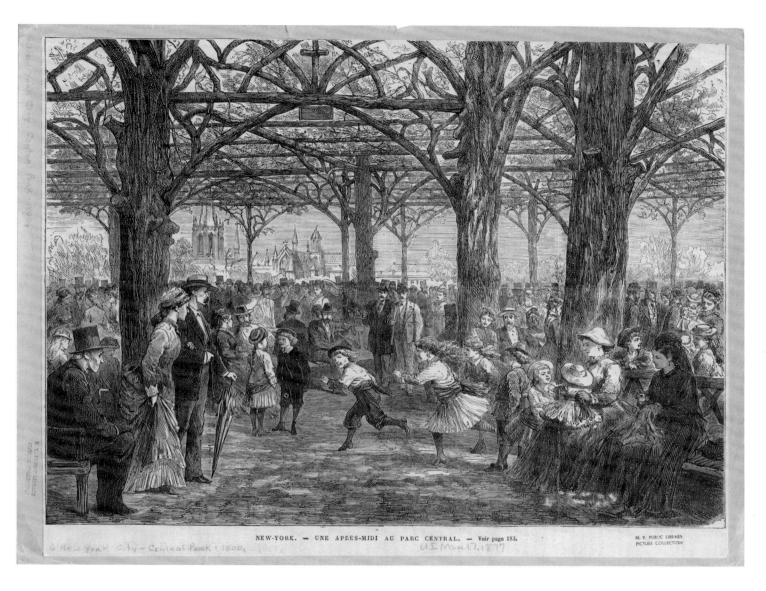

NEW-YORK. — UNE APRÈS-MIDI AU PARC CENTRAL. — Voir page 183.

all has been done to beautify it, an American woodland, breaking into meadows, here and there, and brightened with pools and ponds, lurking among rude masses of rock, and gleaming between leafy knolls and grassy levels."

As time enabled the fulfillment of Olmsted and Vaux's vision, Central Park began attracting more American painters—and the buyers who sustained them. By the 1880s, more and more American collectors and artists were flocking to Europe and becoming familiar with the work of both academic and Impressionist painters who depicted scenes of daily life. American painters who studied in Paris or Munich and sketched in the parks and plazas returned home looking for comparable attractions. In Central Park, they found what they had admired in Europe—people enjoying themselves in a cosmopolitan city, dressed in similar styles and parading in settings equivalent to what the artists had discovered abroad. Here, at last, thought a new generation of artists, were American things worth painting. From the 1880s to the present, artists have explored every part of the park the first painters could only imagine, finding inspiration—as Downing so rightly predicted—in its "secluded walks . . . and broad alleys filled with thousands of happy faces."

Artist unknown
New-York: une après-midi au Parc Central, 1877
Print, 9½ x 12 in.
(24.1 x 30.5 cm)
New York Public Library,
New York

A WALK IN THE PARK WITH THE PAINTERS

To see how Central Park has matured and evolved over the 150 years since Olmsted and Vaux planned it, let us take a stroll from one end to the other, accompanied by the painters—and a few writers. You can walk the entire length and breadth of the park in a few hours. Olmsted and Vaux thought very carefully about the routes of the pedestrian paths, their vistas, and their benefits to all who visited the park on foot. Olmsted wrote regularly to the park's commissioners, explaining both the specifics and the general goals of the park's layout. In one especially revelatory letter, he said, ". . . it is one great purpose of the Park to supply to the hundreds of thousands of tired workers, who have no opportunity to spend their summers in the country, a specimen of God's handiwork that shall be to them, inexpensively, what a month or two in the White Mountains or the Adirondacks is, at great cost, to those in easier circumstances." Starting at the southern entrances, we'll let the artists show us not only which sites attracted them but also how differently they portrayed the same sites.

Rackstraw Downes
The Oval Lawn, 1977 (detail)
See pages 83–85

ENTERING THE PARK

Grand Army Plaza, at Fifth Avenue and 59th Street, is the most formal of the park's entrances. This horseshoe-shaped inset of trees embracing sculpture and a fountain forms an elegant transition from the canyons of the urban grid to the open spaces and curving paths of the park. F. Scott Fitzgerald felt a change of mood when approaching this corner from within the park. In his essay "My Lost City" (1935) he wrote, "Whole sections of the city had grown rather poisonous, but invariably I found a moment of utter peace in riding south through Central Park at dark towards where the facade of 59th Street thrusts its light through the trees. There again was my lost city, wrapped cool in its mystery and promise."

On the north side of Grand Army Plaza stands Augustus Saint-Gaudens's equestrian statue of General William Tecumseh Sherman. Memorialized for his campaigns that helped end the Civil War, the general is led by Victory as his horse tramples a branch of Georgia pine. The statue, eleven years in the making, was completed and installed here in 1903. Two years later, Henry James, visiting New York for the first time since 1883, saw the plaza and the statue on his way into the park. In *The American Scene*, he described it as "the heterogeneous, miscellaneous apology for a Square marking the spot at which the main entrance, as I suppose it may be called, to the Park opens toward Fifth Avenue; opens toward the glittering monument to Sherman, toward the most death-dealing, perhaps, of all the climaxes of electric car cross-currents. . . . The best thing in the picture, obviously, is Saint-Gaudens's great group, splendid in its golden elegance and doing more for the scene (by thus giving the beholder a point of such dignity for his orientation) than all its other elements together."

For all its merit, few painters have chosen to depict this monument. The seemingly casual attitude of generations of artists toward this major gateway into Central Park is captured in Richard Estes's *Equestrian Statue of General Sherman by Augustus Saint-Gaudens Viewed from a Bus* (right). Estes shows the statue as many people now see it—on the successor to the electric trams that James feared might strike him down. Estes juxtaposes the mundaneness of a bus ride with the seriousness of the memorial by one of America's greatest sculptors to the nation's most bitter conflict. By 1995, the gilding James admired had turned black; it has since been restored. Estes (b. 1932) is a Photorealist known for his New York City street scenes,

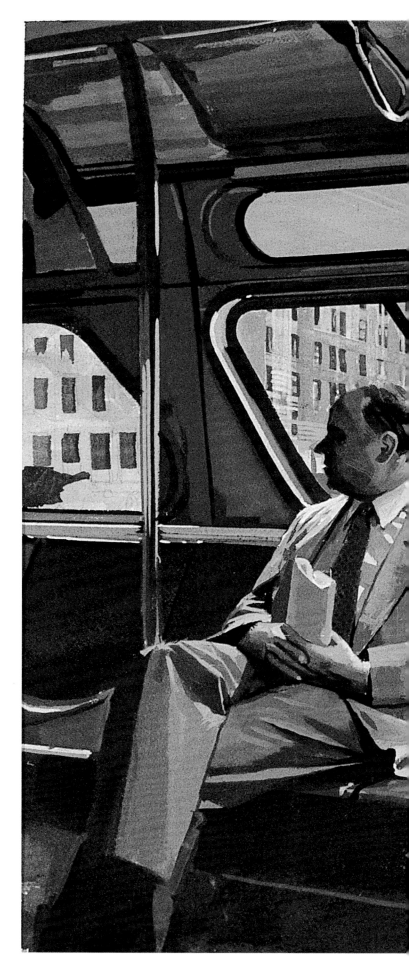

Richard Estes
*Equestrian Statue of General
Sherman by Augustus Saint-
Gaudens Viewed from a Bus*, 1995
Acrylic and gouache on board,
15¼ x 19¾ in. (38.7 x 50.2 cm)
Private collection

William Zorach
Fifth Avenue from the Plaza, 1951
Watercolor and pencil on paper, 22 x 15 in.
(55.9 x 38.1 cm)
Private collection

often featuring highly reflective surfaces that capture bits of the cityscape not within the frame.

A backward glance to the south takes in the rest of Grand Army Plaza and the stony mass of the city beyond. William Zorach's watercolor *Fifth Avenue from the Plaza* (opposite) contrasts the severe lines and sharp angles of the buildings rising jaggedly as far as the eye can see with the soft, rounded forms of the trees surrounding the Pulitzer Fountain, built with funds donated by the newspaper publisher Joseph Pulitzer in 1912. Zorach (1887–1966), though best known as a sculptor, painted watercolors of New York throughout his life.

An even more monumental sculpture, the Maine Memorial, lends grandeur to the park's other southern entrance, at Columbus Circle. Completed in 1913, it was donated by Pulitzer's archrival, William Randolph Hearst, the newspaper publisher whose *Morning Journal* profited immensely from its coverage of the Spanish-American War. The memorial honors the sailors who perished when the USS *Maine* exploded in Havana harbor in 1898. It was designed by Harold Van Buren Magonigle, a former student of Calvert Vaux, and its figures were sculpted by Atillio Piccirilli.

In *Central Park Skyline* (page 46), Guy Carleton Wiggins (1883–1962) softens and reduces the scale of the oversize monument and its groupings of allegorical figures—*Courage Awaiting the Flight of Peace* and *Fortitude Supporting the Feeble* at the base and *Columbia Triumphant* at the top. Wiggins was a prolific painter of New York snow scenes. Here, the Maine Memorial on the left, the solid wall of buildings along Central Park South on the right, and the looming towers of the Pierre and Sherry-Netherland hotels on Fifth Avenue in the distance form a frame around the park. Only the entrance at a break in the perimeter wall offers an escape from the gray bleakness.

The park's outer wall—built in part of gneiss excavated on site—circumscribes the whole park. Childe Hassam (1859–1935), the leading exponent of Impressionism among American painters, saw its artistic potential in *Promenade—Winter New York* (page 47). The wall cuts a bold diagonal through the canvas, reminiscent of the Japanese prints that inspired French Impressionists. It separates the park's trees, rendered with feathery strokes, from the solid figures set off boldly in black against the snow.

Hassam painted the park frequently after his move in 1893 from lodgings downtown to a studio on West 57th Street. Born and raised in the Dorchester neighborhood of Boston, he began painting urban scenes there in 1884. He came to New York after spending several years in Paris (1886–89), where he was deeply influenced by both the Barbizon and Impressionist painters he encountered. From the Impressionists he acquired not only technique but also awareness of the artistic possibilities inherent in daily life. In an interview he said, "I sketch these things because I believe them to be aesthetic and fitting subjects for pictures. There is nothing so interesting to me as people. I am never tired of observing them in every-day life, as they hurry through the streets on business or saunter down the promenade on pleasure. Humanity in motion is a continual study to me."

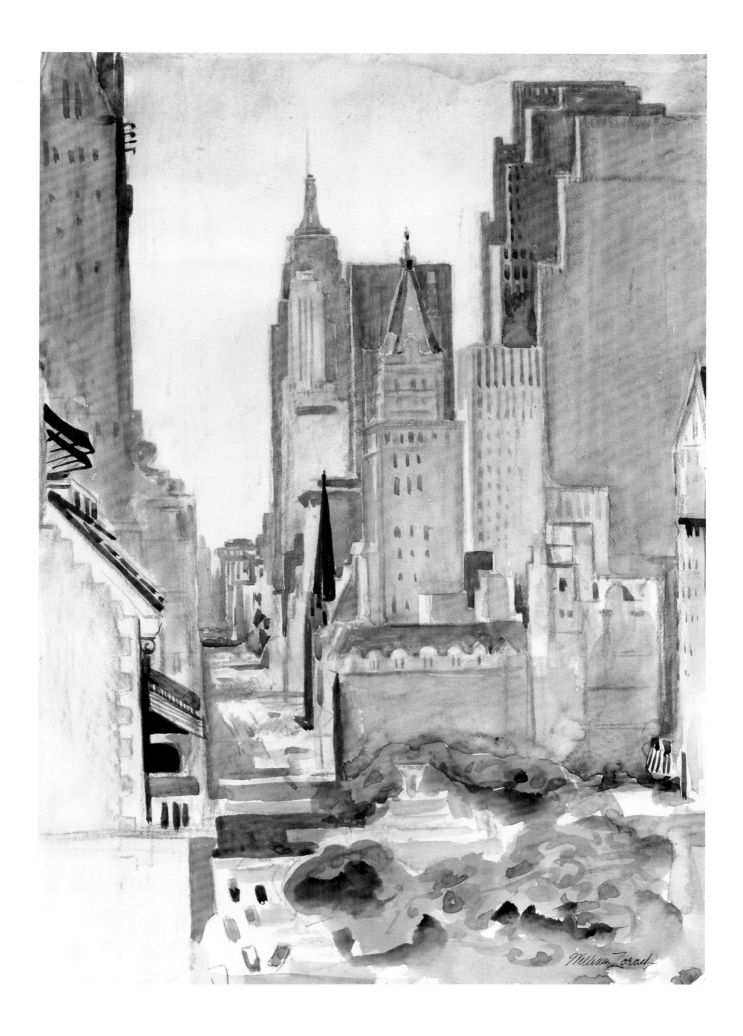

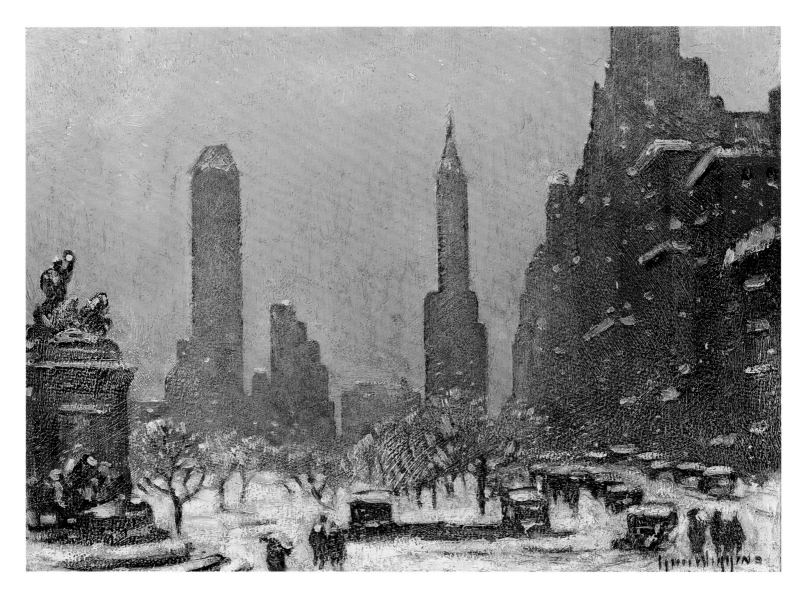

Guy Wiggins
Central Park Skyline, 1936
Oil on board, 12 x 16 in.
(30.5 x 40.6 cm)
Private collection

THE LOWER PARK: POND, ZOO, AND MEADOW

If one enters the park at Grand Army Plaza, the first major feature one comes upon is the Pond. The view from there of the array of grand hotels that rim the park is one of the iconic vistas of twentieth-century New York—captured in works such as Joseph Delaney's *Central Park Skating* (see page 106). Long before the Plaza, the Savoy-Plaza, the Sherry-Netherland, and the Pierre filled that space, however, the view from the Pond offered a very different prospect, as seen in Jasper Cropsey's *A View in Central Park—the Spire of Dr. Hall's Church in the Distance* (1880; page 48). Cropsey (1823–1900), born on Staten Island, is best known as a painter of the Catskills and Hudson Valley, where he lived. Profoundly religious, he saw the hand of God in the beauty of nature and believed that the best art was a faithful reproduction of nature. Cropsey visited Europe in 1847–49 and was impressed by works of Constable and Turner. He kept a studio in the city from 1869 to 1885 but painted few city scenes.

 Cropsey's only view of Central Park shows the influence of British painters in the treatment of the sky and the reflection of the setting sun on the water, as well as in the inclusion of a distant church, reminiscent of Constable's views of

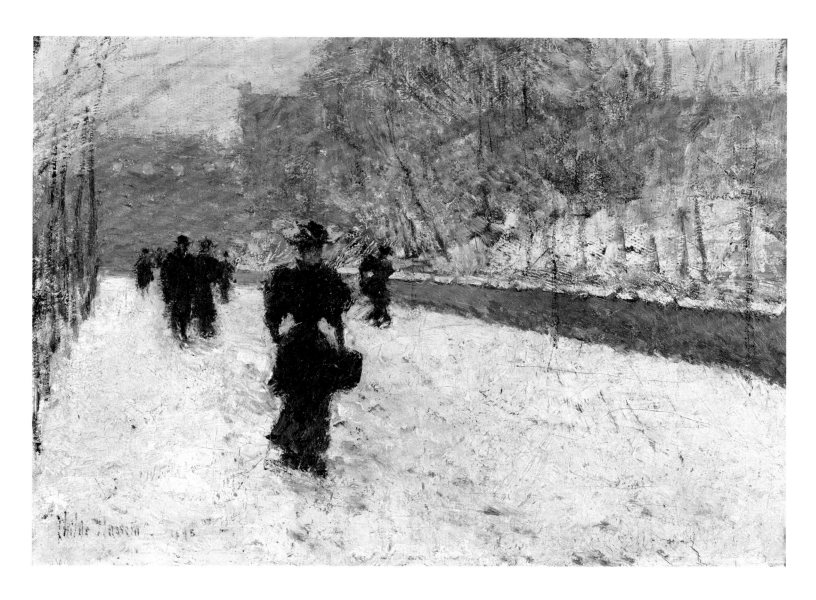

Salisbury Cathedral. The tower and spire are of the Fifth Avenue Presbyterian Church, at 55th Street, where Dr. John Hall was rector. Completed in 1875, it was then one of the tallest structures in the city—surpassed, among church spires, in 1888 by St. Patrick's Cathedral a few blocks farther south. As though to bring the divine into the park, Cropsey has reduced the church's actual quarter-mile distance from the Pond, so its spire can be reflected in it.

The two swans were the ancestors, literal or figurative, of others painted at the Pond by Childe Hassam in 1895 and George Bellows in 1906. The Pond's most famous waterfowl, however, were never seen. They were the ducks that obsessed Holden Caulfield in J. D. Salinger's *The Catcher in the Rye.* What did they do in the winter when the Pond froze, he wondered. One cold night, after being expelled from yet another boarding school, Caulfield walks all around the Pond without finding a single duck.

Leon Kroll's *Scene in Central Park* (page 49) also captures the warm glow of the setting sun's reflection in the Pond. The flat brushwork and broad patches of color defining the rocky hills bear the unmistakable influence of Cézanne, whose work impressed Kroll when he visited Paris in 1908. Kroll (1884–1974) painted this scene three times in 1922. He spent almost his entire career in New York City and painted the park at least nine times between 1922 and 1965.

Childe Hassam
*Promenade—Winter
New York*, ca. 1895
Oil on canvas, 10 x 14 in.
(25.4 x 35.6 cm)
Private collection

OPPOSITE

Jasper Francis Cropsey
A View in Central Park—The Spire of Dr. Hall's Church in the Distance,
1880
Oil on canvas, 17¼ x 12¼ in. (43.8 x 31.1 cm)
Private collection.

ABOVE

Leon Kroll
Scene in Central Park,
1922
Oil on canvas, 27¼ x 36 in. (69.2 x 91.4 cm)
Smithsonian American Art Museum,
Washington, D.C.

Like many of the artists who painted in the park, he studied at the nearby Art Students League on West 57th Street and later at the National Academy of Design. In Paris, Kroll befriended Robert Delaunay, a Fauve painter who broke his subjects into abstract units of bright color, and Marc Chagall, whose dream-like scenes perhaps influenced Kroll's *Sleep, Central Park* (see pages 152–53). Just as Cropsey felt free to bring his church closer to the park, Kroll altered the skyline for each of his park paintings. In his autobiography, *A Spoken Memoir*, he explained, "I select out of nature what I need, using it as an encyclopedia of fact, and then compose it. I shift the buildings, and I shift the trees."

North of the Pond is the Zoo. Animals were kept on exhibition at this site from the park's founding. George Templeton Strong, the New York attorney and diarist, visited the menagerie, as it was then called, on August 10, 1869. "To Central Park this afternoon to inspect the live critters assembled in and around the old Arsenal building—the nucleus of our future Zoological Garden. The collection is not large, and consists of donations sent in and received without any system: sundry bears, black bears and a grizzly bear, prairie dogs, foxes, beautiful ocelots, owls, eagles, two meek camels, pheasants, monkeys, macaws, etc. It amounts to little. But the critters look healthy and receive much attention from visitors." If the three African Cape buffaloes that General Sherman had

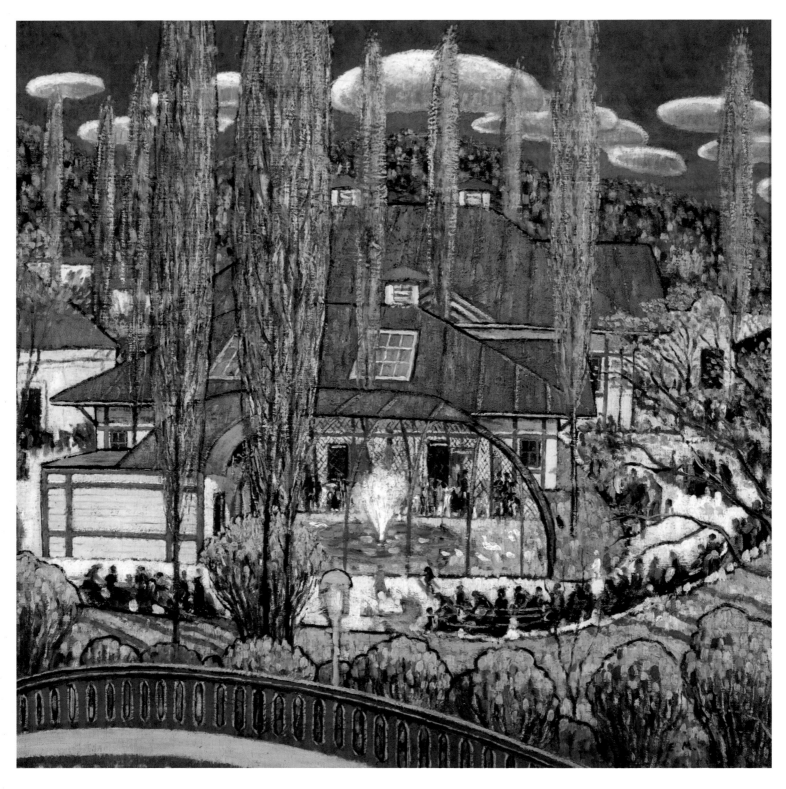

Edward Middleton
Manigault
*The Zoo (Menagerie in
Central Park)*, 1911
Oil on canvas, 20 x 20 in.
(50.8 x 50.8 cm)
Columbus Museum of Art,
Columbus, Ohio

brought back from Georgia and given to the menagerie in 1865 had still been alive, Strong surely would have mentioned them.

Since its earliest days, the Zoo has been one of the most popular features of Central Park. In 1870, separate facilities were built to house the animals. These were replaced in 1934 by the series of Georgian Revival buildings that, with the Arsenal, form a square centered around the sea lion pool. Edward Middleton Manigault's *The Zoo (Menagerie in Central Park)* (above) shows a crowd of visitors lined up to enter several of the original buildings on a crisp autumn day, as others fill the benches around the cages. The bright colors and thick brushwork,

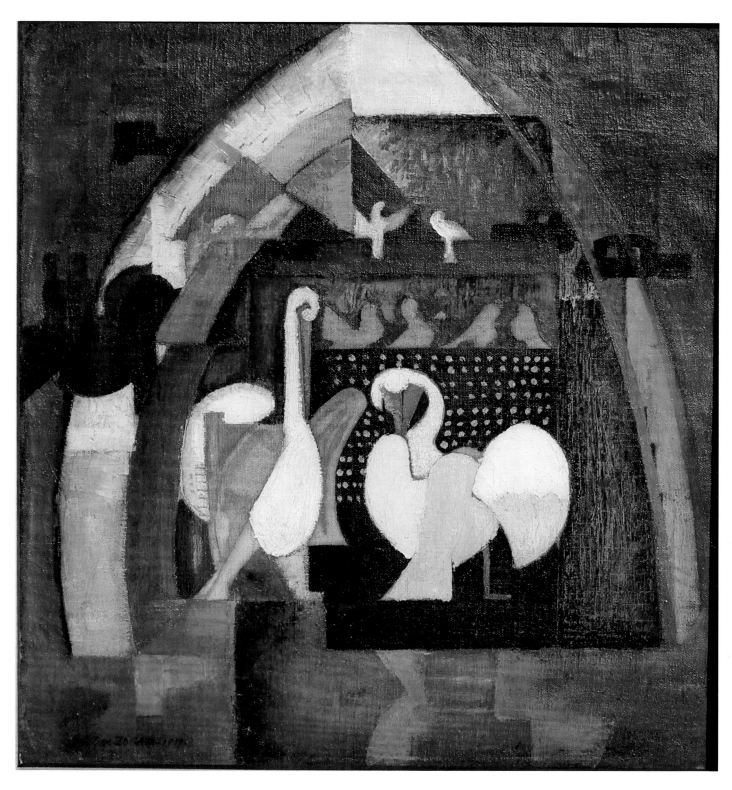

as well as the poplars rising to the clouds, give the cluster of red-roofed buildings the look of a Post-Impressionist French village.

Manigault (1887–1922) was a versatile painter who experimented with several European styles during his short life. In succession a realist, a Post-Impressionist, a Fauve, a Symbolist, and a Cubist, he lived in New York from 1905 to 1919. Like George Bellows, a classmate at the New York School of Art, he was especially attracted to Riverside Park, which he painted twenty times between 1907 and 1909. He turned to Central Park in 1910 and 1911 (see pages 57, 58–59, 114–15, 176–77), during his explorations of Post-Impressionism and Fauvism.

William Zorach
Pelican Cage—Central Park,
1918
Oil on canvas, 22 x 18 in.
(55.9 x 45.7 cm)
Private collection

The interior of one of the zoo buildings was of special interest to William Zorach. In 1917, he painted *Pelican Cage—Central Park* (page 51) on the back of his canvas *Reflections*, a view of fishing boats by night, probably done in Provincetown in 1916. In the zoo painting, the building is defined by Cubist washes of color suggesting water and the sky beyond the enclosure. The simplified, rounded forms and varied poses of the birds perhaps presage the sculpture for which Zorach is best known.

Zorach was born in Lithuania and brought to Cleveland at age four. He studied at the Cleveland School of Art and came to New York in 1908, enrolling at the National Academy of Design. A sojourn in France in 1910–11 exposed him to a wide variety of artists. He worked in the studio of the academic Jacques-Émile Blanche and saw works by Matisse and the Fauves. Only later, after his return to New York, did Zorach come to appreciate the Cubists. In his 1967 autobiography, *Art Is My Life*, he described his evolving view. As though recalling the juxtaposition of birds and building in *Pelican Cage—Central Park*, he wrote, "After the Armory Show I began making my visual observations of nature into Cubist patterns. It was another revelation; that one was not confined to the small section of nature framed in the space of a canvas and seen only from one point of view but was free to use all the colors and directions of space and form that surround one. My painting took on a deeper and more mystical tone. My subject matter became imaginative and expressive. I tried to paint what I felt was the inner reality of life around me."

To the northwest of the Zoo is the Sheep Meadow. Its fifteen acres were planned as one of Central Park's largest evocations of an English landscape. Sheep—Southdown and, later, Dorset—did in fact graze there until 1934. In addition to their scenic value, the sheep helped trim and fertilize the lawn. They were tended by a shepherd and housed in the Sheepfold. That building later became Tavern on the Green. William Merritt Chase depicts the view of the Sheep Meadow looking south in *The Common, Central Park* (opposite) as it appeared in 1889. To the vast expanse of lawn, Chase adds one speck of red, the banner that signaled "keep off." For contemporary viewers, the novelty in the view was the block of nine-story apartment buildings, among the first to rise above the trees on what was still called West 59th Street. They were completed in 1883 and known as the Navarro Flats, after the builder, José de Navarro, or as the Spanish Flats, because each of the eight buildings had a Spanish name. An unsuccessful early attempt at a cooperative, the complex was sold off piecemeal, beginning in 1926.

Chase (1849–1916) was born in Indiana and came to New York in 1869 to study art at the National Academy of Design. A few years later, a group of patrons underwrote a stay in Europe. When Chase returned to New York, he became a significant teacher as well as a painter. He taught for years at the Art Students League, leaving for a decade to establish what he first called the Chase School of Art, later the New York School of Art. In 1891, he created the Shinnecock Summer School of Art on the eastern end of Long Island; during the summers he spent there he produced many of his best-known works—landscapes of the dunes and scrub near the then-undeveloped Southampton. At these schools, he worked with and taught many of the painters who in due course sought out Central Park, including Manigault, Bellows, and Edward Hopper.

William Merritt Chase
The Common, Central Park, 1889
Oil on panel, 10⅛ x 16 in. (25.7 x 40.6 cm)
Private collection

Chase's own early style, developed in Munich, favored darker shades, but his palette gradually lightened, especially after he saw the Durand-Ruel Gallery's New York exhibition of 289 Impressionist works in 1886. The show came at a time when Chase's works were losing esteem, prompting him to consider other styles. In a burst of creative energy, he produced at least a dozen paintings of Central Park during the summers of 1887–90, the years before he founded Shinnecock. He focused his attention on the park in part because of a strange fracas in Brooklyn's Prospect Park. After painting there for two tranquil summers, he was denied renewal of the requisite permission by the park superintendent, on the fictional grounds that only amateurs were allowed to work in the park. The superintendent was a painter himself, trying to shut out his talented rival.

THE MALL AND THE BETHESDA TERRACE

Park visitors have always been drawn to the Mall. This quarter-mile esplanade is the broadest pedestrian walk and the only straight feature in a park otherwise dominated by curving paths and roads. As part of the democratic ideas of the park's planners, the Mall was intended as the area where all park visitors could congregate and promenade. It is lined by a triple row of American elms, chosen by Olmsted and Vaux for their graceful shape and eventual height. The current grove, planted in the 1920s to replace the originals of 1858, numbers about 150;

they and the elms lining Fifth Avenue are the largest surviving stands in North America, monitored every year for any signs of Dutch elm disease.

Music on the Mall, Central Park (below) by Jay Edward Hambidge shows the sun-dappled promenade and a genteel crowd seated on the benches that line it—as though waiting to watch a parade of fashion plates like the young woman in the foreground. Hambidge (1867–1924), a student of Chase's at the Art Students League, was a prolific magazine illustrator. His writings on the mathematical proportions and symmetry in Greek architecture, sculpture, and ceramics influenced contemporary artists. This painting was done to illustrate an article in the August 1901 issue of the *Century Magazine*, "Midsummer in New York," by Mariana Griswold Van Rensselaer. An early New York art critic, she was the first to write extensively about William Merritt Chase. Like her friend Edith Wharton, Van Rensselaer also wrote about architecture and design. An intrepid journalist, for this summer issue of the *Century* she found warm weather diversions everywhere, from Central Park to the slums of the Lower East Side. Though the Mall was indeed visited by people of all ranks, Hambidge features only the more elegant component, depicting the city's poorer classes elsewhere in the article. The young woman pondering her next step might have

Jay Edward Hambidge
Music on the Mall, Central Park, 1901
Oil on canvas, 20 x 27½ in.
(50.8 x 69.9 cm)
Private collection

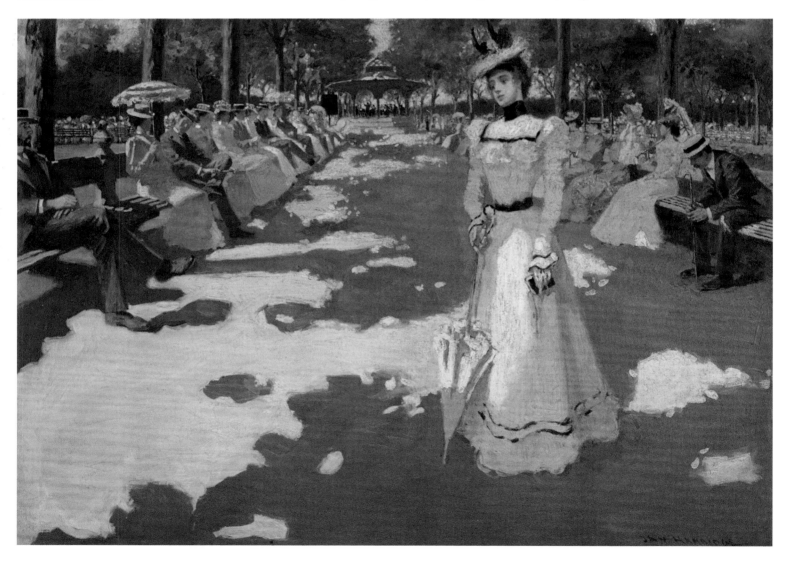

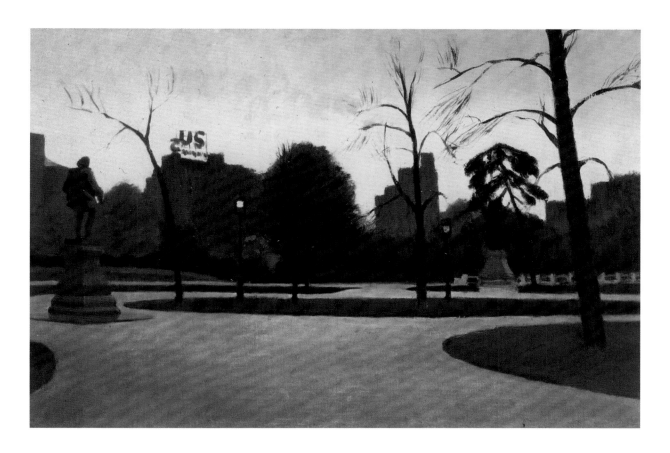

Edward Hopper
Shakespeare at Dusk,
1935
Oil on canvas, 17 x 25 in.
(43.2 x 63.5 cm)
Private collection

been the ill-fated Lily Bart, protagonist of Edith Wharton's *The House of Mirth*, who agreed to meet on the Mall the married man she naïvely thought was going to advise her on her dwindling finances.

The southern end of the Mall, where Hambidge's figure stands lost in thought, is anchored by a cluster of commemorative statues. The first, the standing figure of William Shakespeare by John Quincy Adams Ward, was installed in 1872. Appropriately, it was dedicated by William Cullen Bryant, the poet who in 1844 was the original advocate for a major park in New York City. Shakespeare was soon followed by Robert Burns, Sir Walter Scott, and Fitz Greene Halleck, all seated. This part of the Mall became known as Poets' Walk. In 1892, they were joined by a standing figure of Christopher Columbus, positioned opposite Shakespeare.

Both the Bard and Columbus appear in the first of Edward Hopper's two paintings of Central Park. Hopper set many of his paintings at a specific time of day, mostly in the flat bright light of midday or at night. *Shakespeare at Dusk* (1935; above) is one of only four in early evening. It depicts the park in late autumn just after the sun has set. The statue of Shakespeare and a few buildings are silhouetted against the yellow glow of the southern horizon as the street lamps turn on, while Columbus is in shadow.

Hopper (1882–1967) came to the city from Nyack, New York, at age eighteen to study with Chase, who by then had founded his New York School of Art. The New York art world of 1900 was small. Among Hopper's classmates that year were two other future painters of Central Park, Gifford Beal and George Bellows. A few years later, Hopper was painting in Gloucester, Massachusetts,

with Leonard Kroll. By 1924, when Hopper had achieved enough success as a painter to give up commercial illustration, he had found the themes he continued exploring throughout his life. Architecture, distinctive times of day, and solitary figures—often standing in contemplation rather like the statue of Shakespeare—are three of the major interests united here.

At the opposite end of the Mall from Shakespeare, and visible in the distance in Hambidge's painting, was the Gazebo, a bandstand used for concerts. The Gazebo was part of Central Park's plan to provide facilities for various kinds of entertainment. The concerts, originally performed on Saturdays, proved so successful that by popular demand from working people, who were free only on Sundays, the park management eventually abandoned its strict policy against working on the Sabbath and introduced Sunday evening concerts in 1877 and Sunday afternoon concerts in 1884.

The park's early building program also had an educational aspect, featuring architecture from different parts of the world that visitors might otherwise never see. The Gazebo, designed by Jacob Wrey Mould and built in 1862, was the park's Moorish note. Mould boasted that he was "hell on color," and gave himself free rein with the Gazebo. The bandstand's palette included grays, blues, greens, reds, yellows, and black. The canopy featured gilded stars on a blue background. Elsewhere on the canopy were the names of leading composers. Even a Fauve like Manigault could not capture the full range of color in *Gazebo in Central Park* (opposite and pages 58–59). He shows the Gazebo on a summer afternoon in 1911 as couples and families appear to be gathering for a concert.

The colors of the park also captured the imagination of contemporary New York writers. Willa Cather, in her 1916 story "The Diamond Mine," describes the atmosphere created by a late afternoon snowfall, not in Manigault's flamboyant Fauve palette but in subtler shades: "Overhead it was a soft, rainy blue, and to the west a smoky gold. All around the horizon everything became misty and silvery; even the big, brutal buildings looked like pale violet water-colours on a silver ground. Under the elm trees along the Mall the air was purple as wisterias. The sheep-fold, toward Broadway, was smooth and white, with a thin gold wash over it."

The fountain in front of Manigualt's Gazebo was one of two at the north end of the Mall. Both fountains and the Gazebo were removed around 1923, when the Naumburg Bandshell and additional paving were installed to accommodate larger performances and audiences. The second of these now-vanished fountains is the centerpiece of Maurice Prendergast's watercolor *In Central Park* (page 60)—a lively daytime scene composed mainly of women and children, with a few men conversing on a bench and perhaps in the crowd on the central walk of the Mall. A portion of the Gazebo can be seen off to the right. For a few years Prendergast (1858–1924) was one of the park's most devoted painters; he depicted it at least thirty-six times in watercolor and twice in oils between 1900 and 1903. He sketched his subjects in the park but executed the paintings in his studio.

Born in Newfoundland and raised in Boston, Prendergast had no formal training when he began work as a commercial artist. His conversion to painting may have been inspired by his contemporary and fellow Boston commercial artist Childe Hassam, who spent the summer of 1883 in Europe. Prendergast

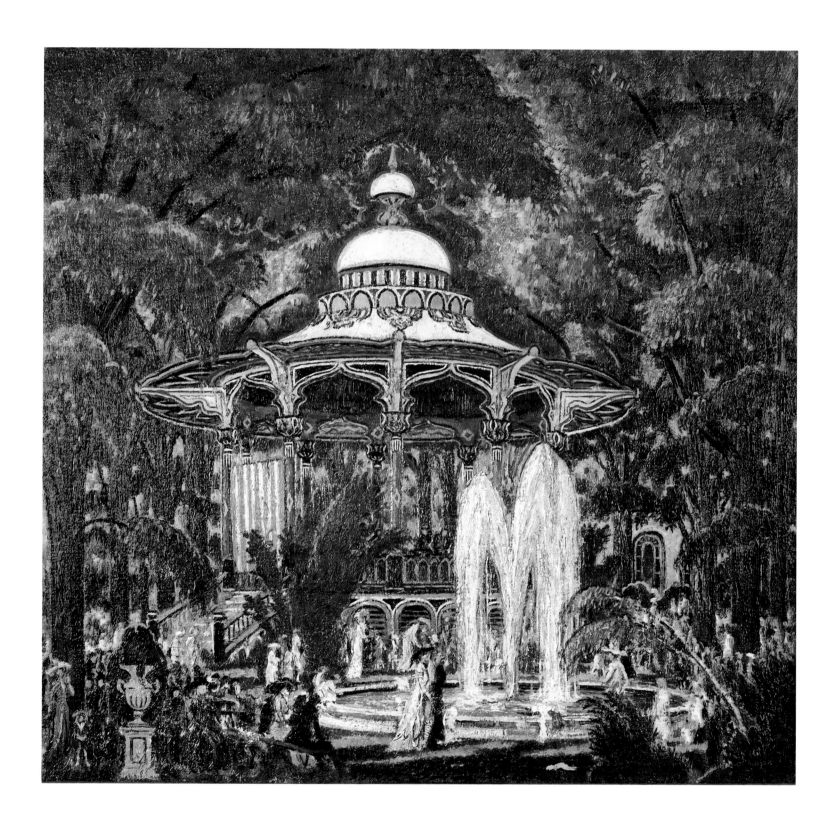

ABOVE AND OVERLEAF

Edward Middleton
Manigault
Gazebo in Central Park, 1911
Oil on canvas, 20 x 20 in.
(50.8 x 50.8 cm)
Private collection

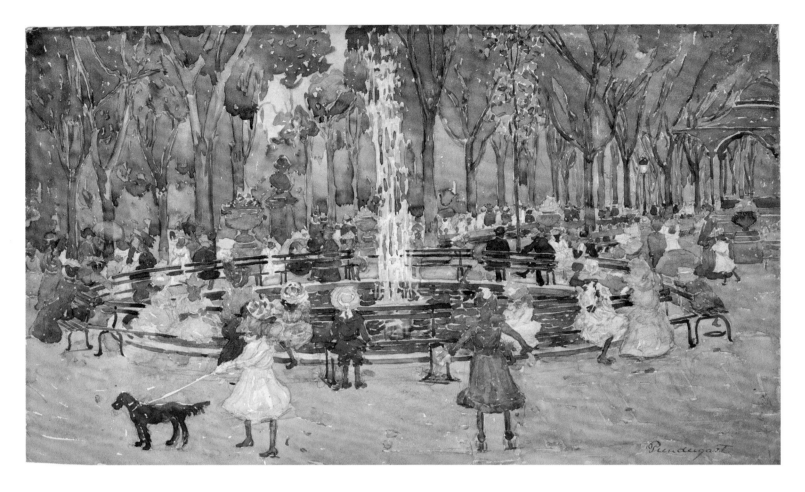

ABOVE

Maurice Prendergast
In Central Park, ca.
1900–1903
Watercolor and graphite
on woven paper, 12¼ x
20 in. (31.1 x 50.8 cm)
Private collection.

OPPOSITE

Reginald Marsh
*Central Park (with the
Beresford on Central
Park West in the
Background)*, 1943
Chinese ink and water-
color on paper, 13½ x
19½ in. (34.3 x 49.5 cm)
Private collection

followed that path in 1886, going to England and Wales. In 1891, he left Boston again for four years, which he spent mainly in Paris. A favorite subject of both French and American painters at the time was the Jardin du Luxembourg, a park in the center of Paris featuring fountains and a broad staircase. John Singer Sargent had painted it as early as 1879. Prendergast found in it some of the themes he returned to so often in Central Park and elsewhere. His dabs of bright color creating human forms, set off by park scenery, seem especially suited to the dresses of the era. As in the scene at the fountain, men rarely appear. His few paintings populated by men are of priests and cardinals in their vestments. Prendergast kept an apartment at Washington Square from 1914 until his death ten years later, but he crossed the Atlantic often, and after 1903 found inspiration mainly in Europe and at various New England seaside resorts, where he continued painting his colorful crowds in pleasant settings.

At the northern end of the Mall are the twin staircases leading down to the Bethesda Terrace. With its fountain surmounted by a statue of the Angel of the Waters, the terrace was the climax of Olmsted and Vaux's plan, the architectural centerpiece of the entire landscape. As Vaux wrote, "The landscape is every-thing, the architecture nothing—til you get to the Terrace. Here I would let the New Yorker feel that the richest man in New York or elsewhere cannot spend as freely . . . just for his lounge."

The grandeur of the staircases, the elaborate carvings on the walls and balustrades, the patterned paving of the terrace itself—designed to be admired

from above—and the distinctive *Angel of the Waters* all made this the most sophisticated and dramatic point in the park, the equal of anything in Europe and surpassing anything else then in America. Because it is situated below the level of the Mall, nestled into the folds of two slopes, and fronts a curve in the Lake with woods on the opposite side, any approach to the terrace reveals it suddenly, by artful surprise. From the time it was created, the Bethesda Terrace and its fountain have been powerful magnets for artists, who have depicted the scene from every angle.

Approaching from the Mall, one first sees the balustrade and the four piers that frame the two staircases. Reginald Marsh captures this vantage point on a day in 1943 when servicemen on leave in New York are looking for distraction. *Central Park (with the Beresford on Central Park West in the Background)* (below) is a precise rendering of the view from the easternmost of the four piers. Marsh (1898–1954) was the foremost depicter of New York's rowdier side, showing the working classes at their recreations and diversions. He produced innumerable paintings and drawings of the crowds disporting on Broadway and the Bowery, at burlesque and vaudeville theaters, and at Coney Island. Central Park was a rare subject for him.

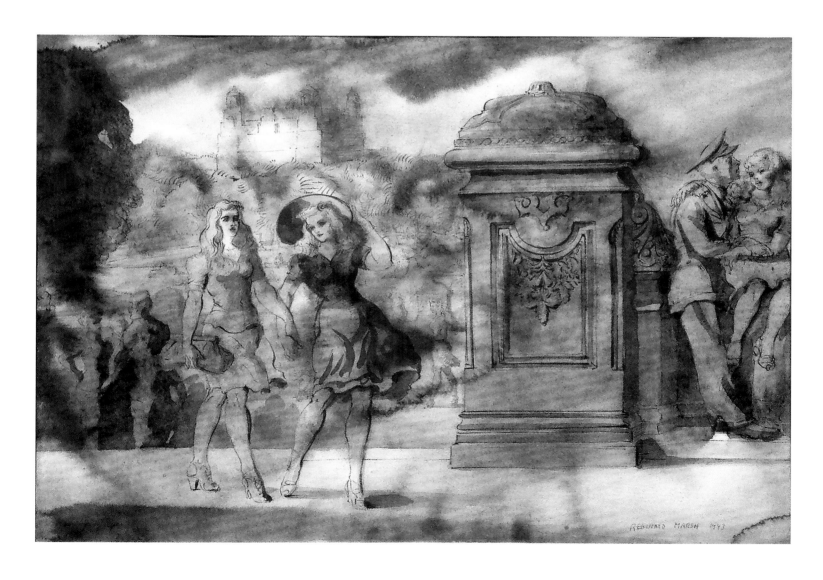

Frederick Brosen
Bethesda Fountain Terrace,
1996
Watercolor and graphite
on paper, 34 x 23 in.
(86.4 x 58.4 cm)
Private collection

In 1922, soon after Marsh graduated from Yale, the *New York Daily News* hired him to sketch the downtown theater scene. His drawings appeared in publications ranging from the urbane *New Yorker* to the Marxist *New Masses*. No one could mistake his strollers for the kin of Prendergast's ladies. When he studied at the Art Students League in 1921, his teacher was John Sloan, whose major painting of Central Park (see page 113) is filled with pointed social commentary. But Marsh applied his classical training to these popular themes. He was particularly influenced by Renaissance and Baroque drawing of figures in movement, as can be seen in the way he emphasizes his figures' turning forms and the lines of their bodies beneath their clothes. His men have the muscularity of Michelangelos; his women, the buxomness of Rubenses.

The view down the steps to the terrace and fountain is as dramatic today as when first seen in the 1860s. Frederick Brosen's *Bethesda Fountain Terrace* (1996; opposite) shows the staircase opposite the one in Marsh's scene. His vista highlights the measured descent; the bold lines and angles of the hard paving surfaces contrast with the softness of the water in the circular pool surrounding the fountain. The shape of the fountain is prefigured by that of the urn with its plantings at the top of the staircase wall. Beyond the terrace, the formality dissolves into the curving forms of the Lake and the wooded hills in the distance, as nature takes over. Brosen (b. 1954) specializes in urban scenes. He studied at the Art Students League and at Pratt. In addition to painting New York City, he has depicted Paris, Venice, Florence, and Siena. The clarity of his images comes from a watercolor technique adapted from English painters like Turner—the use of transparent layers of color on a graphite drawing.

Prendergast's *The Mall, Central Park* (pages 64 and 65) depicts a bright crowd descending the west staircase. The popular red parasols punctuating the canvas are echoed in the plantings in the urns at the top of the stairs, and the scene itself echoes the scenes Prendergast had painted in the Jardin du Luxembourg.

The *Angel of the Waters* statue atop the fountain is by Emma Stebbins, a New Yorker who worked for years in Rome and knew its fountains and all their historical and iconographic connotations. The Angel of the Waters is described in the Gospel According to St. John (5: 2–4) as descending to a pool in Jerusalem known as Bethesda; the angel "troubled the waters," and the blind, lame, and withered who stepped in were cured. In Central Park, the biblical reference was supported, literally, by the four cherubs at the base of the statue: Temperance, Purity, Health, and Peace. When the statue was dedicated in 1873, New Yorkers were still conscious of the benefits of the city's supply of clean water from the Croton Reservoir, thirty-eight miles north of the city, which had been piping water to Manhattan since 1842.

The terrace and its fountain, though most often depicted on sunny summer days, rewards painters at all hours and in all seasons. George Bellows chose an afternoon in late autumn 1905 for *Bethesda Fountain* (page 66), when the site was nearly deserted. Standing as far back as he could, near the arcade that is concealed by the stairways, and seemingly crouching to be at the same level as the fountain's rim, he painted the *Angel of the Waters* silhouetted against the sky. The monochrome palette, soft brushwork, and pensive mood contrast with Bellows's exuberant scenes of people celebrating and picnicking on the lawns

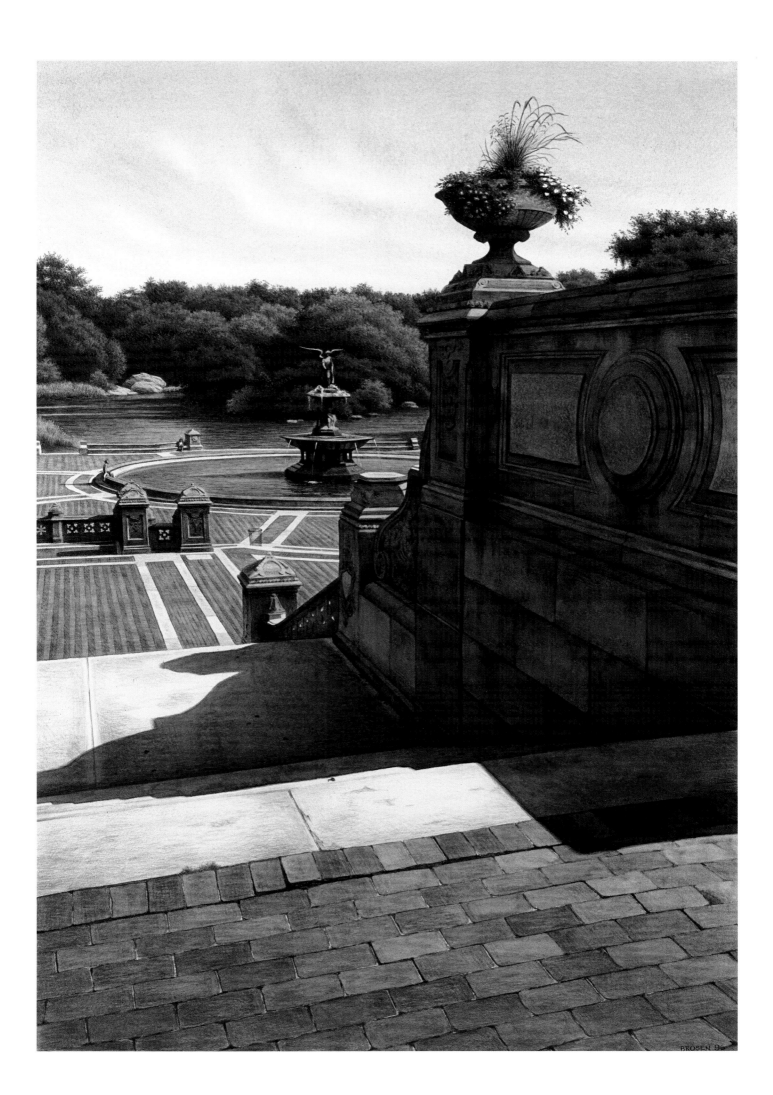

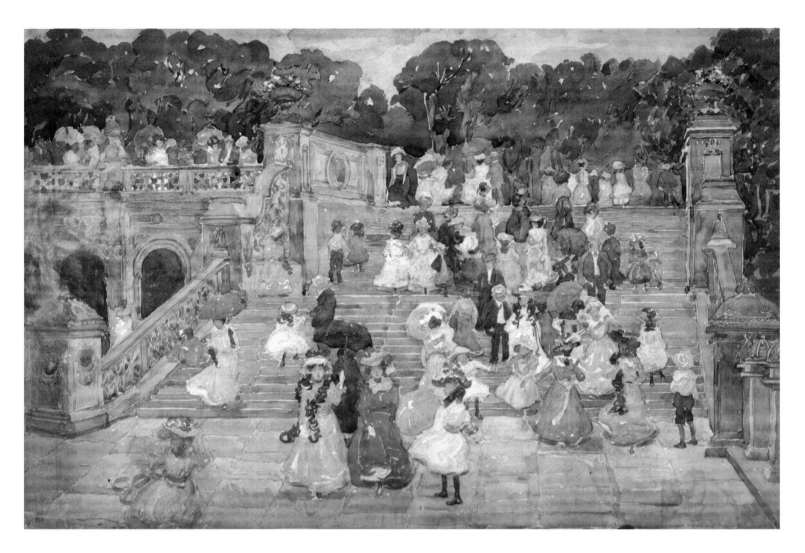

(see pages 134–35 and 146–47). Here, instead of an evanescent moment in May or June, he evokes the eternal watchfulness of the angel who stands over the park at all times of year.

Bellows (1882–1925) came to New York from Ohio in 1904, enrolling at Chase's New York School of Art. The initial focus of his work was the city, from its parks to its docks, from lawn parties to boxing matches. He painted Central Park at least three times during his first year in New York. and the park continued to be an intermittent subject as late as 1921, in lithographs, even while Bellows spent more time painting landscapes and coastal scenes far from the city.

In addition to Chase, Bellows acknowledged his teacher Robert Henri, a strong advocate of painting from life, as a major influence. In 1908, Henri (1865–1929) organized an exhibition of work by his associates, who came to be known as The Eight—Arthur B. Davies, William Glackens, Ernest Lawson, George Luks, Maurice Prendegast, Everitt Shinn, and John Sloan, as well as Henri himself. All but Davies painted Central Park. Henri's own few park paintings, however, are not as distinctive as those of snow-covered city streets. Another teacher Bellows credited was Jay Hambidge, particularly for his ideas on symmetry. "Ever since I met Mr. Hambidge and studied with him," Bellows wrote, "I have painted few pictures without at the same time working on his theory."

ABOVE AND OPPOSITE
Maurice Prendergast
The Mall, Central Park,
1901
Watercolor and pencil
on paper, 15¼ x 22½ in.
(38.7 x 57.2 cm)
Art Institute of Chicago,
Chicago

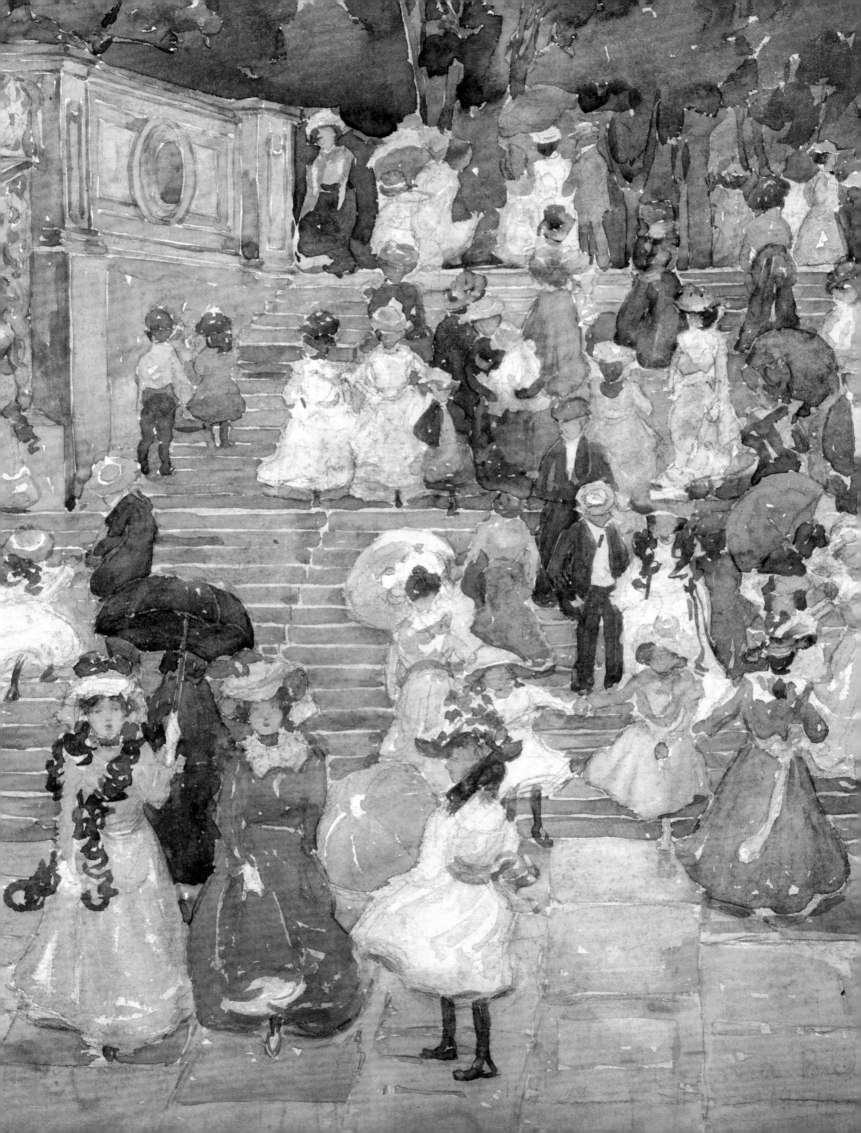

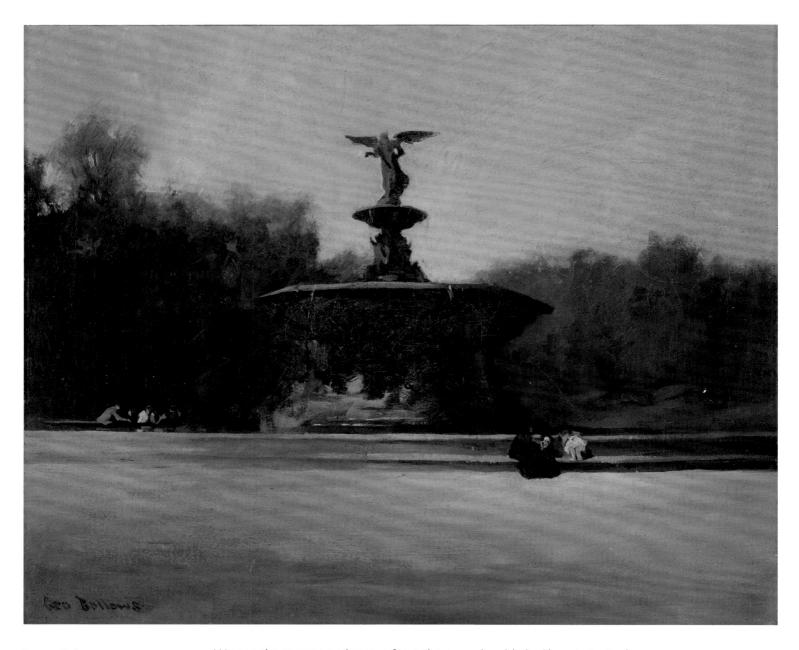

George Bellows
Bethesda Fountain, 1905
Oil on canvas, 20¼ x 24⅜ in.
(51.4 x 61.9 cm)
Hirshhorn Museum
and Sculpture Garden,
Smithsonian Institution,
Washington, D.C., Gift of
Joseph H. Hirshhorn

We see the terrace and statue from the opposite side in Chase's *An Early Stroll in the Park* (opposite) on a bright day in July, as indicated by the flowering lotuses in the basin. This is one of several Central Park paintings in which Chase depicts women on their own enjoying both the park's most familiar sites and its less frequented nooks. Independent ventures into the park were considered safe and acceptable for the new woman of the 1880s.

It seems unlikely that on such a fine summer morning the Bethesda Fountain would have been deserted, but an artist may use the setting as he pleases. In an interview with *Harper's Weekly*, "Mr. Chase and Central Park," published May 2, 1891, Chase said, "When I start to paint out of doors, I put myself in as light marching order as possible. . . . I carry a comfortable stool that can be closed up in a small space and I never use an umbrella. I want all the light I can get. When I have found the spot I like, I set up my easel and paint the picture on the spot. I think that is the only way rightly to interpret nature."

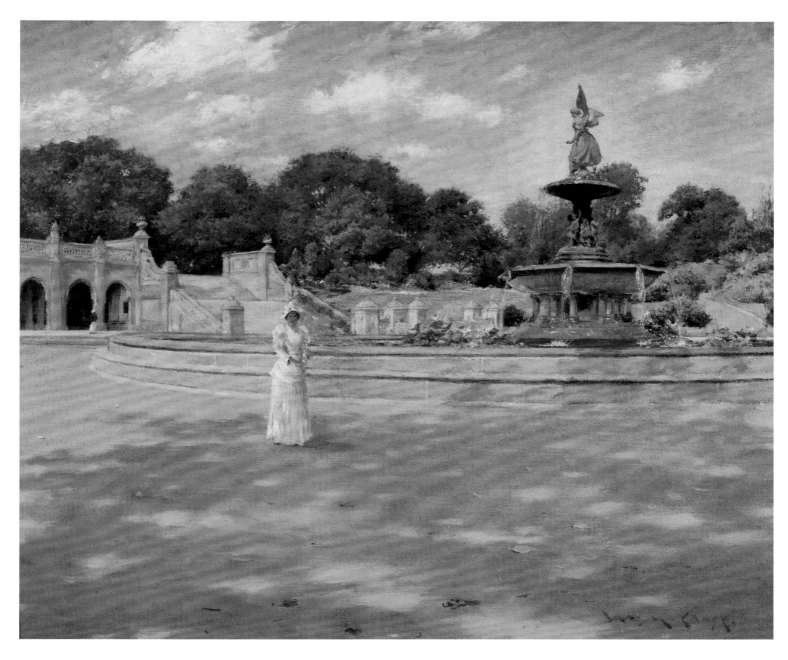

Here, Chase has put his easel and stool near the edge of the Lake to show the fountain and one set of stairs. Rather than depicting the full panorama, as an illustrator might, he impressionistically crops both edges of the site's architectural features to focus the viewer's attention on the sole person in the vast expanse. Walking toward us, clothed in the soft fabric of a modern dress, she both echoes and is in sharp contrast to the scene's only other figure, the *Angel of the Waters*, who, clad in flowing, classically draped garb forged of hard metal, faces away from us. When Chase painted this scene, about 1890, park visitors no doubt still remembered the angel's symbolic message of bringing pure water to the city. But by the 1880s, concern about malaria and fetid smells from the park's water bodies had led to their temporary drainage and the replacement of all the water pipes. Knowledgeable contemporaries might have seen the living woman's freshness as a counterpoint to the faded promise of the angel.

William Merritt Chase
An Early Stroll in the Park,
ca. 1890
Oil on canvas, 19¼ x 23¼ in.
(48.9 x 59.1 cm)
Montgomery Museum of
Fine Arts, Montgomery,
Alabama
The Blount Collection,
1989.2.4.

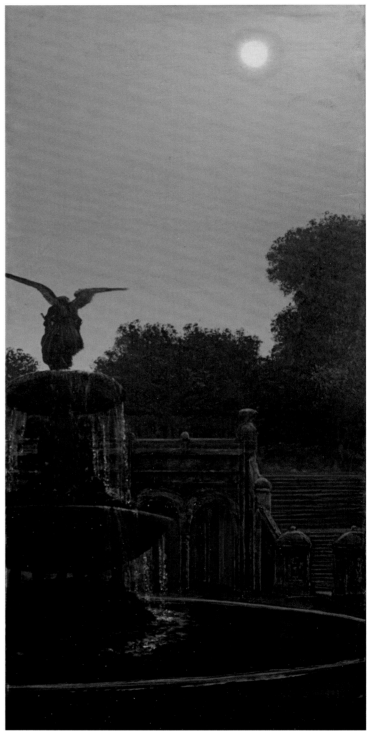

While most artists have painted the Bethesda Terrace by day, Stephen Hannock (b. 1951) chose to depict it at twilight when the park's street lamps go on, illuminating the stairs and reflected in the basin, and on an evening suffused with moonlight. Hannock actually drew the scene at midday, to get the maximum amount of detail; he then used his imagination to create the light and mood. His *Bethesda Fountain (Twilight)* (1993; above left) and *Bethesda Fountain (Evening)* (1993; above right) each have their own glow, which derives from his distinctive method of polishing oil on canvas. He begins by knifing modeling paste onto the

canvas and smoothing it out. He then applies pigments to etch out his subject, covers the pigments with a layer of resin, and polishes the resin with a sander. He then repeats the process; some paintings have as many as twelve layers of paint and resin, giving them a luminous surface. Hannock lived in New York from 1981 to 2002. He has also done an aerial view of the park at dusk (see pages 192–93). He now lives in Williamstown, Massachusetts, and is best known for his many paintings of the oxbow in the Connecticut River near Northampton, Massachusetts, and for scenes of flooded rivers, all cast in distinctive light.

FROM THE LAKE TO THE HARLEM MEER

For nearly a century, visitors following the lakeshore to the east of the terrace came upon a fanciful two-story wooden building along the water's edge. This was the boathouse, designed by Vaux, where the public could rent a rowboat or step into the park's gondola to be poled around the Lake. On the building's upper level, a long, open terrace stretched between the pavilions at either end, one square, the other rectangular, each ornamented differently. J. Carroll Beckwith's *The Boathouse in Central Park* (ca. 1890; left) shows the square pavilion and some of the boats awaiting riders. Vaux's structure was replaced in the 1950s by the current brick building.

Beckwith (1852–1917), an accomplished portraitist, probably never let his sitters forget that for four years he had shared a studio in Paris with John Singer Sargent. The sitters included Mark Twain, Theodore Roosevelt, and his colleague William Merritt Chase. Born in Missouri, Beckwith studied in Chicago and New York before moving on to Paris in 1873. After five years at the École des Beaux-Arts, he returned to New York, joining Chase at the Art Students League, where they opened new painting and drawing departments. Beckwith taught at the league for eighteen years. He lived and worked at the Sherwood Studios, owned by his uncle, close by on West 57th Street. Beckwith and Jasper Cropsey were both living in the building in 1880, when Cropsey painted his similar view of the Pond (see page 48). They each used a somber palette for the trees and buildings, saving the brighter colors for the reflections off the water.

North of the Bethesda Terrace and the Lake is a series of more naturalistic woodlands and meadows, punctuated by a few architectural features. The Ramble, directly opposite the terrace, can be reached either by the Bow Bridge or by a longer walk past the boathouse. Olmsted intended this section to be in striking contrast to the more formal lower regions of the park. As he wrote to the park's chief landscape gardener on September 26, 1863, his goal was "a sense of the superabundant creative power, infinite resource and liberality of Nature." The Ramble was to feature winding paths, streams, a small woodland pond, a cave, summerhouses, and rustic benches. It opened in June 1859, one of the first areas of the park deemed ready to receive the eager public. That a

OPPOSITE LEFT
Stephen Hannock
Bethesda Fountain (Twilight), 1993
Polished oil on canvas,
72 x 36 in.
(182.9 x 91.4 cm)
Private collection

OPPOSITE RIGHT
Stephen Hannock
Bethesda Fountain (Evening), 1993
Polished oil on canvas,
72 x 36 in.
(182.9 x 91.4 cm)
Private collection

ABOVE
J. Carroll Beckwith
The Boathouse in Central Park, ca. 1890
Oil on panel, 15¾ x 9¾ in.
(40 x 24.8 cm)
Private collection

concert was held there days later, on July 9, suggests, however, that the plantings had not yet reached their intended density.

By the early 1870s, Olmsted's vision of a lush woodland must have been fully realized. The Ramble made a strong impression on the young Edith Wharton. As she later wrote in *A Backward Glance*, "I also recall frequent drives with my mother, when the usual afternoon round of card-leaving was followed by a walk in the Central Park, and a hunt for violets and hepaticas in the secluded dells of the Ramble." In her fiction, Wharton used the seclusion of the Ramble as a metaphor. When the heroine of *The Custom of the Country*, Undine Spragg, needs to confront Elmer Moffatt, her ex-husband, they meet in the Ramble, where no one is likely to catch sight of them.

Not everyone thought of the Ramble as a place for clandestine meetings, however. William Merritt Chase's *Park Bench* (left) depicts another young woman by herself, looking up expectantly in pleasant anticipation of someone coming to join her. The rustic bench made it obvious to anyone at the time that the location was the Ramble. Today, a few new rustic benches have been installed to evoke the original atmosphere. Wharton's Undine Spragg, in the hope of going unrecognized, wore "her plainest dress, and wound a closely patterned veil over her least vivid hat; but even thus toned down to the situation she was conscious of blazing out from it inconveniently." In contrast, the confident woman in Chase's painting wears a light blue dress that sets her off against the spring foliage, and her pink hat echoes the sunlight dappling the pavement. The sloping bedrock behind the bench places this scene along the edge of the Lake, where there would have been a clear view across to the Bethesda Terrace.

The Ramble is known worldwide among birdwatchers as one of the best places in North America to see the spring and fall migrations of songbirds. For birds flying over New York City, the big parks are oases surrounded by miles of inhospitable terrain. Within Central Park, the wilder plantings and sheltered waters of the Ramble are especially attractive. The first publication on bird sightings in the park appeared in 1886, and today nearly three hundred species have been found there.

Only one painter has seen birdwatching as a subject for art—George Claire Tooker (1920–2011). Tooker's chief interest was, in his own words, "people and their relations to each other and the outside world." He is best known for *Subway*, a disturbing 1950 view of several seemingly apprehensive people on a platform awaiting a train. *Bird Watchers* (1948; page 72) has a different mood. After completing several paintings with rather pessimistic themes, Tooker "decided it was high time to paint a pleasant picture about something positive. . . . I painted pictures of my friends, my sister, my mother, . . . Paul Cadmus; just a congregation of my friends, people I cared about." Though not a birder himself, he did go on at least one bird walk. He placed his watchers, including the painter Paul Cadmus

William Merritt Chase
Park Bench, ca. 1890
Oil on canvas, 12 x 16 in.
(30.5 x 40.6 cm)
Museum of Fine Arts, Boston

George Claire Tooker
Bird Watchers, 1948
Egg tempera on gesso
board, 26¼ x 32¼ in.
(66.7 x 81.9 cm)
New Britain Museum of
American Art, New Britain,
Connecticut
Gift of Olga H. Knoepke,
1992.33

(in the center of the back row), in a landscape of bare rock slopes and arches that resembles the western edge of the Ramble. Tooker's preferred medium—egg tempera on a gessoed board—was used by many early Renaissance painters, who were wont to include bare trees and severe rock slopes in the backgrounds of religious works. Viewers may interpret the figures, some gazing upward, as evoking a spiritual sense—or simply on the lookout for birds. The man with his hands in the gesture of submission could be acknowledging a greater presence—or admitting he was wrong about an identification. Tooker himself came away from his bird walk thinking birders were jealous and competitive.

East of the Ramble is the Conservatory Water—better known as the Model Boat Pond. The first name comes from the original plan, which was to have a formal flower garden at this site. The garden, however, was created elsewhere. To take advantage of the several streams that converge in this low spot at 74th Street, Olmsted and Vaux had wanted a naturalistic pond but compromised on the cement basin, whose graceful curves and still water have attracted artists ever since. In *Central Park* (pages 73 and 74–75), Childe Hassam painted a woman and small child at the basin's edge around 1892. Her attire and forthright

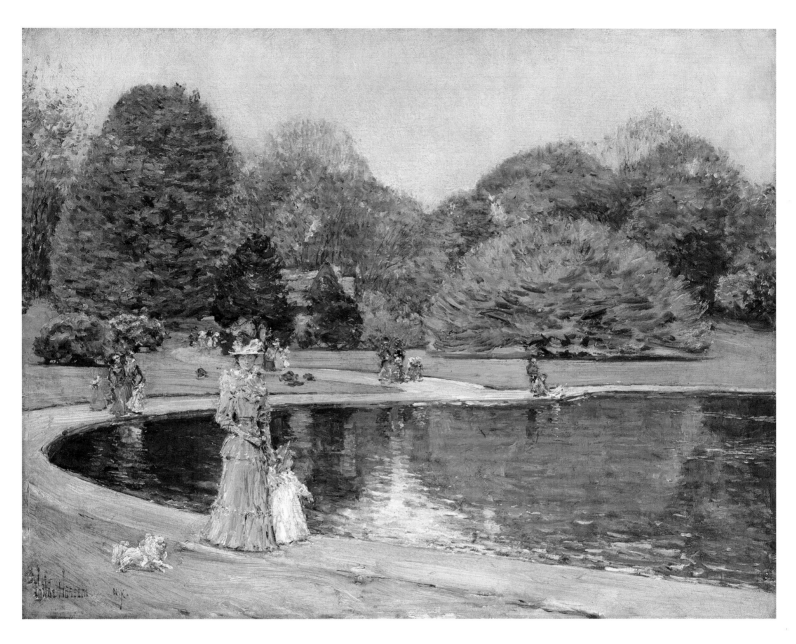

ABOVE AND OVERLEAF
Childe Hassam
Central Park, ca. 1892
Oil on canvas, 18 x 22½ in.
(45.7 x 57.2 cm)
Private collection

gaze are so similar to that of the woman on the Ramble bench in Chase's paint-ing of a few years earlier (see pages 70–71) that one wonders if they are one and the same person. Chase himself painted children at the Conservatory Water (see pages 122–23), and Prendergast depicted it a few years later (see page 124). The small building among the trees in Hassam's painting is long gone. Today, a few flowerbeds around the current building, where model boats are stored, are the only hint of the original plan for the site.

The sections of Central Park above 79th Street have attracted fewer art-ists, perhaps because they were designed by Olmsted and Vaux with a broader brush. The Great Lawn, a relatively recent addition to the park, occupies the site of the receiving reservoir of 1842, originally part of the city's vital water sup-ply but supplanted in the twentieth century by a more comprehensive system ranging into the Catskills. Debates about how best to use this thirty-seven-acre stretch raged for decades; competing proposals included playing fields, a World War I memorial, an opera house, a boulevard linking the two great museums bordering the park, and many suggestions for additional buildings. The decision, finally reached in 1930, was a compromise between Olmstedians and active

recreationists. Designed by the American Society of Landscape Architects, it comprises a large oval lawn and a new water body at the base of Belvedere Castle, the Turtle Pond. The designers retained Olmsted's preferred curving lines to circumscribe the lawn, where today there are ball fields. Work on the project began after the reservoir was drained in 1931 and filled with rubble excavated during the construction of Rockefeller Center.

The terrace at the Belvedere Castle is the best place to see how this area was redesigned. Richard Estes's *Central Park, Looking North from Belvedere Castle* (pages 78–79 and 80–82) shows the full sweep of the Turtle Pond and the Great Lawn beyond, as they looked in 1987. From this vantage point, we can clearly see how the park is framed by the buildings lining it. On a late autumn afternoon, when the leaves have fallen from all the trees except the oaks, the long shadows cast by the castle in the low sun seem to exaggerate the structure's scale. This prefigures today's debate about the height of new buildings just south of the park that put large sections of the park in shade.

This is Estes's first painting of the park since his 1965 depiction of the Conservatory Water (see pages 128–29). In the intervening two decades, he mastered the technique that has made him the most highly regarded of Photorealist painters. His Photorealism involves much more than faithfully reproducing a photograph. When he finds an interesting site, he takes many photographs of it, each with a different vanishing point. These enable him to capture all angles and distances in equal detail, not as the eye or a single photograph would see them, but as they will ultimately appear in the finished painting. Estes makes color prints of the photos, then attaches one print to another until he has created a wide-angle view of the scene, as here, and finally enlarges them to the scale of the painting. From this photographic composite, Estes sketches the features he wants, omitting those that don't interest him, on a canvas covered in a gesso ground of white or tan. Next, he paints over the sketch in acrylic, which can easily be altered, enabling him to adjust vanishing points, perspective, and horizon lines. Finally, he adds the details in oil, painstakingly applied with fine brushes.

The Great Lawn (short for Great Lawn for Play) is perhaps best known for hosting events ranging from summer concerts of the New York Philharmonic and Metropolitan Opera, to concerts of popular singers like Diana Ross and Simon and Garfunkel, to an antinuclear rally and a papal visit. Intensive use by event attendees and ball players wore down the lawn by the 1970s; it was fully restored in 1997.

Few park artists of earlier generations might have considered the eroded lawn worth painting, but the wide, flat landscape with broad bands of land and sky attracted Rackstraw Downes in 1977. In *The Oval Lawn* (pages 83–85), he depicts it from the northeast corner.

Downes (b. 1939) is English, educated at Cambridge and the Yale School of Art. He moved to New York from Maine in 1965 and painted his first small landscapes of Central Park the next year. Downes is drawn to panoramic scenes—often of factories, dumps, highway ramps, housing projects, and construction sites—which he paints on long, narrow canvases. His vistas are so wide that the eye cannot take in the entire image at once, and he emphasizes their breadth

by curving the horizon at the canvas's edges. Downes's approach to his distinctive choice of subject is labor intensive. He always works on site, starting with pencil sketches and then moving on to oil sketches, before finally proceeding to the long, narrow canvas that encompasses the entire scene. To create the fine details that fill his paintings, Downes uses extremely small brushes. Because consistent light and atmospheric conditions are key elements of his work, it often takes him months or years to complete his on-site sketching.

The Oval Lawn, with its desiccated grass and compacted soil, presages Downes's later attraction to seemingly bleak sites around Texas oil refineries, Maine parking lots, and the New Jersey Meadowlands. But the expanse of lawn, dotted with a few small figures under a pastel sky, also evokes British landscape painting; the subtle tones in the sky are inspired in part by his admiration for John Constable. Without prettifying the view, Downes transforms the Great Lawn at its nadir into a pastoral scene full of interest and delicate detail.

Three years later, Christo sketched the Great Lawn from the Belvedere Castle as part of his preparation for *The Gates.* This 1980 collage (page 88) incorporates pencil, fabric, charcoal, wax crayon, and pastel, superimposed on a photograph of the Fifth Avenue skyline by his long-time photographic partner, Wolfgang Volz. It shows a summer view of the Great Lawn and the Turtle Pond with a series of gates running around the perimeter of the oval. Between 1979, when Christo and Jeanne-Claude, his wife and artistic partner, first conceived *The Gates*, until the installation in 2005, Christo did more than six hundred depictions of the project in various parts of Central Park. These studies helped them to see how their concept of an endless arcade of saffron cloth panels along Central Park's paths would work throughout the park's varied terrain and in all weather conditions. Today in retrospect, the studies also document how the park appeared during those years of decline and restoration. The Turtle Pond, for instance, which had a severe edge in 1980, has since been re-landscaped with a naturalistic border of marsh plants that now host much more wetland wildlife.

Christo Vladimirov Javacheff, born in Bulgaria in 1935, and French-born Jeanne-Claude Denat de Guillebon (1935–2009), had lived in New York City since 1964. Like their other installations, *The Gates* was intended both to inspire and to enable people to see something familiar in a new way. During *The Gates'* short existence, February 12–27, 2005, and ever since, few visitors who saw it could look at this landscape without a fresh appreciation for the park's contours, colors, and contrast with the city surrounding it. The artists sought to give no higher purpose or more personal meaning to their work. For them, Central Park, so often a *subject* of art, was transformed by *The Gates* into an *object* of art. Four million people saw *The Gates* during its two-week lifetime. Today, *The Gates* is long vanished, but, as Christo and Jeanne-Claude intended, the drawings and collages stand as independent works of art.

East of the Great Lawn is the Metropolitan Museum. Rackstraw Downes painted its rear façade in 1966, soon after he arrived in New York City. At that time, he did several small oil sketches of the museum and the reservoir, and nearby autumnal and winter park landscapes with rich, heavily laden brushwork very different from his mature style. *Behind the Met* (page 86) shows the glowing red of the bricks and the gray granite Gothic arch that were part of the

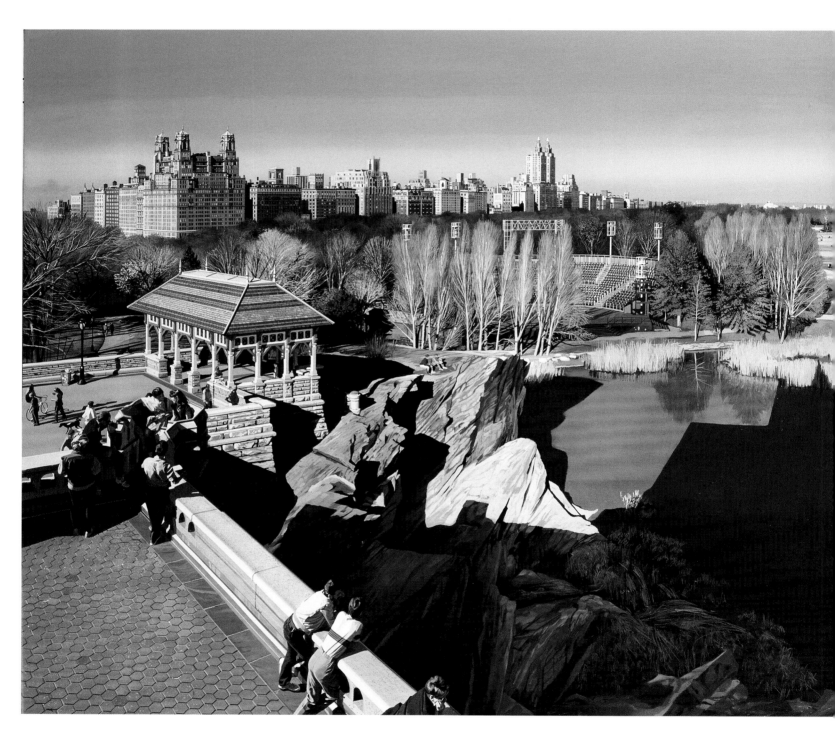

ABOVE AND OVERLEAF

Richard Estes
*Central Park, Looking North
from Belvedere Castle*, 1987
Oil on canvas, 36 x 86 in.
(91.4 x 218.4 cm)
Private collection

78 **A WALK IN THE PARK WITH THE PAINTERS**

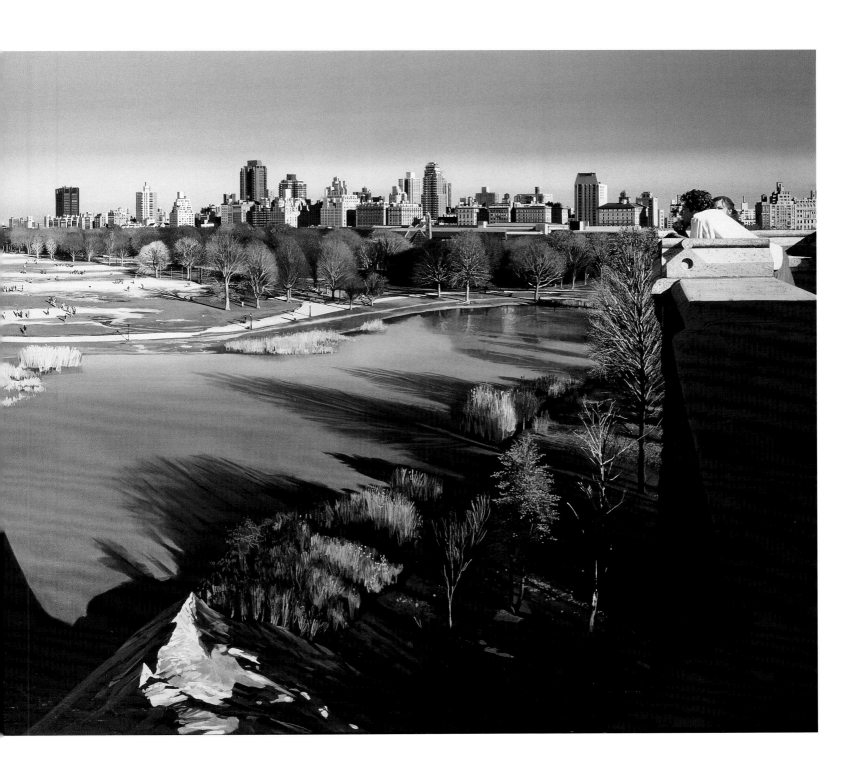

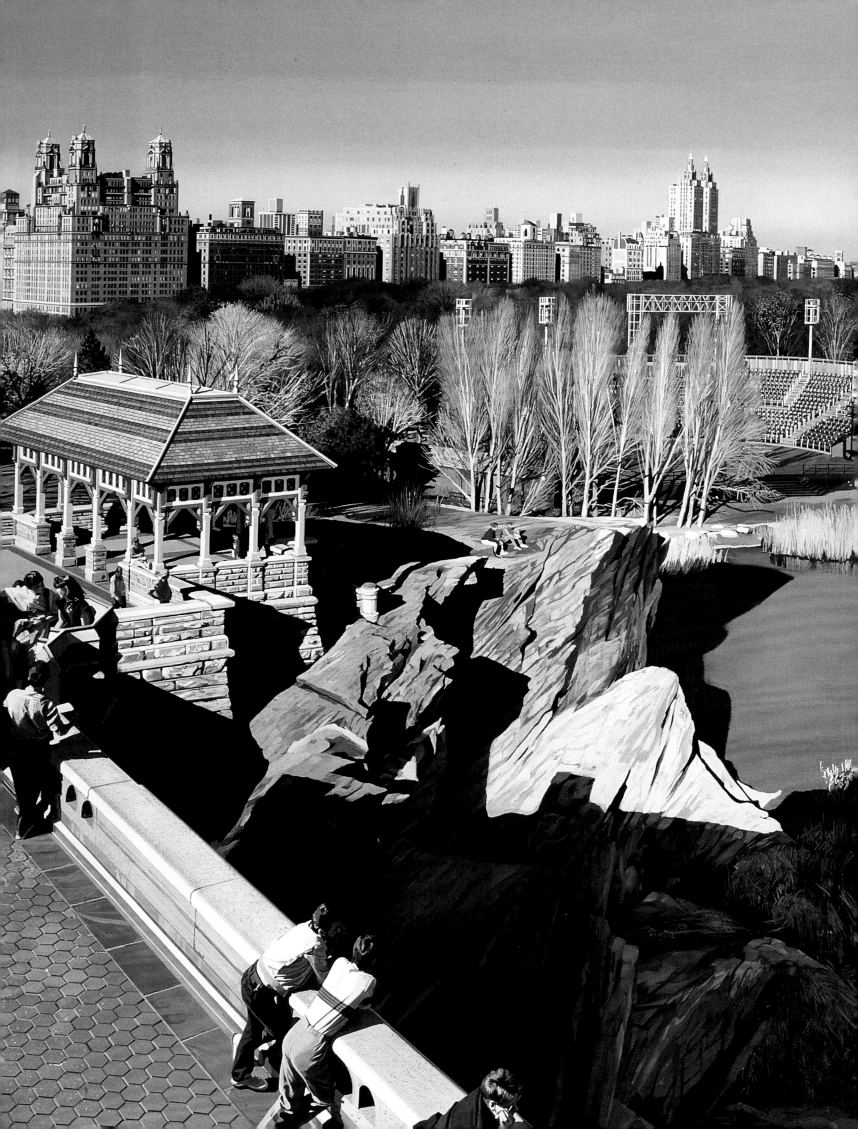

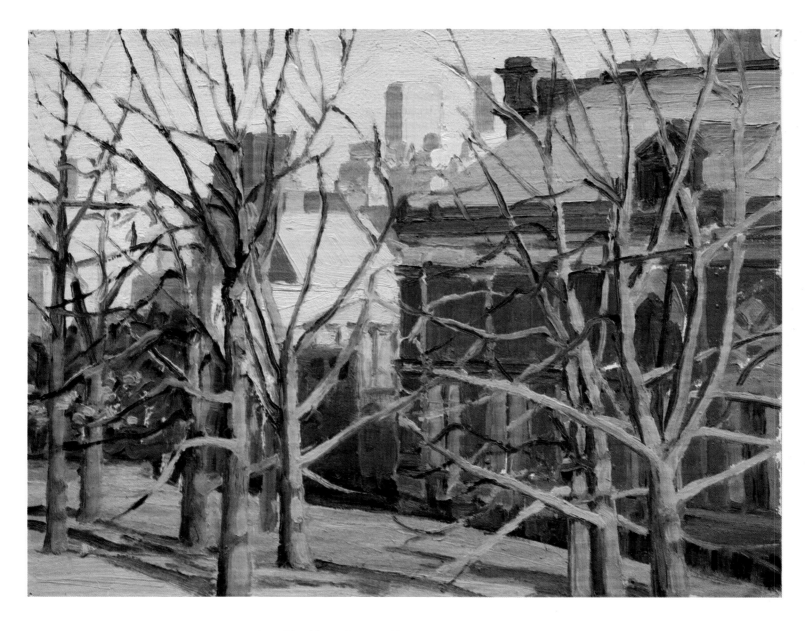

museum's original building, designed by Vaux and Mould, as well as some of the later additions beyond. The white columns and pediment are part of the façade of the Bank Branch of the United States, built in 1822–24 on Wall Street and later installed at the museum. All these elements have been invisible from the park since the museum extended its building in the 1970s.

North of the Great Lawn is an even larger expanse—the reservoir. It covers 105 acres, one-eighth of Central Park, and holds a billion gallons of water. Completed in 1862 to supplement the rectangular receiving reservoir of 1842, it has the graceful curves of a lake. Today, the reservoir no longer supplies city buildings, but it does fill the park's other water bodies. As with the original reservoir, many uses were proposed for this site when its major purpose was eliminated. The conclusion was to leave it as it was, a natural-looking feature of the park's varied landscape. Today, it still fulfills Alexander Jackson Downing's vision, expressed in the August 1851 issue of *The Horticulturist*, for "limpid water, covering many acres, and heightening the charm of sylvan accessories by the finest natural contrast."

Robert Bowden's watercolor *Reservoir at East 90th Street, Looking West* (page 89) gives a sense of its immensity. The broad, flat strokes of color convey the calmness of the waters at the hour when the wind dies down as the sun is setting. Beyond the park's rim of trees, the cliff-like buildings of Central Park West further accentuate the view's scale. Tallest of these is the Eldorado, the northernmost of the four twin-towered apartment houses built on Central Park West in 1930–31 that give the avenue its distinctive character and add so much to the view from across the park. Bowden (b. 1932) is a watercolorist trained at Carnegie Mellon University in Pittsburgh. He has painted many parts of Central Park.

Beyond the reservoir, around 105th Street, there was once a plant nursery. Forty acres of land in this area were originally earmarked for an arboretum that would contain specimens of every native North American tree and shrub that could be grown on the site. When that ambitious plan proved unfeasible, some of the acreage was used as a nursery to supply flowers for the rest of the park. In 1890, William Merritt Chase depicted two of his independent women there.

In *The Nursery* (page 90), the long perspectival lines of the red building and the rows of plant frames draw the eye back to the end of the cultivated landscape, where it meets what looks like an uncut meadow beyond the hedge. On this June day, the frames in the foreground are overgrown with weeds, those near the abandoned watering can look empty, while the distant ones still need tending. From foreground to background, the figures more directly convey the transition from leisure to work. The woman on the left seems lost in reverie as she holds some flowers she has picked. Viewers at the time were probably aware of the park's strict rules against picking anything and may have wondered how the woman obtained permission to gather her bouquet. Beyond her, another woman bends gracefully to inspect an exuberant plant that perhaps should have been moved long before. In the distance, a gardener leans over a plant frame, hard at work.

In 1898, a large greenhouse, or conservatory, was built near the nursery, at the park entrance on Fifth Avenue and 105th Street. Open to the public, it featured displays of tropical plants and the elaborate flowerbeds that were popular at the time. But in 1937, New York City Parks Commissioner Robert Moses razed the structure, replacing it with three gardens that retain its memory in their collective name, the Conservatory Garden. Just as Olmsted and Vaux had decided that the park's buildings should represent the architectural styles of many nations, so Moses instructed Gilmore Clarke, his chief landscape architect, to lay out a French, an Italian, and an English garden. Betty Sprout, Clarke's wife, created the planting plan that brought them to life. The Italian garden featured a lawn surrounded by yew hedges, while the French and English gardens consisted mainly of flowers—annuals in the French garden, primarily perennials in the English. Over the succeeding decades, however, the latter two gardens withered from neglect until 1982, when Elizabeth Barlow, then director of the Central Park Conservancy, asked the horticulturist Lynden Miller to restore them. The colorful, sophisticated plantings in the Conservatory Garden today reflect Miller's continued active involvement in its design and maintenance.

Wisteria, The Conservatory Garden in Central Park (2014; page 91) by Simon Parkes (b. 1954) shows one of the Italian garden's most long-lasting

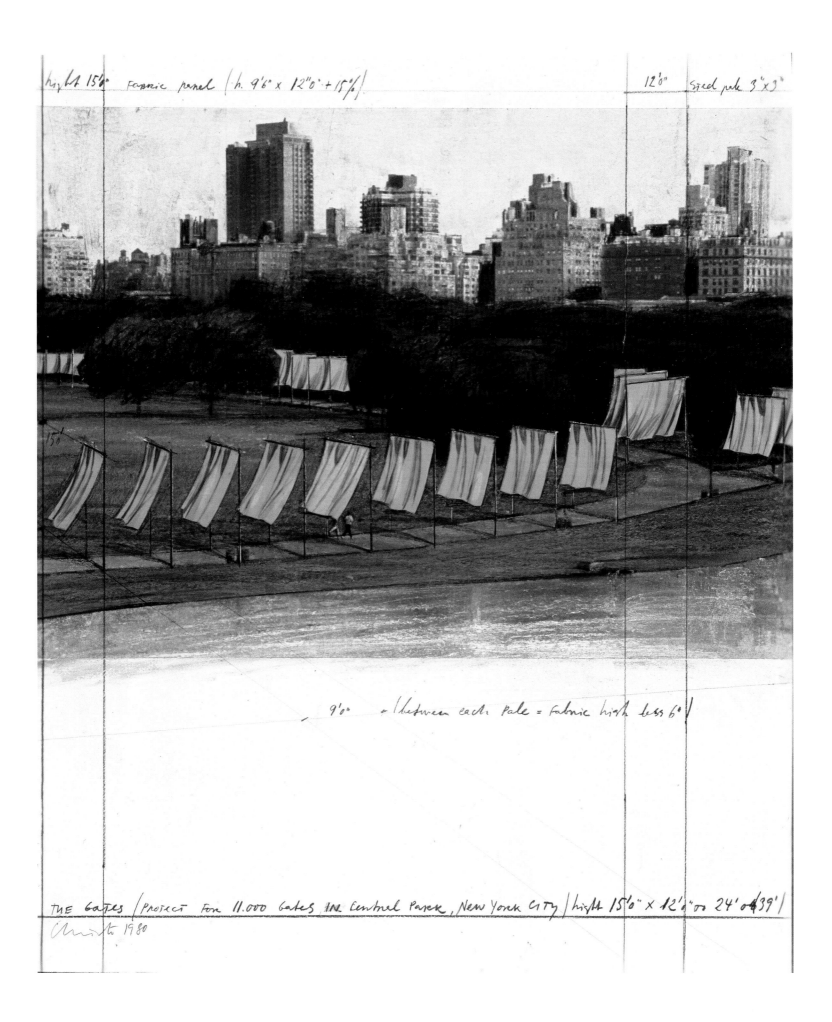

hight 15'0" Fabric panel (h. 9'6" x 12"0" + 15%) 12'0" Steel pole 3"x3"

150'

9'0" + (between each Pale = fabric high less 6")

THE GATES (PROJECT FOR 11.000 Gates IN Central Park, New York City) hight 15'0" x 12'0" to 24' or 39')
Christo 1980

OPPOSITE
Christo
The Gates, Project for 11,000 Gates in Central Park, New York City, 1980
Collage: pencil, fabric, photograph by Wolfgang Volz, charcoal, wax crayon, and pastel,
28 x 22 in.
(71.1 x 55.9 cm)
Private collection

ABOVE
Robert L. Bowden
Reservoir at East 90th Street, Looking West, 1995
Watercolor on paper,
7¹⁄₁₆ x 14¾ in. (17.9 x 37.5 cm)
Private collection

features, the pergola on the hill beyond the yew hedges. Parkes, born in England and trained as a painting restorer, moved to New York in 1978. Among the many paintings he has restored are several plein air studies by Camille Corot, who often painted the rural landscape outside Rome and the gardens of the region's old villas. When Parkes took up painting in the 1990s, Corot's style inspired him, so it is not surprising that Parkes was attracted to Central Park's most Italianate feature at the time of year when its colors most closely resemble the rich but subdued palette favored by Corot. "Outside the city," Parkes notes, "most of the leaves have fallen by mid-October, but New York's microclimate keeps them hanging on. All over the park, the colors can be truly eccentric, and this wisteria is no exception. Unkempt and unpruned, it is quite the spectacle in autumn."

Two water bodies are focal points of the northern end of the park, the Pool and the Harlem Meer. The Pool, on the west side of the park between 100th and 103rd Streets, was created by damming a stream that now flows in a series of cascades through the steep, wooded Ravine to the northeast. Frederick Brosen's *The Pool II* (page 92) shows it on an autumn day—the season when Jay-jay in Evan Rhodes's *The Prince of Central Park* was settling in on its north side. "The jungle surrounding the Great Hill was less forbidding in the light. In fact, Jay-jay thought, weaving his way through the tangle of holly and privet and cockspur thorn, I could live as happy as Yogi Bear in here. A carpet of painted leaves cushioned his every step and shafts of sunlight lanced through the leafy canopy."

To the east, the Harlem Meer forms the park's northern limit. The twelve-acre Meer was created out of a swamp when the park was extended in 1863 from 106th to 110th Street. That sixty-five-acre stretch was considered too rocky and too wet for profitable development, so it was given to the park. Christo is one of the few artists to have depicted the Meer. This 2003 collage (page 93), one of the many he did in preparation for *The Gates,* shows the Harlem Meer on a clear

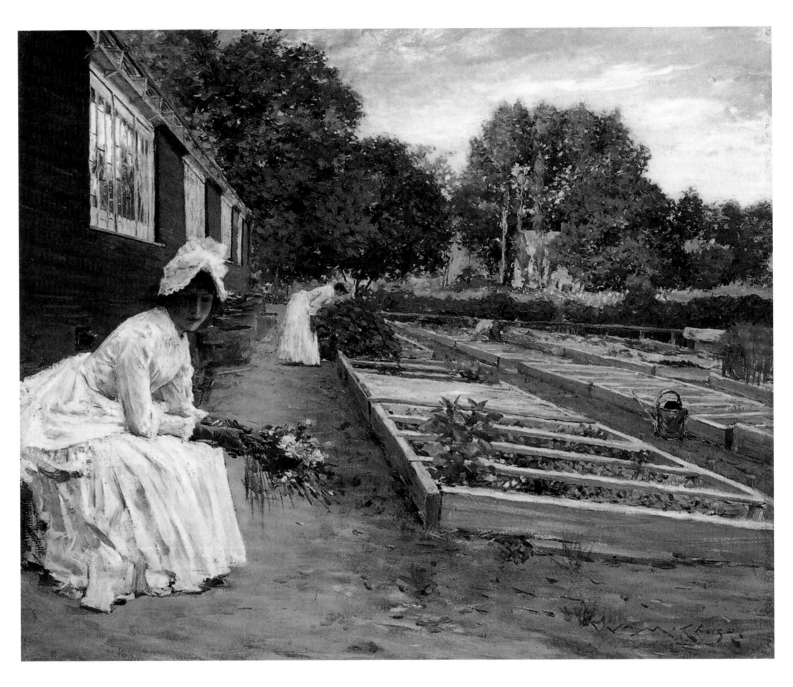

ABOVE
William Merritt Chase
The Nursery, 1890
Oil on panel, 14⅜ x 16 in.
(36.5 x 40.6 cm)
Manoogian Collection,
Detroit

OPPOSITE
Simon Parkes
*Wisteria, The Conservatory
Garden in Central Park*,
2014
Oil on board, 16 x 12 in.
(40.6 x 30.5 cm)
Collection of the artist

LEFT
Frederick Brosen
The Pool II, 2001
Watercolor and graphite
on paper, 7 x 4 in.
(17.8 x 10.2 cm)
Private collection

OPPOSITE
Christo
*The Gates, Project for
Central Park, New York
City*, 2003
Collage: pencil, fabric,
wax crayon, charcoal,
pastel, enamel paint,
technical data, and
fabric sample, top:
12 x 30½ in.
(30.5 x 77.5 cm);
bottom: 26¼ x 30½ in.
(66.7 x 77.5 cm)
Private collection

winter day with the first hints of spring that come with westerly breezes. The upper part of the collage highlights the paths around the Meer on which gates were to be installed.

From Grand Army Plaza to the Meer, artists have found inspiration in the park's landscapes and landmarks, in all seasons and times of day. Gathering places and quiet corners alike have attracted them. In addition to promenades and contemplation, the park was designed to host a wide range of activities—sporting and social, intimate and celebratory—and painters have been as inspired by these pastimes as by the setting itself.

Christo 2003

5"VINYL TUBE

PIVOT BOLT W/ 1 1/2 DIA. SPHERE HEAD

FASTENING NUTS

CAST ALUMINUM SLEEVE
FASTENING BOLTS

STEEL BASE PLATE 8"X 8"

LEVELING BOLTS (5/8")

STEEL BASE

Base Detail
no scale

RUBBER GROUND PROTECTION
FASTENING NUT AND WASHER

The Gates (project for Central Park New York City) Central Park South, 5th Ave, Central Park West, West 110th St.

Free Flowing Fabric panels (Nylon cloth) suspended from horizontal head section (Length 8'6") between gates 10'0"- 12'0"
height 16'0" width at gates from 6'0" to 18"

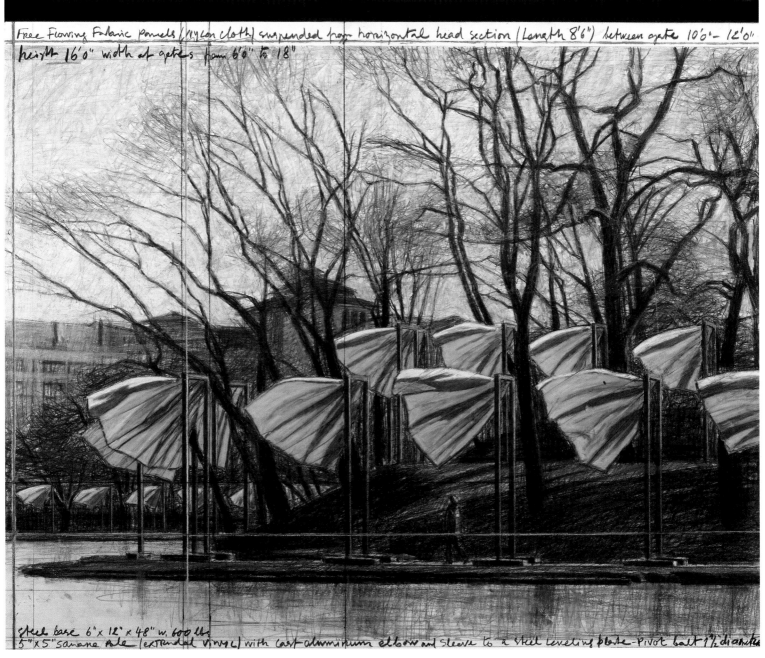

Steel base 6"x 12"x 48" w. 600 lbs
5"x 5"square pole (extruded vinyl) with cast aluminum elbow and sleeve to a steel leveling plate - Pivot bolt 1½ diameter

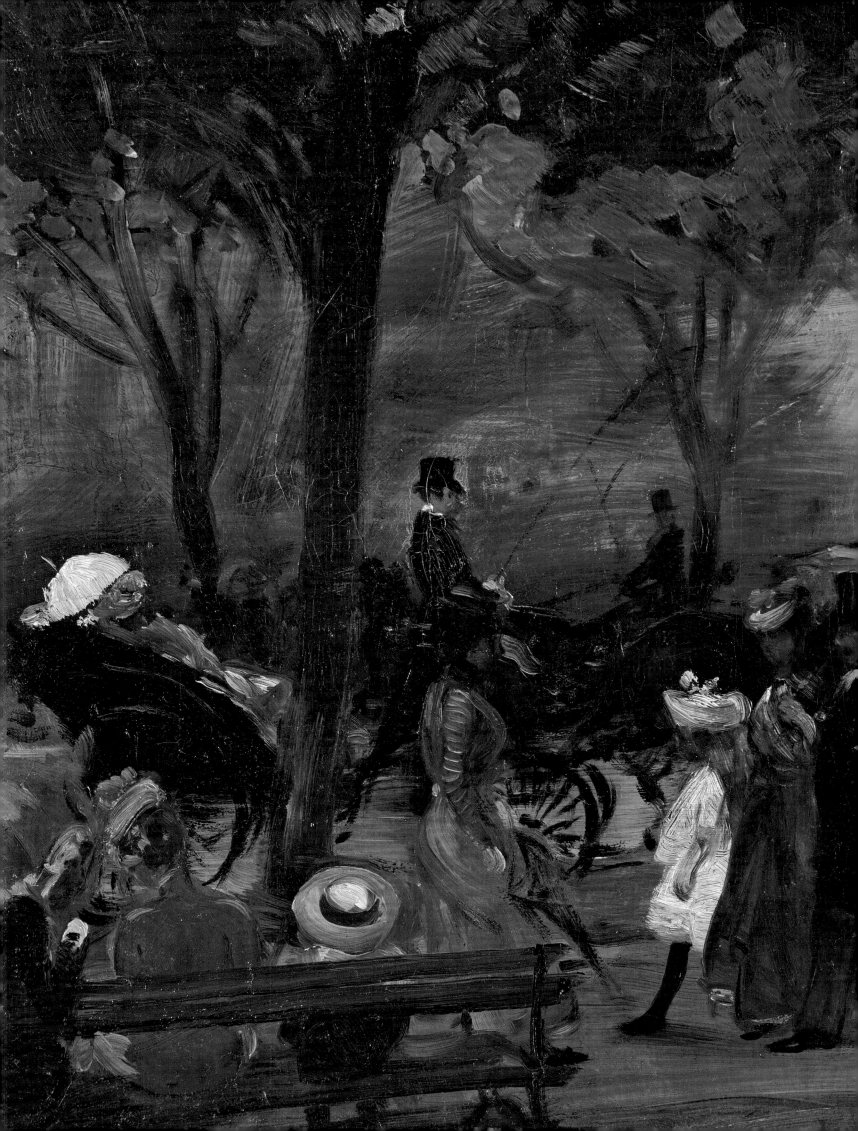

POPULAR ACTIVITIES

Olmsted and Vaux—as well as the editorialists and other advocates of open public space—all anticipated that Central Park would provide the city with a wide range of leisure activities. But the park's recreational delights exceeded anyone's expectations, enhancing life for the many New Yorkers who flocked to it and serving as a model for change in other cities. The first Central Park art—published in magazines and as prints—disseminated a vivid portrayal of the new recreations the park offered. And, just as certain sites in the park held a particular attraction for the first generations of park painters, certain activities became favorite subjects, among them ice skating, riding, and sailing model boats.

William Glackens
The Drive, Central Park,
ca. 1905 (detail)
See page 112

ICE SKATING

After the invention in 1850 of a new skate with improved control and speed, the popularity of ice skating soared. New Yorkers, however, had almost nowhere to skate, as ponds in the most populated areas of the rapidly growing city were eliminated. But in early December 1858, when Central Park was still under construction, part of the man-made Lake was filled with water. No sooner had it frozen over than three hundred people came with their skates and ventured onto the ice. The following Sunday, an estimated ten thousand people appeared, many to skate. By the mid-1860s, it was not uncommon for some thirty thousand people to come to the park to skate or watch others. Weather, of course, affected the numbers. In January 1863, there was only one skating day, whereas in January 1865 there were twenty-six. When the ice was firm, the park was kept open for skaters until midnight, four hours past the regular closing time.

The popularity of skating created new economic opportunities. In New York, skates could be bought for as little as 50 cents or as much as $25. In the park, they could be rented for 10 cents an hour, with a dollar deposit. Boys could earn a few cents per skater by lacing up their skates, no doubt an especially challenging task for women dressed in voluminous skirts. But the cost of renting skates was still well above what the poorer classes could afford, particularly on top of public transportation, which from downtown neighborhoods cost 10 to 12 cents round trip and took about an hour. Park skating thus began as a fashionable sport for those with leisure time by day or in the evening. As more working- and middle-class people moved into neighborhoods closer to the park and took to the ice, some of the upper-class skaters formed private clubs elsewhere.

Ice skating had an especially strong impact on women, who had few opportunities for exercise besides walking. Chaperones, if they accompanied their charges at all, were not expected to follow them out onto the ice. There, unmarried women could move hand-in-hand or arm-in-arm with a man without arousing suspicion. For safety as well as for fashion, skating attire featured shorter skirts than those for any other purpose, and ankles were revealed. The ice was also a place for strangers to meet and for couples to tryst out of view of others. As not all women relished this propinquity, an area on the west side of the Lake was designated as the Ladies' Pond, where the only men permitted were those escorting women, and unaccompanied women risked neither censure nor ogling.

Many of the first depictions of skating were made for engravings in magazines or for lithographic prints. Like the other early views of the park, these helped make the place better known to the public, to the rest of America, and to other artists. Winslow Homer's skating scene of 1861 (opposite top), made originally for a print in *Harper's Weekly*, shows skaters of varying degrees of skill, from the stately to the speeders to those who have taken a fall, on the Lake west of the Bow Bridge. Homer exaggerates the width of the Lake and shows the Ramble as a series of snow-covered, treeless hills extending far into the distance. On January 28, 1860, *Harper's* published Homer's depiction of the Ladies' Pond (opposite bottom), where, despite the stated restrictions, some men still seem to be showing up—and showing off—on their own. One woman lifts her skirt a bit to show her footwork as her companion looks on and tries to emulate her.

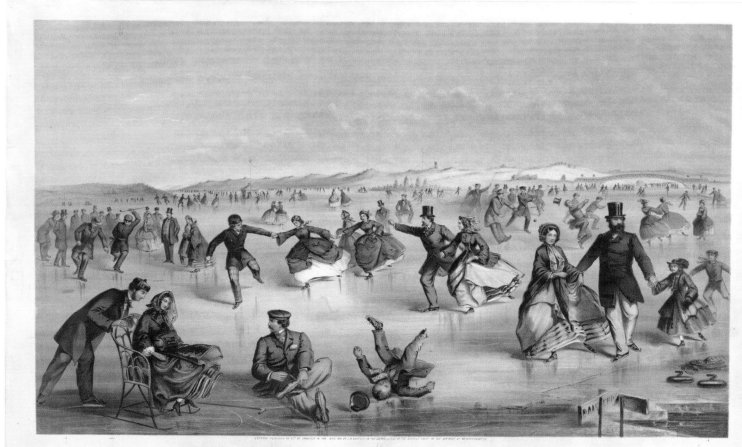

SKATING ON CENTRAL PARK, NEW YORK.

Lith. & Published by J. H. BUFFORD 313 Washington St. Boston.

ABOVE
Winslow Homer
Skating in Central Park,
New York, 1861
Color lithograph with
hand coloring, 19¼ x
29⁷⁄₁₆ in. (48.9 x 74.8 cm)
Metropolitan Museum of
Art, New York
Bequest of Edward
W. C. Arnold, 1954
(54.90.605)

RIGHT
Winslow Homer
Skating on the Ladies'
Skating-Pond in Central
Park, New York, 1860
Engraving, 13¾ x 20⅛ in.
(34.9 x 51.1 cm)
Smithsonian American
Art Museum,
Washington, D.C.

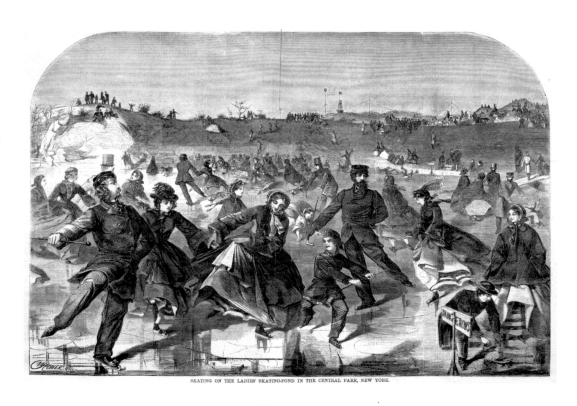

SKATING ON THE LADIES' SKATING-POND IN THE CENTRAL PARK, NEW YORK.

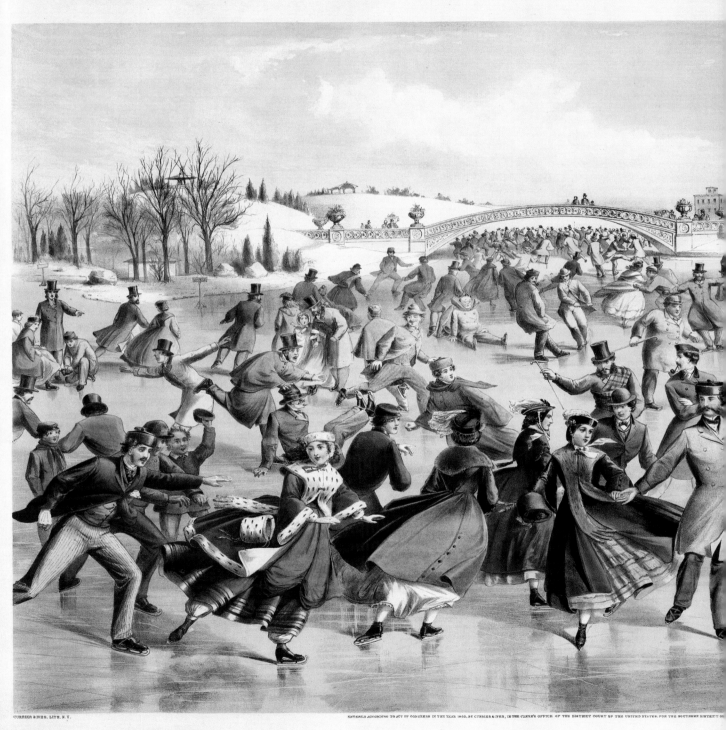

ENTERED ACCORDING TO ACT OF CONGRESS IN THE YEAR 1862, BY CURRIER & IVES, IN THE CLERK'S OFFICE OF THE DISTRICT COURT OF THE UNITED STATES, FOR THE SOUTHERN DISTRICT OF

CENTRAL - PARK, WIN

THE SKATING POND.

NEW YORK, PUBLISHED BY CURRIER & IVES, 152 NASSAU ST.

In an 1862 Currier & Ives print (left) by Charles Parsons (1821–1910), girls' and young women's skirts have risen well above the ankle, higher than any shown by Homer two years earlier. In the left foreground, the woman in exposed bloomers and the man pursuing her are both in classical poses dating back to ancient Greek depictions of nymphs and satyrs. The only lady in a full-length skirt is being pushed in a sled. In the background, one boy ties a young woman's skates, perhaps for a few pennies, while others take a comic tumble. Though drawn from the same vantage point as Homer's scene, this print is oriented toward the east rather than north, showing the Bow Bridge and a "warming house" where skates were rented and refreshments sold. The Ramble has a few trees and a summerhouse in approximately the spot where one stands today.

Johann Mengels Culverhouse (1820–ca. 1891) came to New York from Rotterdam in 1849 and painted American versions of traditional Dutch genre subjects such as taverns, markets, and skating scenes. In one from 1865 (pages 100–101), the vantage point is the southeast side of the Lake, as indicated by the position of the Bow Bridge and the Ramble's summerhouse. Another warming house, one of three or four around the Lake, is to the left, on the site of the future Bethesda Terrace. Shorter skirt length distinguishes the active women skaters from those who are only standing and watching.

The extension of park hours to midnight when the skating was good gave artists an opportunity to paint night scenes. John O'Brien Inman (1828–1896) deploys a full moon reflecting off the snow and ice, as well as the lights under the arches of the Bethesda Terrace, to illuminate his 1878 skating scene (pages 102–3). The foreground in the painting is to the east of Culverhouse's vantage point, closer to where the boathouse stands in Beckwith's 1890 painting (see page 69). A warming house is still there, and in the distance, up the steps of the terrace, snow on the roof of the Gazebo sets it off from the trees. As though the sight of people falling, cavorting, and showing off was irresistible, Inman rotates the *Angel of the Waters* statue atop the Bethesda Fountain 180 degrees, so that she can enjoy the antics. Snow or reflected moonlight on the edges of her wings, face, and knees clue the viewer in on the joke.

LEFT
Currier & Ives
Central Park, Winter:
The Skating Pond, 1862
Hand-colored lithograph,
20⅜ x 26⅝ in.
(51.8 x 67.6 cm)
Museum of the City of New York, New York

OVERLEAF
Johann Mengels Culverhouse
Skating in Central Park, 1865
Oil on canvas, 19¾ x
35⅛ in. (48.9 x 89.2 cm)
Museum of the City of New York, New York

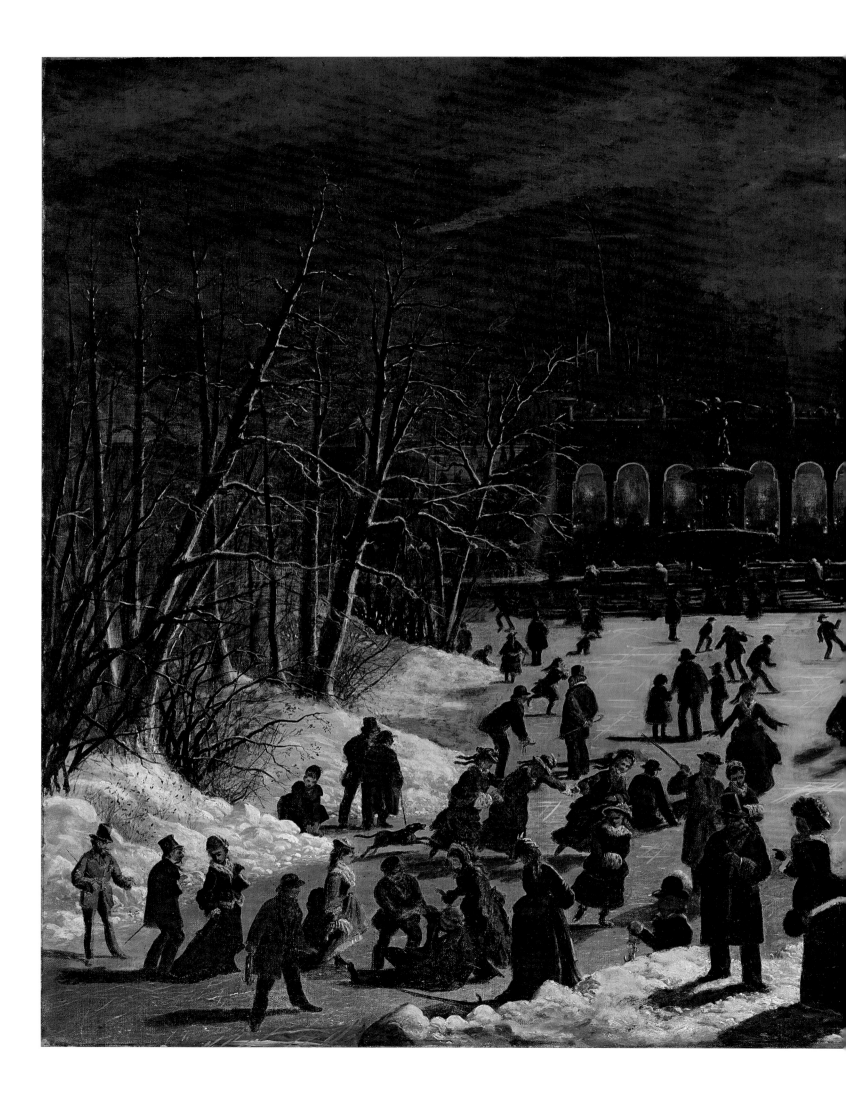

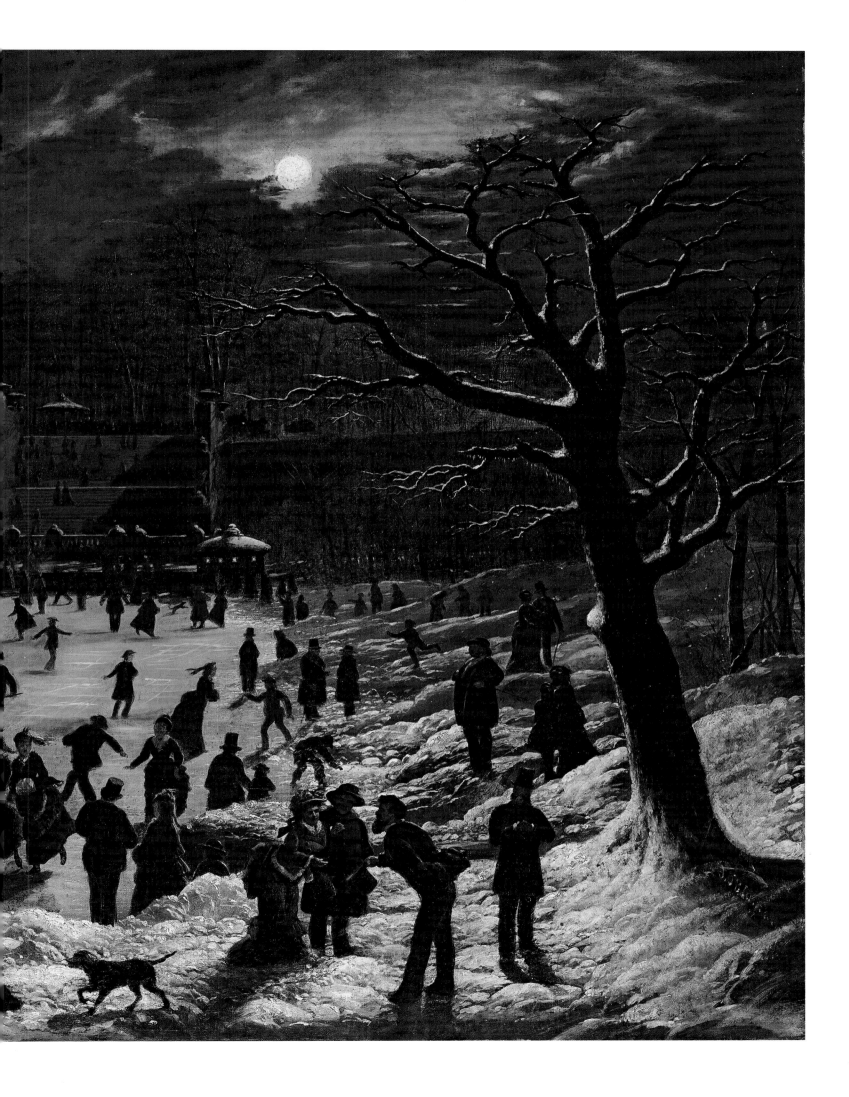

PRECEDING PAGES

John O'Brien Inman
*Moonlight Skating—
Central Park, The Terrace
and Lake*, 1878
Oil on canvas, 34½ x 52½ in.
(87.6 x 133.4 cm)
Museum of the City of
New York, New York

By the time William Glackens painted his skating scene of about 1912 (above and opposite), tall apartment buildings had sprung up on Central Park South, eliminating any sense skaters may have had of being on a country pond. The subject depicted—people falling, gliding in pairs, and showing off—puts the painting in the long tradition of skating scenes, while the palette and brushwork reflect Glackens's interest in Renoir, whose Impressionist canvases captured people enjoying themselves in parks and other natural settings. Glackens's view of the Lake here is from the southeast; the yellow wash connecting two snow banks in the background on the left is the Balcony Bridge, near West 77th Street.

Later in the twentieth century, skating moved from the picturesque Lake, where signs warning that sections of the ice were "dangerous" could be seen in the works of early painters like Winslow Homer, to the controlled environment of an artificial rink. During his long tenure as parks commissioner (1934–60), Robert Moses sought to manage popular activities through new buildings and restrictions. Under his leadership, the park's first rink was created at the northern end of the Pond, near 63rd Street. A contribution of $600,000 from Kate Wollman funded the rink, which opened in 1949. It bears the Wollman name to this day and is still a favorite skating venue, thanks to its safety and accessibility, not to mention the iconic views of the great hotel towers near Grand Army Plaza just to the south. Soon after it opened, it was already drawing some 300,000 skaters a year. For later twentieth-century painters, however, the rink was less inspiring a subject than the postcard-like views of the Pond from the Gapstow Bridge, with the hotels in the background either under spotlight or beneath pastel skies.

One painter who captured the exuberance of the skating at Wollman Rink is Joseph Delaney (1904–1991). His 1968 *Central Park Skating* (page 106) shows how much the activity had changed in the century since Homer and

ABOVE AND OPPOSITE

William Glackens
Skaters, Central Park,
ca. 1912
Oil on canvas, 16½ x
29¼ in. (41.9 x 74.3 cm)
Mount Holyoke College
Art Museum, South
Hadley, Massachusetts

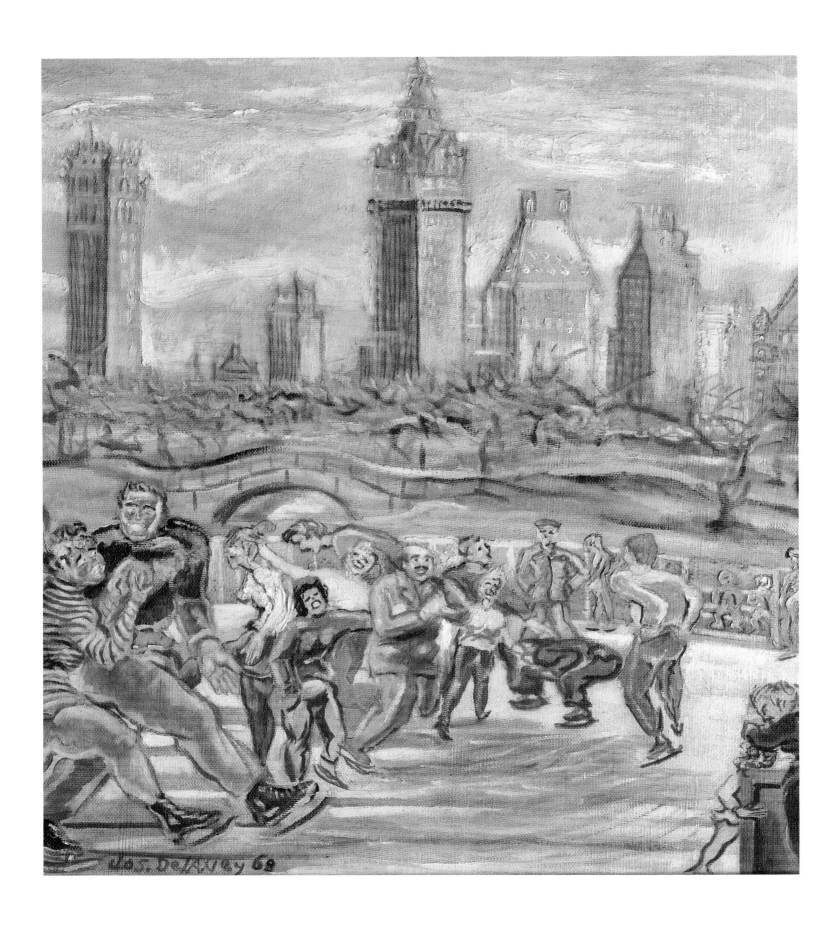

Currier & Ives depicted it. Delaney grew up in east Tennessee and lived in New York from 1930 to 1986, when he returned home to teach at the University of Tennessee in Knoxville. During his first years in New York, he studied at the Art Students League under Reginald Marsh, whose influence is evident in many of Delaney's paintings of crowded New York scenes featuring people of all classes and colors. An African American himself, Delaney's skaters represent the diversity of the city's people and the variety of costumes then appropriate for skating. Artificial ice, piped-in music, and a skyscraper backdrop are all far from what the park's first skaters might have imagined. Embedded in this painting's apparent modernity, however, is a note of nostalgia. The prominent two-chimney structure in the background is the Savoy-Plaza Hotel, designed by McKim, Mead & White in 1927. It had been torn down four years before Delaney painted this view to make way for Edward Durrell Stone's thin, towering, much-maligned General Motors Building.

RIDING

Central Park instantly transformed equestrian recreation in the city. Before the park was built, opportunities for horseback riding were so scarce that no more than a half dozen families kept horses in town. The park's first backers lamented that the city lacked carriage roads comparable to those in European cities. Olmsted and Vaux carefully designed the park's system of roads with attractive but separate networks for carriages, riders, and pedestrians. This division both ensured safety and allowed each group to observe the others, whether with satisfaction or with envy. For riders, an early morning circuit of the park was popular, whereas the most fashionable hour for carriage driving was from 4:00 to 5:00 in the afternoon.

By 1863, nearly all of the park's nine miles of gravel-paved carriage roads were completed. Driving immediately became a popular diversion—for the rich. In 1860, the cost of a carriage ranged from $2,000 to $12,000. That, plus the expenses of horses, their feed, stables, coachmen, and grooms, put driving well beyond the means of most city residents. Henry James notes the distinction in *The Bostonians*, which is set in 1875. When his young heroine, Verena Tarrant, visits New York, each of her two suitors squires her through Central Park. The rich one drives her in his carriage; the poor one escorts her on foot. She enjoys both experiences, but appears to derive greater pleasure from the stroll: "It was very different from her drive yesterday . . . but it was more free, more intense, more full of amusing incident and opportunity. She could stop and look at everything now, and indulge all her curiosities."

In the park's first decade, carriage driving was the most popular pastime. In 1863, two-thirds of the park's visitors arrived by carriage. The fashion created an economic boon for carriage makers and saddlers, as well as employment for stable hands, grooms, and coachmen. The necessity of appropriate attire for both passengers and staff enriched the coffers of tailors and dressmakers.

Unlike the Academy of Music, Metropolitan Opera House, the gentlemen's clubs, or Mrs. Astor's ballroom, which could accommodate no more than her hand-selected Four Hundred, the park was always open to all, from the city's

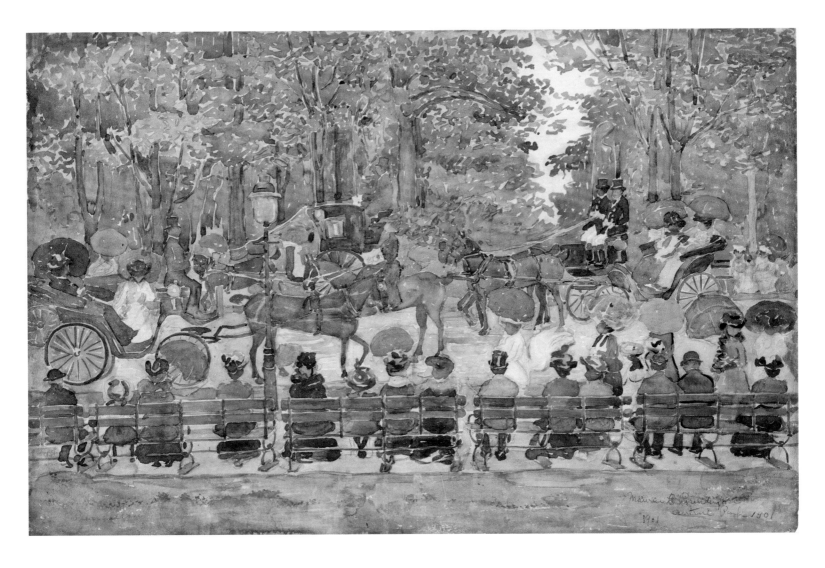

Maurice Prendergast
Central Park, 1901
Watercolor and graphite
pencil on paper, 15³⁄₁₆ x
22¹⁄₁₆ in. (38.6 x 56 cm)
Whitney Museum of
American Art, New York

most genteel to its most notorious. Carriage drives through the park were per-fect occasions for displays of conspicuous consumption by the newly rich, as George Templeton Strong noted in his diary on March 21, 1865: "Fifth Avenue from Forty-ninth Street down was absolutely thronged with costly new equi-pages on their way to Central Park this bright, bland afternoon. It was a broad torrent of vehicular gentility, wherein profits of shoddy and of petroleum were largely represented. Not a few of the ladies who were driving in the most sump-tuous turn-outs, with liveried servants, looked as if they might have been cooks or chambermaids a very few years ago."

Walt Whitman, visiting the park in May 1879, gives a more painterly description of the carriage spectacle in *Specimen Days*. "Ten thousand vehicles careering through the park this perfect afternoon. Such a show! And I have seen all—watch'd it narrowly, and at my leisure. Private barouches, cabs and coupées, some fine horseflesh—lapdogs, footmen, fashions, foreigners, cockades on hats, crests on panels—the full oceanic tide of New York's wealth and 'gentility.' It was an impressive, rich, interminable circus on a grand scale, full of action and color in the beauty of the day, under the clear sun and moderate breeze."

Over the next twenty-five years, the scene changed little, as Maurice Prendergast's 1901 frieze-like watercolor *Central Park* (above) attests. Manned by elegantly liveried staff, carriages transporting fashionably dressed ladies shielding themselves with parasols parade past a rapt "audience" of men, women,

and children seated on the benches that line the drive. In another watercolor of the park of about the same time (above and pages 110–11), Prendergast divides the scene into eight alternating horizontal of bands of green and beige, drawing attention to the park's designers' careful separation of roads for pedestrians, riders, and drivers.

Glackens depicts a similar scene in The *Drive, Central Park* (ca. 1905; page 112). He often painted the grittier parts of the city and its poorer inhabitants, but here he portrays the handsomely attired leisure class enjoying the park on a gorgeous late spring day, The dark canopy of foliage filters harsh rays of the sun and bathes the painting in a cool freshness, rendered in rapid, loose brushstrokes.

Another keen observer of the park was William Dean Howells, whose take was far less idealized than Prendergast's or Glackens's. In his *Impressions and Experiences* of 1896, he wrote: "The people in the carriages are better dressed than those on foot, especially the women; but otherwise they do not greatly differ from the most of these. The spectacle of the driving in the Park has none of the dignity which characterizes such spectacles in European capitals. This may be because many people of the finest social quality are seldom seen there, or it may be because the differences growing out of money can never have the effect of those growing out of birth; that in a plutocracy can never have the last wicked grace of an aristocracy. It would be impossible for instance, to weave any romance about the figures you see in our carriages; they do not even sug-

ABOVE AND OVERLEAF
Maurice Prendergast
Central Park, 1900
Watercolor, pastel, and graphite pencil on paper, 15¼ x 22⅛ in. (38.7 x 56.2 cm)
Whitney Museum of American Art, New York

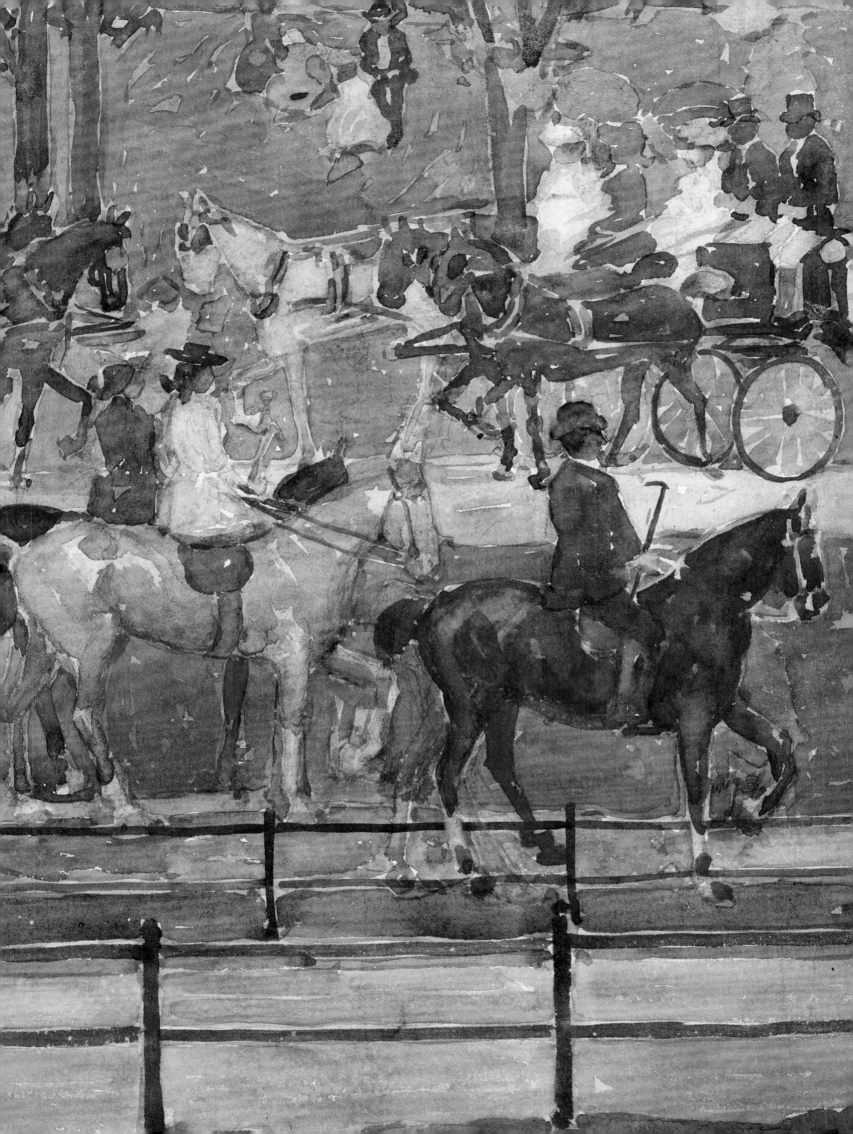

gest the poetry of ages of prescriptive wrong; they are of to-day, and there is no guessing whether they will be of to-morrow or not."

Howells was more prescient than he knew, because the carriage trade was soon to be driven out. Responding to increased demand for motor vehicle access, Central Park authorities ended their resistance and first permitted automobiles to enter in 1899. Pedestrians, horseback riders, and carriage drivers alike complained about the new invaders' noise, smells, and disturbance to horses. To improve their traction on the gravel roads, cars had chains attached to their wheels. The chains gouged the roadbed, making the paving uneven. And when the drives were oiled to reduce dust, the horses lost their footing on the slick surface. Chauffeurs routinely disregarded the original speed limit of eight miles per hour. In November 1906, the park's first major automobile accident killed three pedestrians.

The next year, John Sloan (1871–1951) completed *Gray and Brass* (page 113), in which an impressive limousine carrying expensively dressed passengers passes in front of a row of poor people in shadow on the benches lining the park drive. The high polish on the car, the ladies' elaborate hats, and the indi-

William Glackens
The Drive, Central Park,
ca. 1905
Oil on canvas, 25¾ x
31⅜ in. (65.4 x 79.7 cm)
Cleveland Museum of Art,
Cleveland
1995. Purchase from
the J. H. Wade Fund,
1939.524

John Sloan
Gray and Brass, 1907
Oil on canvas, 21½ x
26⅝ in. (54.6 x 67.6 cm)
Private collection

vidualization of the passengers' faces all contrast with the drab anonymity of those on the benches. Sloan was originally a commercial artist in Philadelphia, where he became part of a circle that included other future members of the Ashcan School such as Glackens, Robert Henri, George Luks, and Everett Shinn. He came to New York in 1904 and focused on subjects in the poorer parts of the city. Whether or not Sloan was inspired by the accident of the year before or simply aware of the general tension caused by this newest reminder of the separation between ordinary park visitors and the elite, this is one of the few paintings he or any other members of the Ashcan School made that portrayed rich and poor together.

Edward Middleton Manigault's *Procession* (pages 114–15), painted four years later, suggests that the tension between horse-drawn carriages and automobiles has been resolved. His frieze-like composition recalls those of Prendergast. Each band of the frieze depicts a different park activity, all gilded by the late afternoon sun. In the foreground, a family walks west through a verdant meadow; just behind them, three elegant vehicles—one carriage and two automobiles—move eastward. On the bridle path beyond, nine riders emerge from beneath the bridge on

Edward Middleton
Manigault
Procession, 1911
Oil on canvas, 20 x 24 in.
(50.8 x 61 cm)
Columbus Museum of Art,
Columbus, Ohio

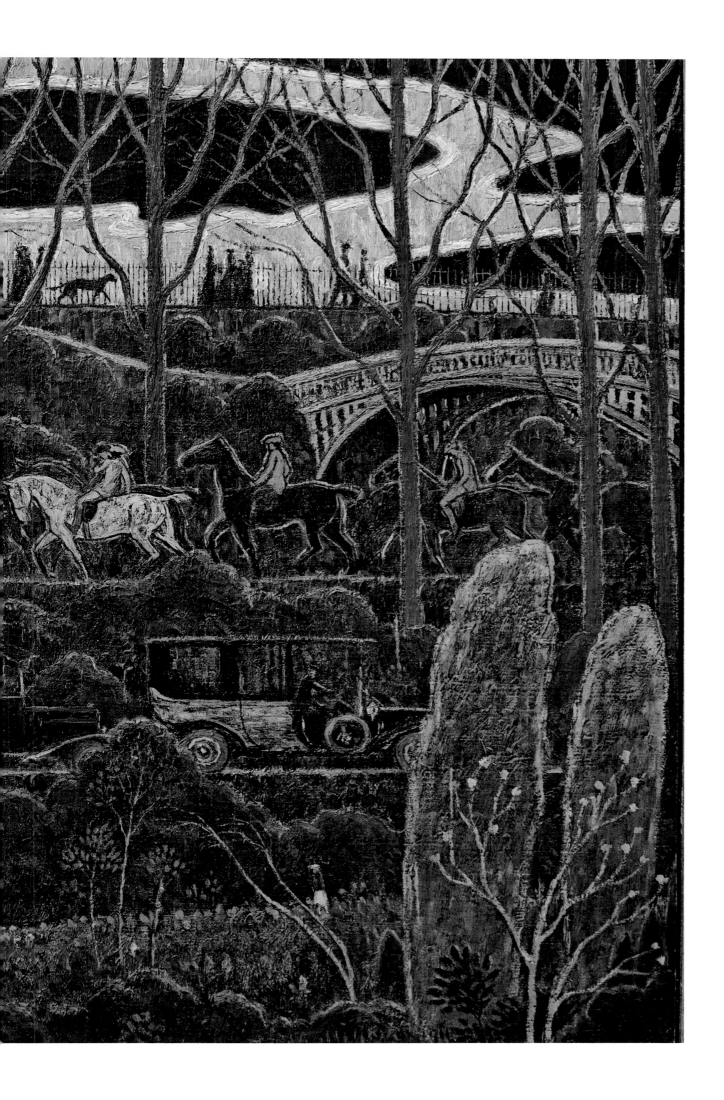

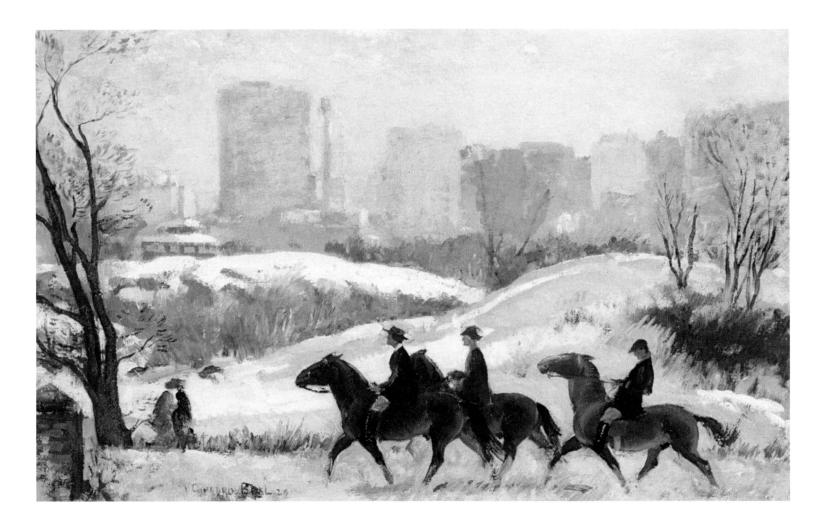

the southwest side of the reservoir and proceed westward. Finally, several walkers heading east are silhouetted against the gold-tinged waters of the reservoir.

Carriages, except for those waiting for tourists on Central Park South, as depicted by Guy Wiggins (see page 46), vanished from painters' repertories when the automobile became both the more stylish and the more serviceable vehicle. In 1912, the park drives were repaved with asphalt to better accommodate cars and the speed limit was raised to 15 miles per hour. Horseback riders still had the bridle paths, however, and painters continued to depict them. Gifford Beal (1879–1956) studied with William Merritt Chase for ten years, and his landscapes and scenes of sporting activities bear the imprint of his Impressionist mentor. In his 1920 painting *Park Riders* (above), three well-turned-out equestrians enjoy a ride through a nearly empty park on a crisp winter day, the frosty air casting the snow and distant buildings in shades of blue and pink.

Milton Avery (1885–1965) often painted riders and other subjects in Central Park during the late 1920s and 1930s. He arrived in the city in 1925, at age thirty-two, with only minimal training at the Connecticut League of Art Students. It was in New York that he first saw French modernist paintings, and the experience had a profound effect on his art; he was particularly influenced by the Fauves and their bold use of color. Many years later, at Avery's memorial service, Mark Rothko cited his scenes of Central Park as among his most memorable and most characteristic.

ABOVE
Gifford Beal
Park Riders, 1920
Oil on panel, 24 x 36 in.
(61 x 91.4 cm)
Private collection

OPPOSITE
Milton Avery
Blue Horses, Central Park, ca. 1929
Oil on board, 18 x 30 in.
(45.7 x 76.2 cm)
Private collection

Rothko himself was influenced by Avery's palette and juxtaposition of colors in resonating combinations. In *Blue Horses, Central Park* (ca. 1929; below), Avery depicts horses entering and leaving the park at 90th Street and Central Park West. In the 1920s, there were several stables nearby catering to Manhattan equestrians. The horse entering the park, still wearing a blanket and feedbag, is perhaps being led by a stable hand to meet a rider already in the park. Avery transforms what was then a series of mostly yellow brick Central Park West apartment buildings of different heights into luminous blocks of color, showing both the impact the Fauves had on him and how he might have inspired Rothko.

Edward Hopper's *Bridle Path* (1939; page 118–19) depicts three riders galloping toward the Riftstone Arch on the western edge of the park just opposite the Dakota Apartments at 72nd Street and Central Park West.. In some respects, *Bridle Path* is an unusual work for Hopper—not only is this his only equestrian painting but its depiction of figures in motion differs considerably from the enigmatic stillness that pervades most of his canvases. The choice of subject may well have been inspired by Edgar Degas, who devoted many canvases to horseracing. Hopper became familiar with Degas's work during several sojourns in Paris in the first decade of the twentieth century and was a great admirer. The Riftstone Arch, built of blocks of Manhattan schist quarried in the park, is one of Calvert Vaux's original structures. He used little or no mortar in constructing it because he wanted some of the park's bridges to appear entirely natural. In the painting, Hopper uses color to harmonize the man-made and the natural; the

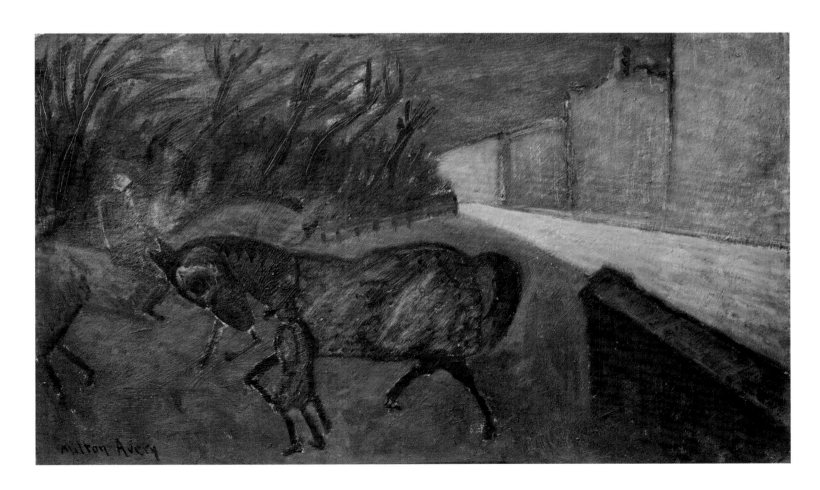

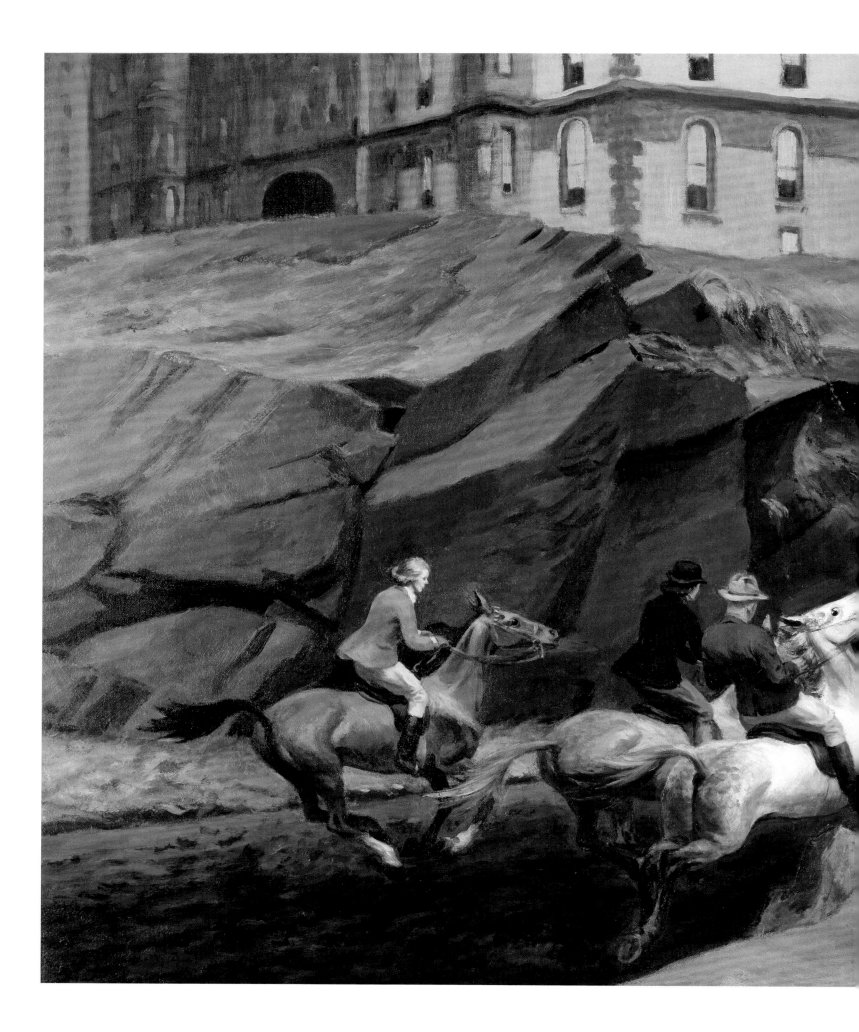

Edward Hopper
Bridle Path, 1939
Oil on canvas, 28⅜ x 42⅛ in.
(72.1 x 107 cm)
Private collection

Reeve Schley
Horseback Riding under the Great Elm, 91st Street, 2003
Watercolor on paper, 19¼ x 25⅛ in. (48.9 x 63.8 cm)
Private collection

color of the Dakota's window shades echoes that of the middle horse and the dry grass on the slopes.

Reeve Schley (b. 1939) paints primarily in New York City, New Jersey, Martha's Vineyard, and Quebec. He has taught for many years at the National Academy of Design on Fifth Avenue at 89th Street, and often brings his students into Central Park to sketch. His style has always featured broad, clear washes of color, but over the years his brushwork has become more abstract or calligraphic, his colors brighter. In *Horseback Riding under the Great Elm, 91st Street* (2003; above), Schley memorializes not only one of the park's grandest trees but also a form of recreation that was soon to vanish. The Claremont Riding Academy, the last stable in Manhattan, closed in 2007. Schley's horses and their mounts, almost transparent overlays on the landscape, can be seen as a premonition that after nearly 150 years, horseback riding would disappear from the park forever.

Another form of riding, however, has survived. The 1880s and '90s saw the first bicycle craze in the park. Women especially welcomed the new form of exercise as an opportunity to move about independently. Instead of being driven, they could drive themselves. Neither a chaperone nor the protection of a gentle-

man was expected. Early park bicyclists most likely used the asphalt pedestrian walks rather than the bridle paths or gravel drives. The modern revival of biking in Central Park began in 1966, when the parks commissioner, Thomas Hoving, closed the roads to vehicular traffic on weekends. Today, the park is off-limits to cars for many hours on weekdays as well.

Alex Katz (b. 1927) grew up in New York City and studied at Cooper Union. His paintings and prints feature figures rendered as bold, flat forms in heightened colors, often against a monochrome background. Though Katz's colors are more intense and his outlines sharper, the influence of Milton Avery on his work is clear. *Bicycle Rider (Bicycling in Central Park)*, a seventeen-color lithograph of 1982 (above), could be a sibling of such Averys as *Bicycle Rider by the Loire* (1954). In this print, Katz evokes all the pleasure of physical exercise on a day when the sun has made the park the perfect place to be.

Alex Katz
Bicycle Rider (Bicycling in Central Park), 1982
Color lithograph, 22 x 30 in. (55.9 x 76.2 cm)
Metropolitan Museum of Art, New York

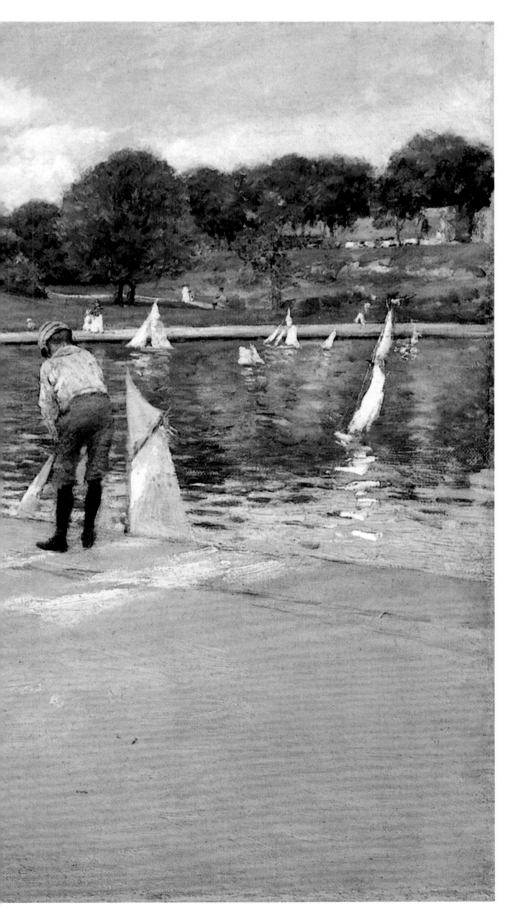

SAILING MODEL BOATS

When Central Park was created, and for decades afterward, it had few facilities designated specifically for children other than the Kinderberg. The word *playground* then meant a field for ball games; there were three in Central Park's original plan. But even allowing the increasingly popular game of baseball to be played in what was originally conceived as a pastoral landscape was hotly contested, as was letting schoolboys and teenagers use the fields, which were usually occupied by men's teams. In 1926, the park had only one playground in the modern sense. Robert Moses, who secured public works funds to build facilities in the park, added nineteen playgrounds, mostly around the park's edges, between 1934 and 1941. During the decades when children's activities in the park were marginalized, artists had few opportunities to feature children in their works. One exception was the sailing of model boats at the Conservatory Water, appropriately immortalized for both children and adults by E. B. White in *Stuart Little*.

William Merritt Chase was the first painter to see the Conservatory Water's artistic possibilities. He painted its distinctive oval shape and sloping rim many times from various angles. *The Lake for Miniature Yachts* (ca. 1890; left) celebrates this pond as a mecca for children. The little yawls, ketches, and sloops were propelled by the wind, and children used a stick to re-launch them when the boats came near the edge. The hill in the background is where José de Creeft's 1959 *Alice in Wonderland* sculpture, based on John Tenniel's illustrations for the first edition of the book, now stands.

Prendergast also painted the Conservatory Water. In *Sailboat Pond, Central Park* (ca. 1902; page 124), two young girls in the foreground are monitoring the boats, poles in hand. On the opposite shore, where today the statue of Hans Christian

William Merritt Chase
The Lake for Miniature Yachts, ca. 1890
Oil on canvas, 16 x 24 in. (40.6 x 61 cm)
Private collection

Andersen sits, a crowd of women has gathered to watch. The reflection of their dresses in the water seems to double the number of craft.

In *Model Sailboat Pond, Central Park, New York* (1904–7; opposite), Ernest Lawson (1873–1939) restores the sailing action to older boys with larger models. Lawson studied at the Art Students League and then in Paris, where in 1893 he met Alfred Sisley, who encouraged his interest in Impressionist techniques and painting out of doors. Lawson returned to New York in 1898 and later became one of the group of painters known as The Eight. Most of his city paintings are of the Hudson River and Inwood, Morningside Heights, and Washington Heights, where he lived. E. B. White's much later description of the pond in *Stuart Little* could have been written about Lawson's painting: "Over the pond the west wind blew, and into the teeth of the west wind sailed the sloops and schooners, their

Maurice Prendergast
Sailboat Pond, Central Park, ca. 1902
Watercolor and graphite pencil on paper,
15½ x 22¼ in. (39.4 x 56.5 cm)
Whitney Museum of American Art, New York

Ernest Lawson
*Model Sailboat Pond,
Central Park, New York,*
1904–7
Oil on canvas, 20 x 24 in.
(50.8 x 61 cm)
Private collection

rails well down, their wet decks gleaming. The owners, boys and grown men, raced around the cement shores hoping to arrive at the other side in time to keep the boats from bumping. Some of the toy boats were not as small as you might think, for when you got close to them you found that their mainmast was taller than a man's head, and they were beautifully made, with everything shipshape and ready for sea." The striking building rising above the trees in the background is Temple Beth-El, designed by Arnold Brunner. It stood on Fifth Avenue at the corner of 76th Street from 1891 to 1946. The dome, ribbed with traditional Moorish patterns that Lawson turned to gold, surmounted a field of stained glass protected by a skylight.

In Garth Williams's drawing of the Conservatory Water for *Stuart Little* (1945; page 126), the only one of Lawson's buildings still in view is the little

LEFT
Garth Williams
Illustration for *Stuart
Little*, 1945
Pen and ink on paper

OPPOSITE
Garth Williams
Illustration for *Stuart
Little*, 1945
Pen and ink on paper,

house where model boats were stored. This structure was later replaced by a larger one, but all the other buildings in the postwar skyline are still there today. Williams (1912–1996) was born in New York City of English parents and studied in London at the Westminster School of Art and the Royal College of Art. When he returned to New York in 1942, his first job was supplying drawings to the *New Yorker*, where E. B. White was a contributor. It was, however, White's editor at Harper & Brothers who put them together when White submitted the manuscript of *Stuart Little*. That was the first of many immortal children's books Williams illustrated. Most, like White's later *Charlotte's Web* and the *Little House* series by Laura Ingalls Wilder, had rural settings, but Williams depicted Central Park again in *Chester Cricket's Pigeon Ride* by George Selden. In this 1981 tale, the cricket and the pigeon touch down one evening at the Lake and admire the view over the water of the twinkling buildings on Central Park South. In 1980, Williams said, "I look for all the action in the story; then I arrange forms and color. I always try to imagine what the author is seeing." In his drawing of Stuart Little's boat, the *Wasp*, sailing into the maw of a floating garbage bag (opposite), Williams has given it all the drama of a schooner attacked by a giant sea monster rising from the deep.

Richard Estes's first painting of the park, titled simply *Central Park*, depicts the Conservatory Water (pages 128–29). He painted it in 1965, before he developed his hallmark photorealist style, but anyone who has been to the Conservatory Water would instantly recognize its distinctive rim. As in Delaney's 1968 skating scene (see page 106), the freewheeling mood of the decade permeates the canvas. Swimming in the model boat pond was never permitted, but on this hot day it was not prevented.

Richard Estes
Central Park, 1965
Oil on board, 36 x 52 in.
(91.4 x 132.1 cm)
Private collection

CELEBRATIONS AND QUIET TIMES

In the decades after the park opened, the number of visitors increased in leaps and bounds. The gatekeepers, who kept careful attendance records until 1874, counted some 7.6 million visitors in 1865 and more than 9.5 million in 1871. Estimates from the 1880s and '90s are of 15 million each year. The growth in attendance reflects how much easier it had become to reach the park. By 1879, there were three elevated train lines and five horse-car routes from downtown, and "uptown" had become home for more and more New Yorkers as development marched northward.

The demographics and the expectations of park visitors were also changing. In its first decade, the park had principally been the playground of the city's upper classes, but by 1877, some 80 percent of the visitors were identified as "working class," a mix of native-born Americans and the immigrants who flooded into New York from nearly all parts of Europe until World War I. For many of these, Central Park may have been the only place offering open space and fresh air that they could reach.

William Glackens
Central Park, Winter, ca. 1905 (detail)
See page 148

Maurice Prendergast
May Day, Central Park,
ca. 1902
Watercolor and graphite
pencil on paper,
19⅜ x 22¼ in.
(49.2 x 56.5 cm)
Whitney Museum of
American Art, New York

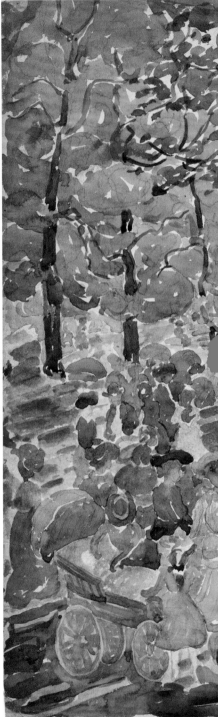

Henry James, walking in Central Park in June 1905, saw the transformation since he had sent Verena Tarrant there in 1875. In *The American Scene* he wrote, "I recall . . . a splendid Sunday afternoon of early summer, when, during a couple of hours spent in the mingled medium, the variety of accents with which the air swarmed seemed to make it a question whether the Park itself or its visitors were most polyglot. The condensed geographical range, the number of kinds of scenery in a given space, competed with the number of languages heard, and the whole impression was of one's having but to turn in from the Plaza to make, in the most agreeable manner possible, the tour of the little globe."

As these new visitors transformed how the park was used, they created new subjects for artists. Most of the nineteenth-century painters depicted people engaged in recreational activities on the roads and the frozen lake or strolling along the Mall and the Bethesda Terrace. Conspicuously absent are scenes of people on the park's extensive lawns, which were originally conceived as scenic vistas evoking the grounds of an English country estate. To preserve the serenity of these views, the lawns were nearly always off-limits. William Merritt Chase's *The Common, Central Park* (see page 53) shows the Sheep Meadow completely empty, as it would have been six days out of seven. The little red banner, then as now, meant "keep off." In the 1860s, Saturday was the only day that people were allowed on the grass. Strict Sabbatarian sentiment was overcome in the 1870s, when the day was changed to Sunday, an acknowledgment by the park's management that it was the only day most people were free to visit the park.

In 1897, the lawns were finally opened to the public every day. Among the happy results was a proliferation of paintings depicting various celebrations and quiet times enjoyed on the greensward. John Sloan, who came to New York in 1904, described the liberating experience. He was not a frequent visitor to Central Park, but he had conscientiously obtained the permit that the Parks Department required of all painters, professional and amateur alike, until commissioner August Heckscher eliminated this regulation in the 1960s. On November 7, 1909, Sloan went into the park with a friend. "[W]e, armed with our permits, walked on the grass of the Central Park of the City of New York with impunity and due pride and we sat down on the grass near a lake at 72nd St.—and made sketches and we were chagrined to find that anyone might at that place go on the grass without permit!"

May Day celebrations on the lawns inspired several artists. First held in the 1870s, this observance shifted—in urban New York—from an agrarian focus on fertility and first planting to an occasion for girls to dance around a maypole and to anoint a May Queen. Dressed in white, emblem of purity and innocence, each girl held a colored ribbon attached to the canopy of the pole. May Day's other association—with the struggle of workers to gain fair labor rights—was kept out of the park. Permits were issued for children's May Day picnics but denied to organizers of events for adult workers. Even the children's events, arranged by the city and schools, were controlled to ensure

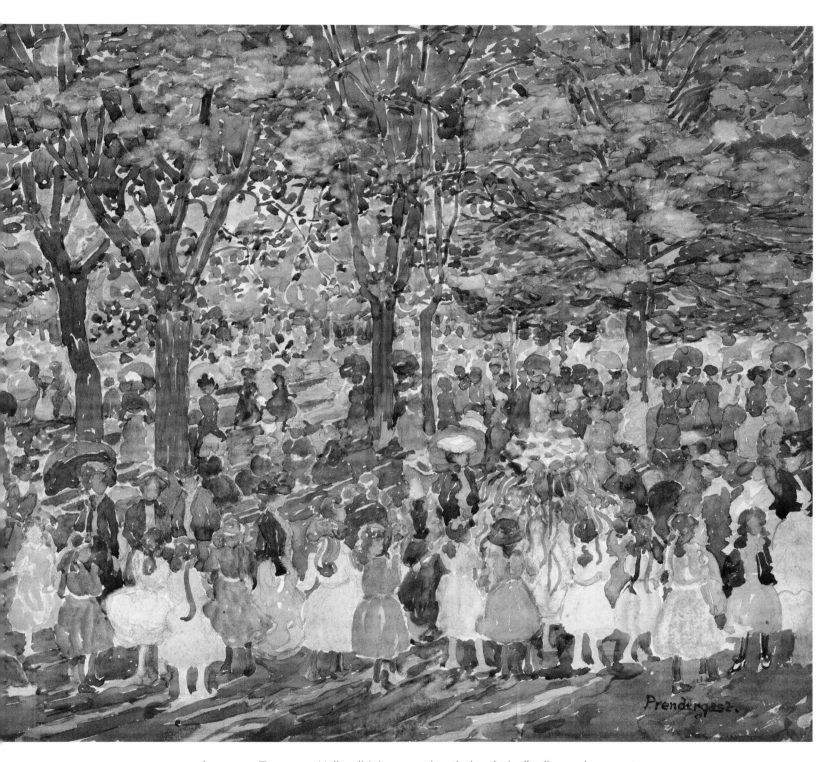

harmony. Tammany Hall politicians, serving their ethnically diverse base, put up maypoles in different parts of the park for their Italian and African American constituents, who elected their own kings and queens of May. But no ethnic, racial, or class tensions are visible in the many May Day paintings by the Ashcan School artists who were attracted to the park, though some also painted rowdier scenes of life downtown.

Maurice Prendergast depicted May Day events eleven times, as well as similar Fourth of July daytime celebrations (see endpapers). His *May Day,*

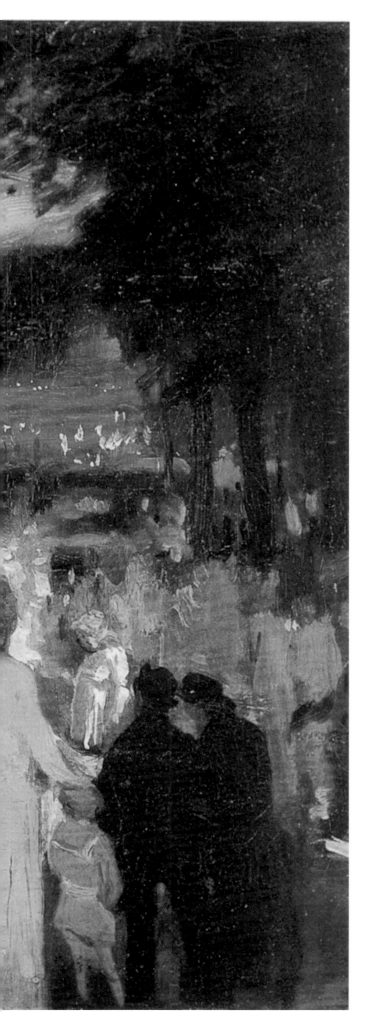

Central Park (ca. 1902; pages 132–33) is typical: a sun-dappled setting under the trees, girls in white frocks dancing around maypoles, attended by mothers and nursemaids, and not a boy in sight. Today, we are too far removed from Prendergast's dabs of color to assess the class of people in his many scenes of ostensibly genteel pastimes, but in 1905 Henry James was struck by how confident the children in the park were that they would move up the social scale: "The children at play, more particularly the little girls, formed the characters, as it were, in which the story was written largest; frisking about over the greenswards, grouping together in the vistas, with an effect of the exquisite in attire, of delicacies of dress and personal 'keep-up,' as through the shimmer of silk, the gloss of beribboned hair, the gleam of cared-for teeth, the pride of varnished shoe, that might well have created a doubt as to their 'popular' affiliation." He might have been describing this very painting.

George Bellows's *May Day in Central Park* (1905; left) shows a broader expanse of lawn where, in the distance, people are sitting or reclining. In the foreground, a few boys, some with hands in pockets and cigarette in mouth, as if to show their disengagement, walk ahead of the girls solemnly carrying the maypole. The tallest of the girls is the May Queen. Bellows strews the orange tone of the maypole flowers and bouquets around the painting—it shows up on a boy's shirt and on distant figures on the lawn. This and the rapid brushwork give the painting a spontaneous feel, as though Bellows executed it in plein air, but the foliage in Central Park is never that thick on May 1. Most likely, he did the painting in the studio afterward, making the trees as leafy and dark as in his later celebration of mid-summer, *A Day in June* (see pages 146–47).

William Glackens depicted May Day events twice. Whereas the other artists treated the occasion seriously, he turned it into a romp. His *May Day, Central Park* (ca. 1905; pages 136–37) must show a later moment in the celebration, perhaps after the athletic events that were often part of the day. The maypole has been left leaning against a tree that some boys are climbing. Others chase the girls, wrestle them to the ground, and run about, while one boy beats a drum. The relative calm of the adults suggests that these high jinks were expected and tolerated at the end of the more formal ceremony.

In the early twentieth century, organized celebrations in Central Park took place only on a few holidays like May Day and the Fourth of July. Since the 1960s, however, more frequent public events on a much larger scale have been held in the park. In addition to opera and orchestra performances, rock concerts, "be-ins," and rallies for various causes, the park has hosted firework displays as part of concerts and New Year's Eve celebrations. Bill Jacklin (b. 1943), an English artist trained at the Royal College of Art, has painted many scenes of crowds in the park, such as his *Double Illumination* (2011; pages 138–39). Jacklin

George Bellows
May Day in Central Park, 1905
Oil on canvas, 18 x 22 in. (45.7 x 55.9 cm)
Private collection

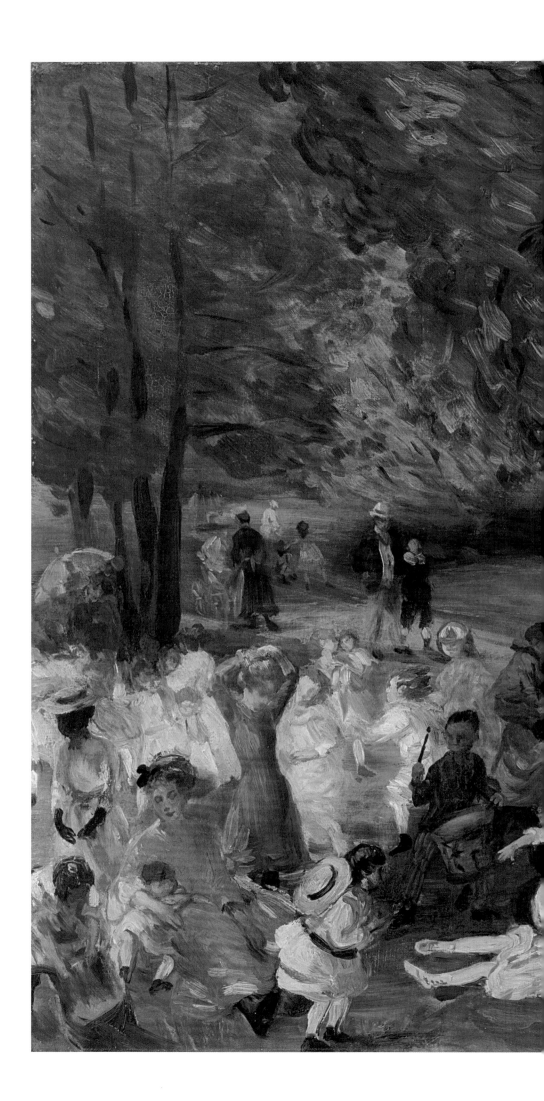

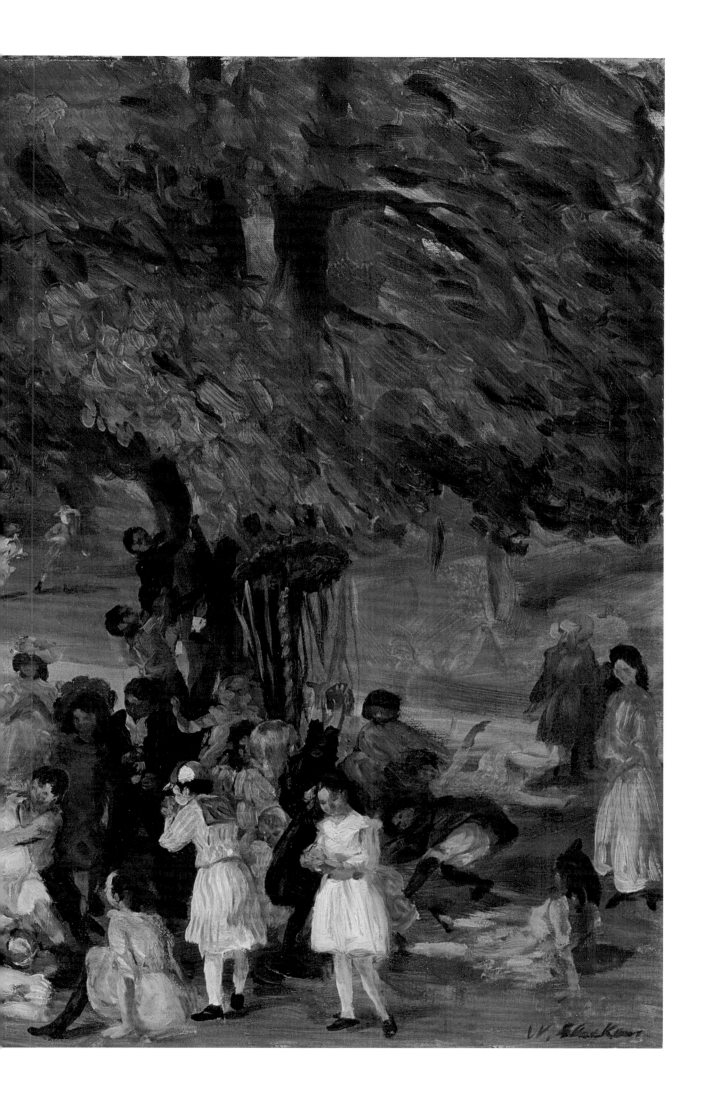

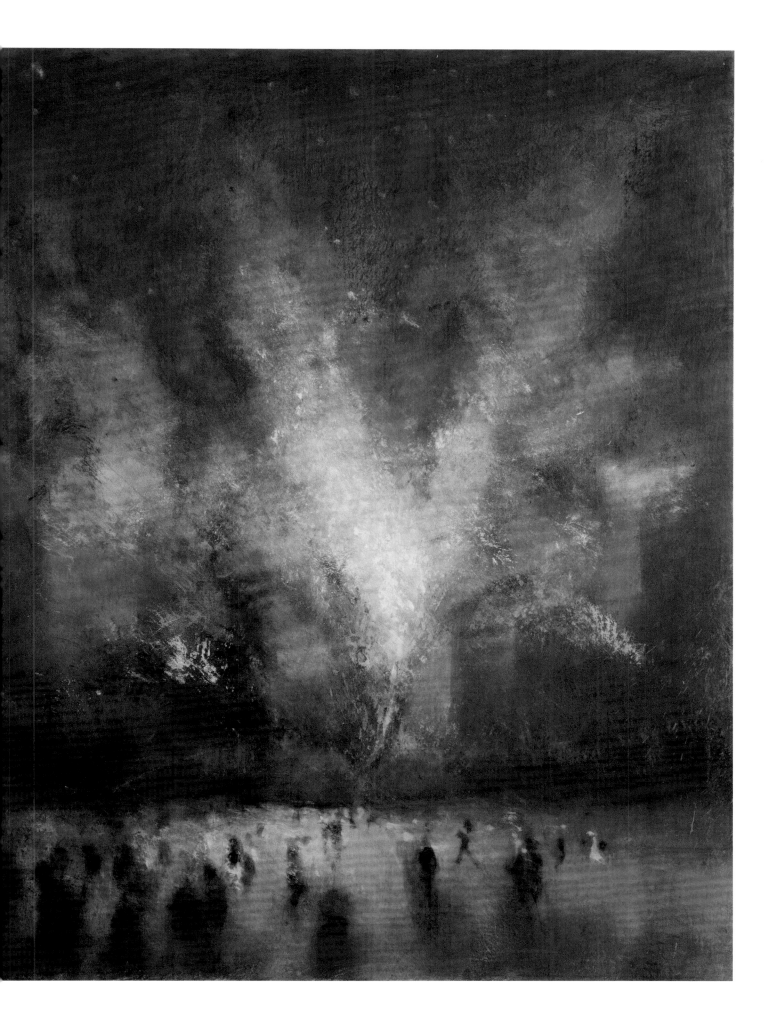

came to New York in 1985 for an exhibition of his work and was inspired to stay. "There were subjects on every corner," he recalls. "I worked my way up 5th Avenue and arrived in Central Park, a grand arena for me, the place where anything can happen. I filled many sketchbooks with images of the Sheep Meadow, the Great Lawn and the Wollman Rink skaters. I was transfixed by the movement of the sun and shadows cast by the buildings at its edges. The people became intricate patterns as they went about their business or simply relaxed on the lawn as the trees surrounded them. I witnessed the celebrations, festivities and parades around the park." In *Double Illumination*, Jacklin has applied layer after layer of oil paint and then glaze on glaze to create a sense of depth. Jacklin says, "The diptych format shows Central Park rather like you might look and blink and look again. It is really about movement and the passing of time. It is about my place in it."

In addition to holiday celebrations, Central Park offered a place for more enduring commemorations of national figures and representatives of the many immigrant groups that became devoted users of the park in the nineteenth and early twentieth centuries. The park is dotted with sculptures memorializing American patriots such as Alexander Hamilton, Daniel Webster, and William Tecumseh Sherman, as well as iconic types like *The Pilgrim*, near East 72nd Street, and the writers along Poets' Walk. Over the years, citizens' groups and some governments representing Germans, Italians, Irish, Spanish, Danish, and several Latin American nations contributed statues depicting their cultural heroes. Few of these would today be considered significant art in themselves, but some appeared in paintings by artists.

Milton Avery's 1929 *Central Park, New York City* (opposite) renders the 1876 bust of Giuseppe Mazzini near the West Drive at 68th Street even more heroic than it is in life. Its monumentality is heightened by the relative smallness of the trees and the three riders on the bridle path in the distance. Mazzini was an Italian patriot who fought with Garibaldi for the unification of Italy, but advocated a republican, rather than a monarchical, government for the new nation. Giovanni Turini, the sculptor of the bust, also fought with Garibaldi. He moved to the United States in 1874 and died in New York in 1899. Both sculptor and subject, therefore, were natural choices for the Italian Americans who underwrote the bust, which they presented to the City of New York in 1878, six years after Mazzini's death.

Though Central Park often draws tens of thousands of people for celebrations and other events, it has always been available every day as a refuge from the urban grid and grind. By the 1890s, painters began capturing the quieter, more intimate or informal moments that so many visitors to the park sought. Just as much of twentieth-century American art—both realist and abstract—focused on evoking interior reflection and experience, many park paintings depicted people absorbed in private moments.

We have already seen some of William Merritt Chase's paintings of women enjoying their time alone at the Bethesda Fountain, in the Ramble, and at the Nursery (see pages 67, 70–71, and 90). His *On the Lake, Central Park* (pages 142–43) depicts a woman engaged in a more active recreational pursuit. Rowing was a newly popular activity for women, and women in small boats they could handle themselves—punts, skiffs, rowboats—was a frequent theme

Milton Avery
Central Park, New York City, ca. 1929
Oil on canvas, 48 x 32 in.
121.9 x 81.3 cm)
Private collection

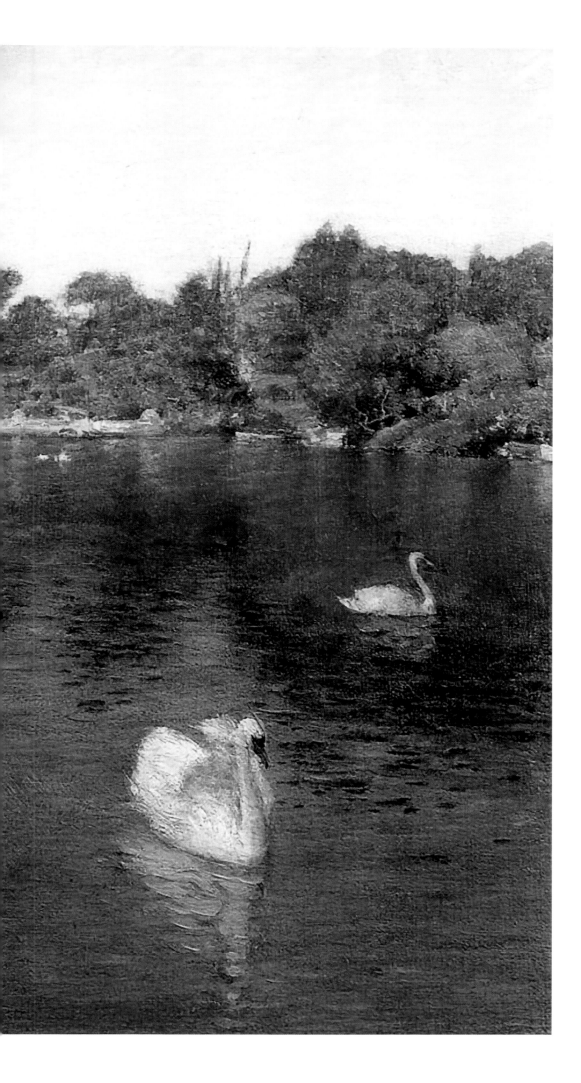

William Merritt Chase
On the Lake, Central Park,
ca. 1890
Oil on board, 14 x 16 in.
(35.6 x 40.6 cm)
Private collection

for Impressionists on both sides of the Atlantic. Here, Chase places his rower near the boathouse depicted by J. Carroll Beckwith (see page 69). She has just set off from the dock, out of sight beyond the left edge of the canvas. The lineup of empty boats on the far shore and the absence of anything but swans on the Lake emphasize her solitude, even though the reflections tell us it is an ideal afternoon to be on the water.

Even nursemaids, subsidiary figures in the May Day scenes and in so many other park paintings, occasionally served as the subject of artists' attention. Many most likely spent far more time in the park than their employers and must have known its byways well. F. Scott Fitzgerald singled them out in *The Beautiful and the Damned*: "It was an afternoon of premature spring. Water was drying on the walks and in the Park little girls were gravely wheeling white doll-buggies up and down under the thin trees while behind them followed bored nursery-maids in two's, discussing with each other those tremendous secrets that are peculiar to nursery-maids." While on their visits to the park with their charges, some may well have paused to glance at the easels of painters working there. Childe Hassam's *Spring in Central Park* (1898; right) shows a day similar to the one on which Fitzgerald sent Anthony Patch into the park. An Impressionist tour de force, it is a study in how colors affect whiteness— on the paving, on the dresses of the two toddlers, and on the apron of their nursemaid, who keeps an eye on them as she strikes a pose that shows off her fashionable puffed sleeves.

The allure of the lawns is the theme of Bellows's *A Day in June* (1913; pages 146–47). Here, as though zooming in on the distant figures in his May Day painting of eight years earlier, the pleasures of walking, sitting, and reclining on the grass come to the foreground. The man with rolled-up shirtsleeves is a self-portrait, as if Bellows wanted to prove that he himself was an active user of the park. Bellows liked this painting so much that he entered it in several exhibitions; in 1917 it won the Temple Gold Medal at the Pennsylvania Academy of the Fine Arts.

In 1913, there were still few buildings around the park's perimeter that exceeded the height of the trees. A landmark indicating the park's exterior limit was a novelty. The building with the copper mansard roof looming over the trees in Bellows's painting is the twelve-story Prasada, at 50 Central Park West, designed by Romeyn & Wynne in the Second Empire style and completed in 1907. Bellows was perhaps the only painter to capture the glow of the roof's fresh copper surface in the sunlight. In 1914, the Prasada was sold in foreclosure, and in 1919 the new owners replaced the mansard roof with plain brick. This New York evocation of Second Empire Paris survived even fewer years than the

Childe Hassam
Spring in Central Park, 1898
Oil on canvas, 29½ x 37½ in.
(74.9 x 95.3 cm)
Private collection

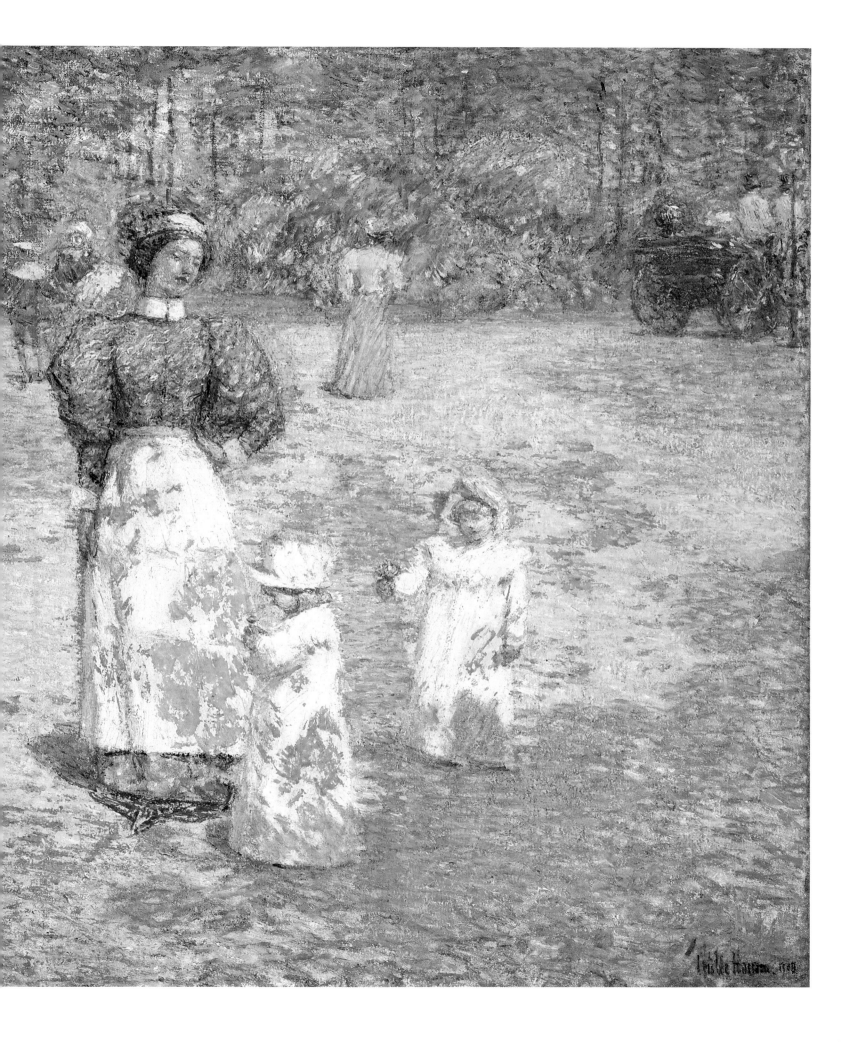

George Bellows
A Day in June, 1913
Oil on canvas, 42 x 48 in.
(106.7 x 121.9 cm)
Detroit Institute of Arts,
Detroit

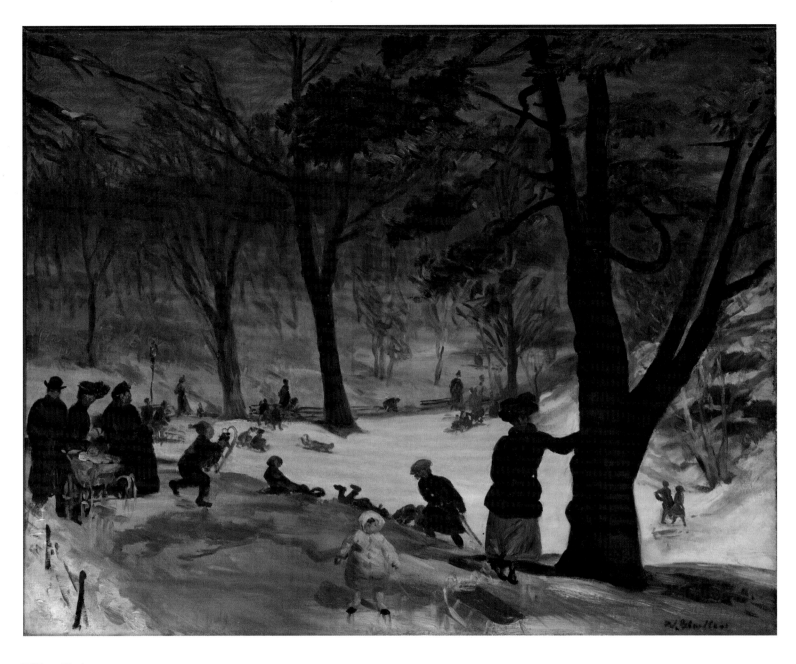

William Glackens
Central Park, Winter,
ca. 1905
Oil on canvas, 25 x 30 in.
(63.5 x 76.2 cm.)
Metropolitan Museum
of Art, New York
George A. Hearn Fund, 1921
(21.164)

short-lived empire itself. Edna Ferber, prolific novelist and playwright, was a later resident of the Prasada. Most of her novels and short stories are set in the West. But in her 1938 tale "Nobody's in Town," she weaves together the lives of three people in the park on a blistering hot day in July—the engineer who manages the reservoir pump house, a summer bachelor, and the girl he dances with at the Naumburg Bandshell that evening.

The park's hills and rock outcroppings are a natural playground for children. In *Central Park, Winter* (above) Glackens contrasts the energy of the children busily sledding with the stiff stillness of the adults watching them, perhaps eager to get home and out of the late-afternoon chill that has turned the paths and slopes under the trees blue. This painting, like Glackens's *May Day, Central Park* (see pages 136–37), was completed around 1905. The use of broad brush strokes and dark tones in both works is typical of the Ashcan School style. By

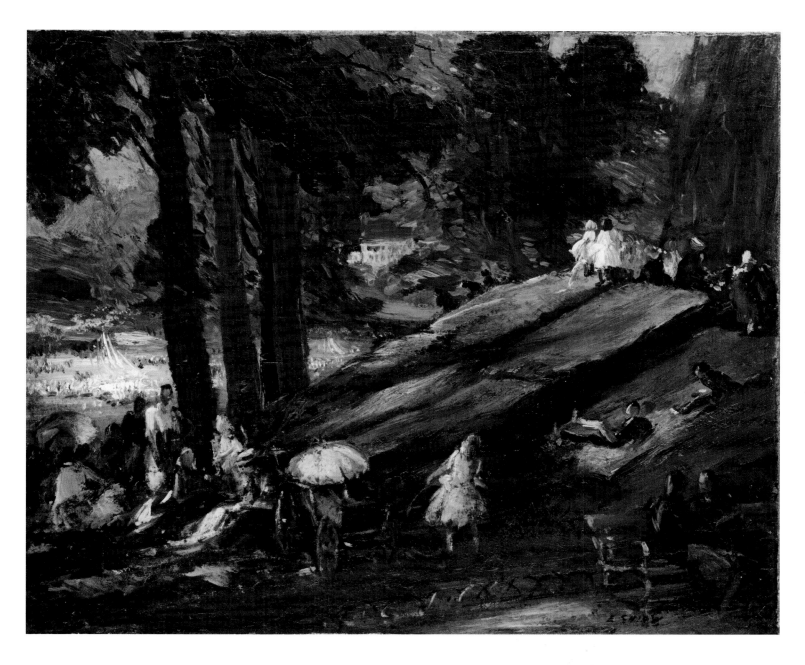

1912, Glackens had moved on to the more feathery strokes and pastel shades of his *Skaters, Central Park* (see pages 104 and 105). inspired by Renoir.

In Everett Shinn's *Central Park* (1920; above and pages 150–51), children climb up and slide down a slab of bedrock at the southern end of the park. The columned building in the background is at the Heckscher Playground. The sketchy white lines on the lawn in the distance appear to be the ribbons of maypoles, around which figures dance—making this perhaps the last depiction of May Day events in Central Park. Shinn (1876–1953) was a member of the Ashcan School and The Eight. He met several of these groups' key figures, including Henri, Glackens, Luks, and Sloan, while studying at the Pennsylvania Academy of the Fine Arts. Shinn came to New York in 1897 and found work as a commercial illustrator. He did the first full-color illustration for *Harper's Weekly*, which so long before had published Winslow Homer's drawings of Central Park. Shinn's primary interest was

ABOVE AND OVERLEAF
Everett Shinn
Central Park, 1920
Oil on canvas, 17 x 19 in.
(43.2 x 48.3 cm)
Private collection

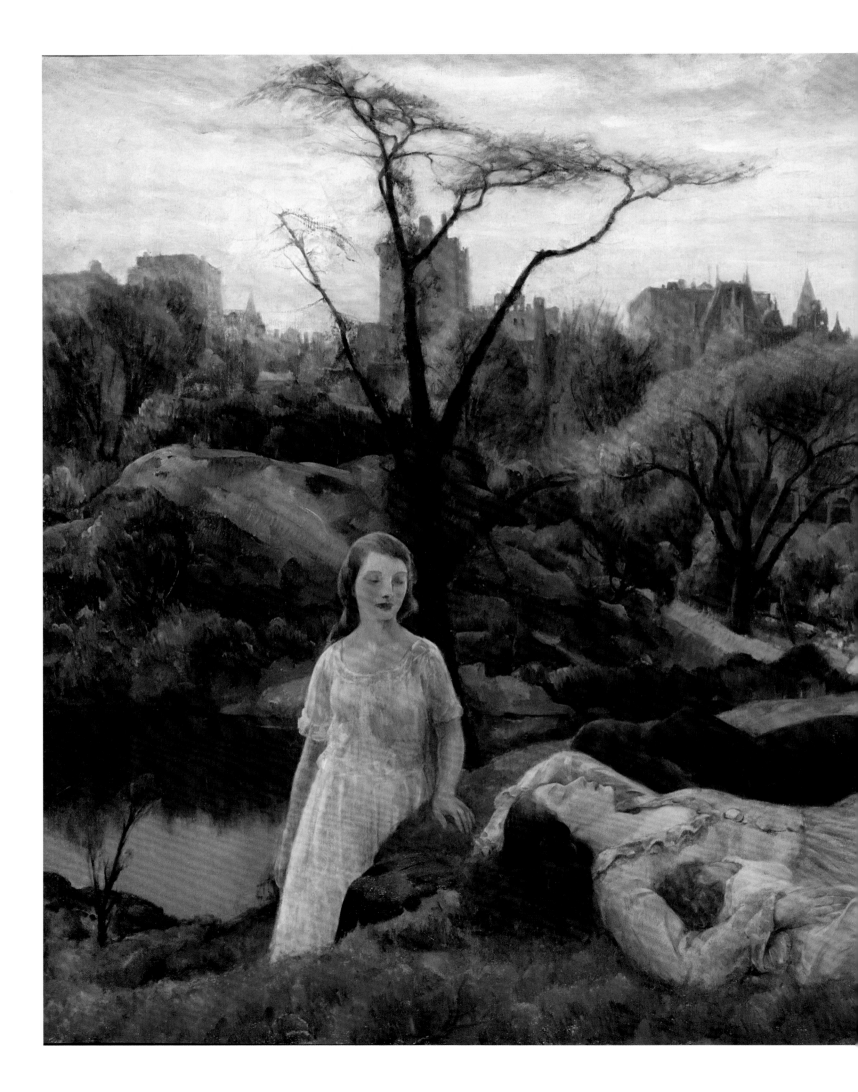

Leon Kroll
Sleep, Central Park, 1922
Oil on canvas, 36 x 48 in.
(91.4 x 121.9 cm)
Smithsonian American Art
Museum, Washington, D.C.

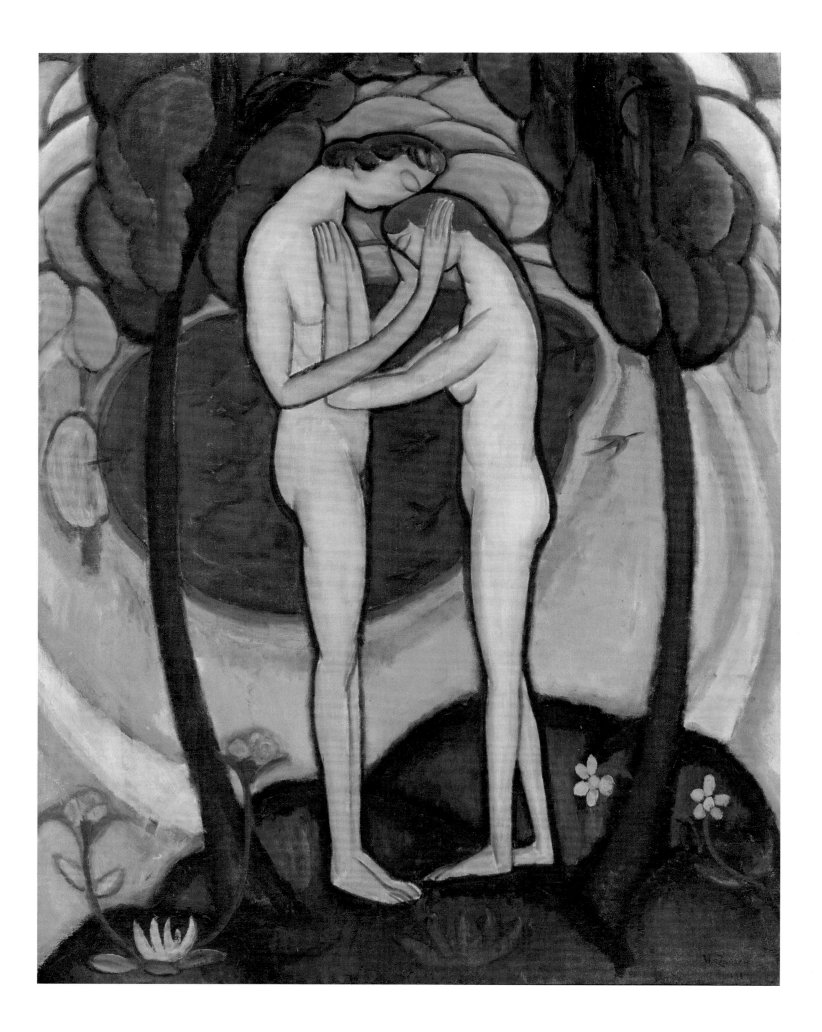

the theater; he participated in it as an actor and set designer, and he also painted theatrical scenes. This is his only painting of Central Park.

Of the three views Leon Kroll painted in 1922 looking southeast toward the Pond and the tall buildings beyond, *Sleep, Central Park* (pages 152–53) is the only one that focuses on people. Unlike *Scene in Central Park* (see page 49), in which the few small, anonymous walkers on the paths and bridge function as punctuation points in the composition, here the four principal figures are presented front and center in a dreamlike, Arcadian setting, with another, less conspicuous sleeper beyond the rock. The two sleeping women, one embracing a small, sleeping child as another young woman looks on, have an almost allegorical quality. Kroll depicted women sleeping or lying on grass or rocks in rural settings a number of times. He brought the theme back to the city in *Katherine Cleaves, Central Park* (1965), a much more literal scene of a woman reading while lying on a rock.

Still more Arcadian is William Zorach's *Spring in Central Park* (opposite). When Zorach returned to New York from Paris in 1912 he married Marguerite Thompson, an American artist he had met in the French capital. She herself had a distinguished career as a painter. Zorach's first New York paintings reflect the happiness of their new life together. In 1913, influenced by Matisse, whom they had met in Paris, Zorach painted two pastoral scenes of mostly nude women and children, sitting or reclining in flowering fields. The following year, he moved the romance into the park. As Zorach fondly remembered in his autobiography, "We begrudged every minute not painting or something related to art. We sketched all over the city—in Central Park, along the waterfront, across the Hudson on the Palisades—and painted wild pictures at home from imagination. Instead of one sun, I painted three red suns. I painted Central Park in all wild colors, peopled with exotic nudes. One morning sketching in the park, I found fifteen dollars in small change under a bush. What a bonanza!"

During the Great Depression, when homeless people slept in Central Park, artists still portrayed it as an oasis of tranquillity. Milton Avery's *Sailors in the Park* (1931; pages 156–57) depicts several types of park users, each absorbed in his or her own affairs: a nursemaid seated on a bench minds her charge in a perambulator while two visiting sailors stroll by, and ladies on another bench converse or watch the others. Women conversing became a frequent theme in Avery's paintings; in this canvas, we can speculate that they may be commenting on the people with whom they share the park.

When there is no evening ice skating, the quietest hours in the park are at night. Though Central Park developed a reputation for danger after dark—statistically undeserved when compared with adjacent neighborhoods—artists rarely depicted its sinister aspect. Edward Hopper's *Night in the Park* (1921; page 158) shows a solitary man reading a newspaper under a lamp pole. This etching examines the range of brightness that a single source of light provides—reflected off the pavement, the paper silhouetting its reader, and the benches and thick foliage. Absorbed in his paper, the man, like so many of Hopper's figures, is self-contained— and certainly not concerned about anyone lurking in the dark.

The German Expressionist George Grosz (1893–1959) brought a very different personal vision to the dark hours. In *Central Park at Night* (1936; page 159), the rock outcroppings in the foreground, twisted and contorted like waves

William Zorach
Spring in Central Park, 1914
Oil on canvas, 46 x 36 in.
116.8 x 91.4 cm)
Metropolitan Museum of
Art, New York, N.Y.
Gift of Peter Zorach, 1979.
1970.223a.b

Milton Avery
Sailors in the Park, 1931
Oil on canvas, 32 x 40 in.
(81.3 x 101.6 cm)
Private collection

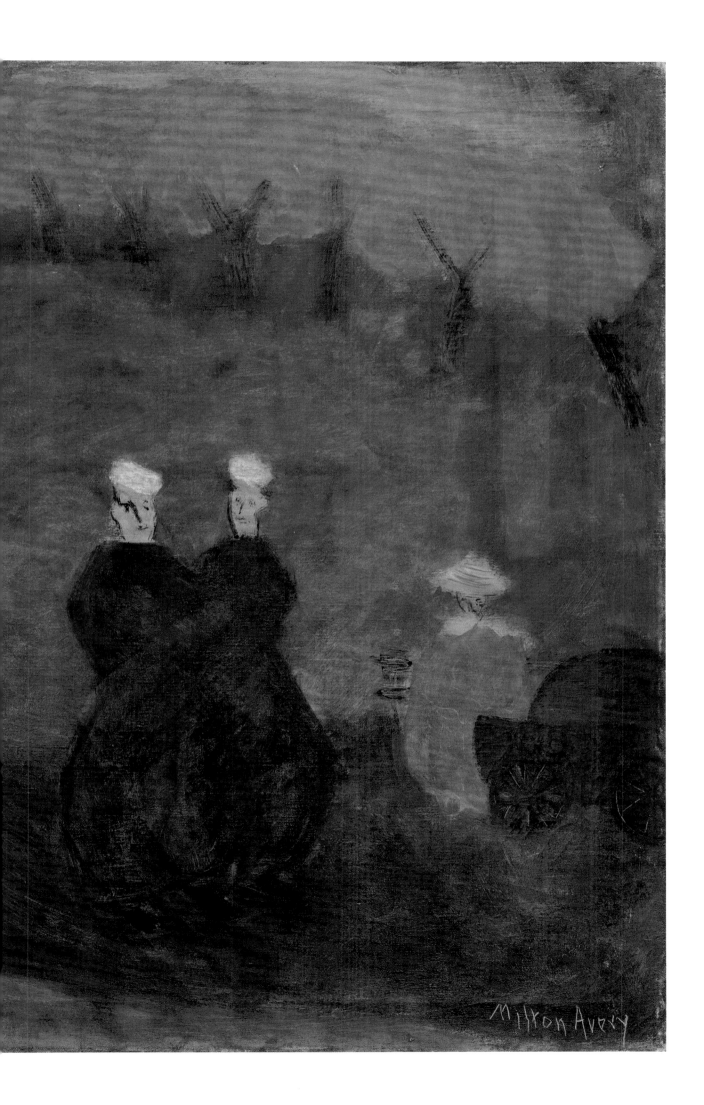

ABOVE
Edward Hopper
Night in the Park, 1921
Etching, 6⅞ x 8⅜ in.
(17.5 x 21.3 cm)
Museum of Fine Arts,
Boston

OPPOSITE
George Grosz
Central Park at Night, 1936
Watercolor, with gouache and
touches of pen and black ink,
selectively gum varnished, on
ivory wove paper, 19¹⁵⁄₁₆ x 12 in.
(50.6 x 35.5 cm)
Art Institute of Chicago,
Chicago
Olivia Shaler Swan Memorial
Collection, 1941.483

in a roiling sea, and the lurid glow emanating from the buildings, as though they were in flames, suggest the turmoil of his own anxious soul, which was torn over the direction his native Germany was headed. Grosz was born in Berlin and served in World War I. In the 1920s, he became an antimilitarist and critic of the Weimar Republic, which did not welcome his satirizing caricatures. Grosz came to New York in 1932, invited to teach a summer course at the Art Students League. John Sloan, then president of the league, recruited him because he thought students would benefit from a radical who had had thorough academic training in Germany. The Nazis had declared Grosz "Cultural Bolshevik No. 1." Grosz stayed in the United States until May 1959, when he returned to Germany, where he died several weeks later. All three of his Central Park paintings, done between 1933 and 1936, depict the landscape in highly anguished personal terms.

The late hours held no fears for Adolf Dehn (1895–1968), who painted Harlem nightclubs and downtown burlesque theaters in addition to nighttime views of Central Park. Like Kroll, who explored the artistic potential of one viewpoint near the Pond a number of times, Dehn kept returning to the lawn just north of the Sheep Meadow. Best known as a prolific lithographer, Dehn also worked in oil and watercolor. He depicted the park in all these media. Dehn came to New York from Minnesota to study at the Art Students League. After World War I, he lived in Paris and Vienna, returning to New York in 1929. In the 1930s, his illustrations appeared in magazines such as the *New Yorker* and *Vogue* that maintained a gloss of urban sophistication through the Great Depression. Dehn's views of the park have a similar cheerful urbanity, showing well-dressed people strolling, conversing, or reclining on what must have been his favorite lawn. Over the decades, he depicted it in all seasons and at all times of day.

In A *Summer Night* (opposite), the glow from the skyscrapers lining Central Park South and as far off as the Empire State Building seems to illuminate the lawn. This oil painting is undated, but the presence of buildings like Rockefeller Center indicates that it must have been done after 1933. The 1941 watercolor *Spring in Central Park* (pages 162–63) shows New York's last peacetime spring before the United States became involved in World War II. With its fresh grass, new leaves, and white flowering shrubs, the lawn is irresistible. The depiction of a young man helping his girl stand up from the grass in the center foreground consciously or unconsciously recaptures the pose of a pair of lovers immortalized in Watteau's *The Embarkation for Cythera*, a painting Dehn must have known from the Louvre. More than twenty years later, in his color lithograph *Gray Day* (1963; pages 164–65), Dehn treats the same setting in yet another medium and with a different palette. Against the familiar backdrop, extending from the Pierre Hotel to the St. Moritz, ladies walk their little dogs after a snowfall in late autumn, when there are still some leaves on the trees. The sky suggests that more snow is on the way, evoking the sense that one must seize the moment to enjoy the beauty of the park before it is again transformed.

The warmth of the sun absorbed by and reflected off the rocks continues to attract visitors to the park to this day. In *Sunday Afternoon in the Park* (1989; pages 166–67), Richard Estes captures the allure of the sun-bathed park on a fine April day. From his vantage point at the Hernshead, a promontory that juts into the Lake, Estes depicts a far more crowded skyline than the iconic view that Dehn painted

Adolf Dehn
A Summer Night, n.d.
Oil on masonite, 24 x
36 in. (61 x 91.4 cm)
Private collection

between 1933 and 1963. In his paintings of so many New York neighborhoods, Estes has become to New York what eighteenth-century artists like Canaletto were to Venice—the loving depicter of the effects of light reflected off buildings and water, with people captured unawares against the backdrop of the city.

What could better demonstrate Central Park's infinite capacity to evoke powerful responses from artists than the contrast between a Photorealist creatively rearranging perception and a Color Field painter abstracting the essence of the park as she felt it? Helen Frankenthaler's *Central Park* (1965–66; page 169) is unique in her work and in the long history of artists who have found inspiration in the park. Frankenthaler (1928–2011) was a native New Yorker. From her childhood on, she was an enthusiastic visitor to the park, later donating three benches in memory of her family. She developed an interest in painting at a young age—at the Dalton School her teacher was the Mexican artist Rufino Tamayo. In 1950, after attending Bennington College, she studied briefly with the Abstract Expressionist Hans Hofmann. At the beginning of her career, Frankenthaler was particularly impressed by Jackson Pollock, who applied paint to canvas without a brush. She developed her own technique of pouring paint, heavily diluted with turpentine, directly onto an untreated canvas, so it soaked in more deeply. This method gave her paintings the look of watercolors, both in the way the pigment affected the surface and in the spontaneous effect achieved. In the 1960s, when Frankenthaler was splitting her time between East 94th Street and Cape Cod, she painted a number of abstracted landscapes and seascapes, giving some of them titles of specific locales. *Central Park* is one of the largest. Viewers may see in it places that might have been an inspiration or may simply enjoy the expressiveness of color conveying the pleasure and joy Frankenthaler derived from the park.

Adolf Dehn
Spring in Central Park, 1941
Watercolor on paper,
18 x 27¼ in. (45.7 x 69.2 cm)
Metropolitan Museum of Art,
New York

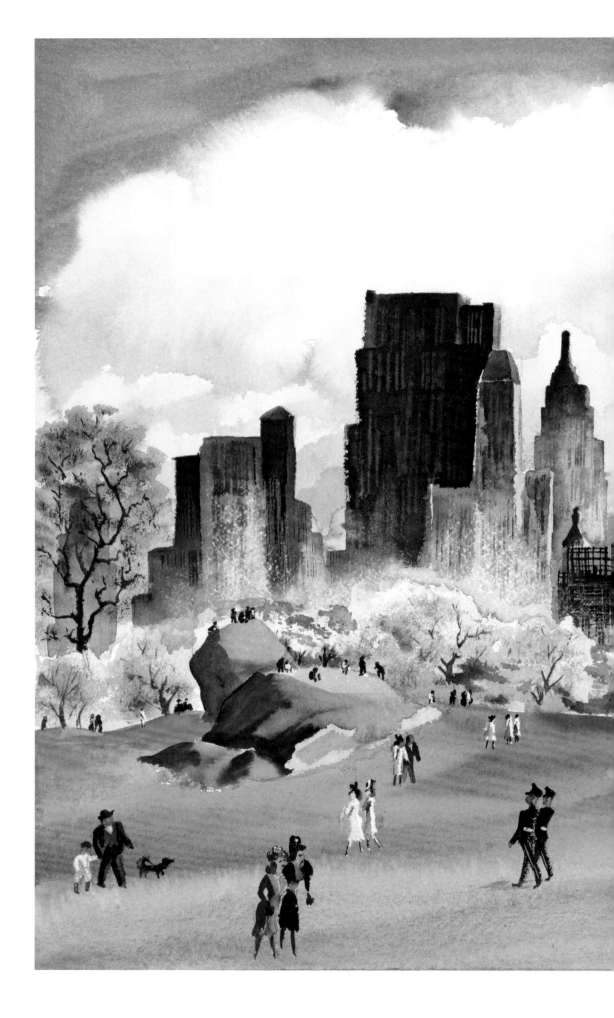

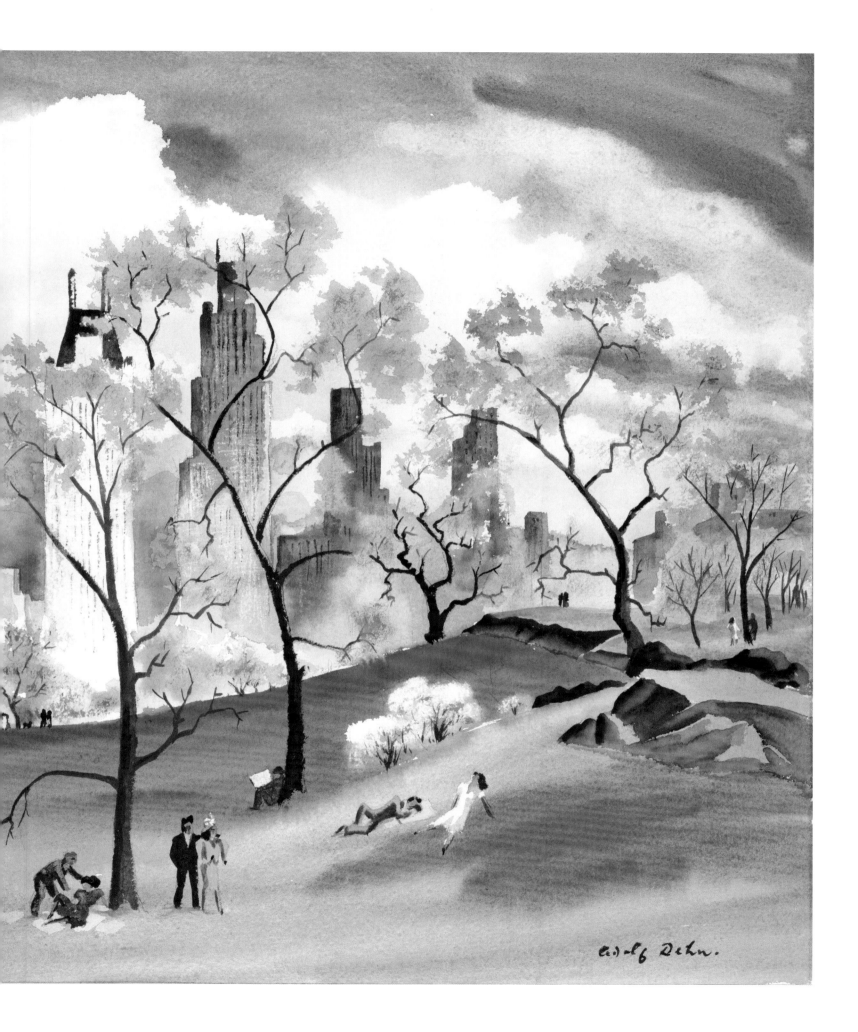

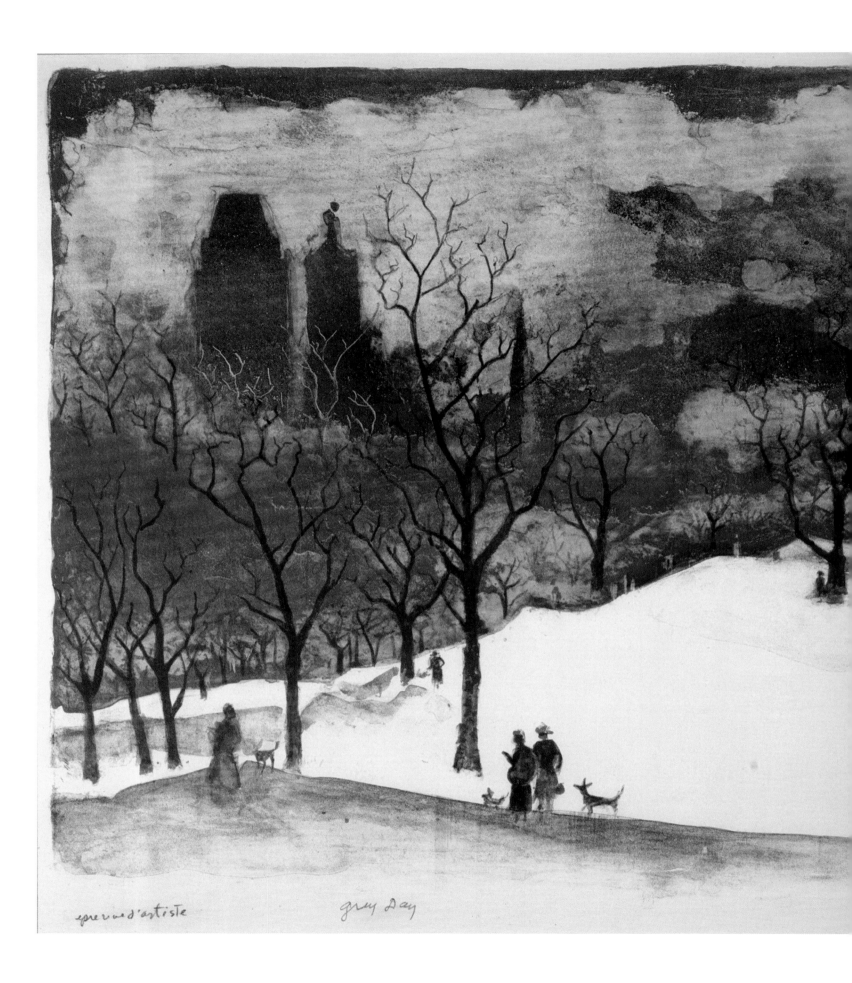

épreuve d'artiste grey day

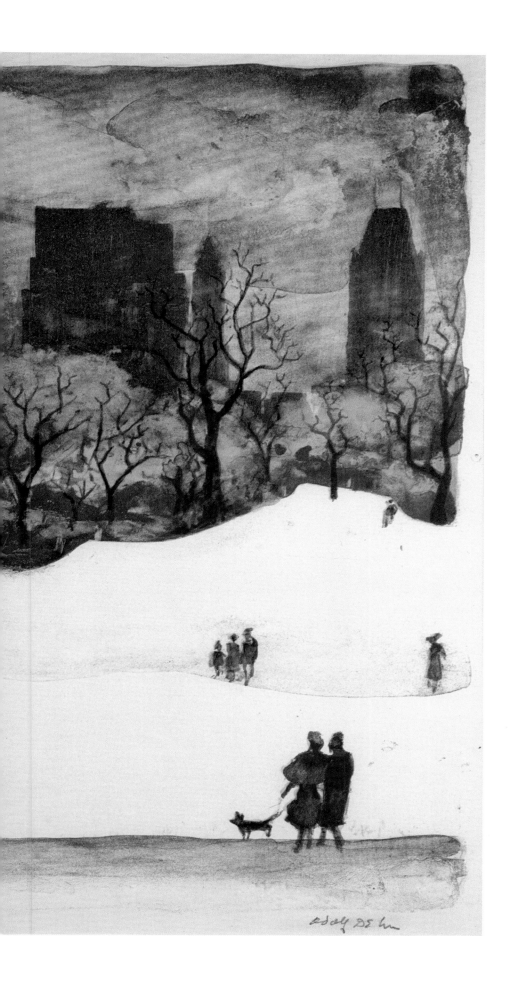

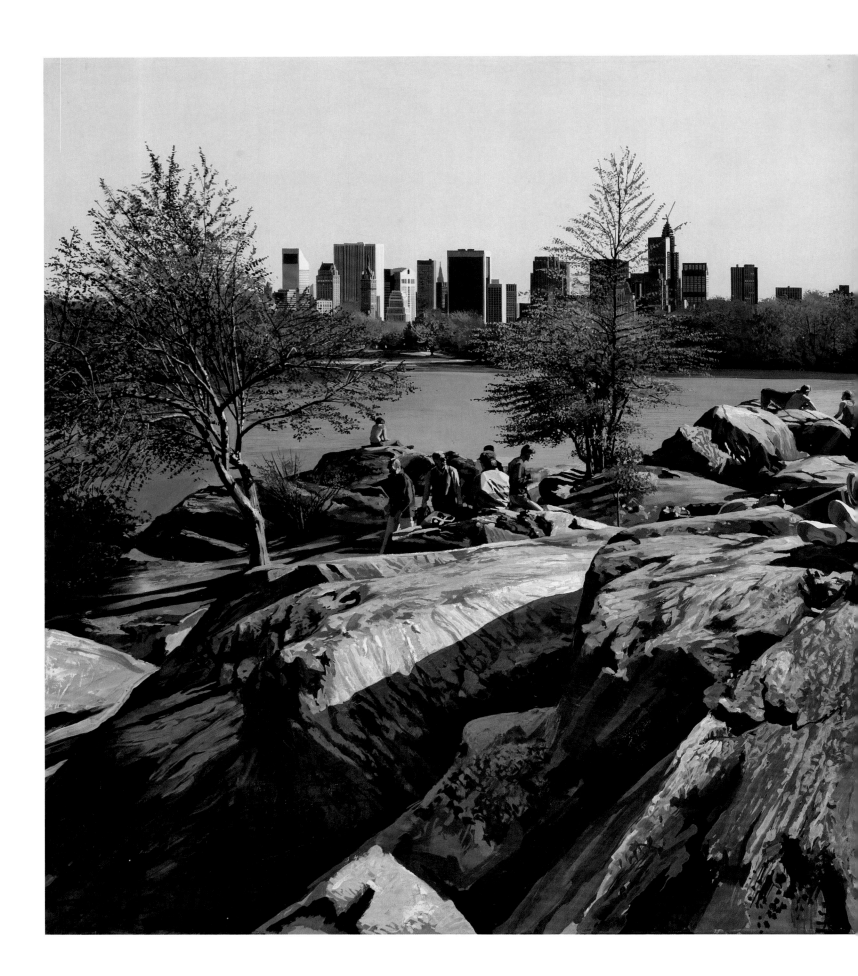

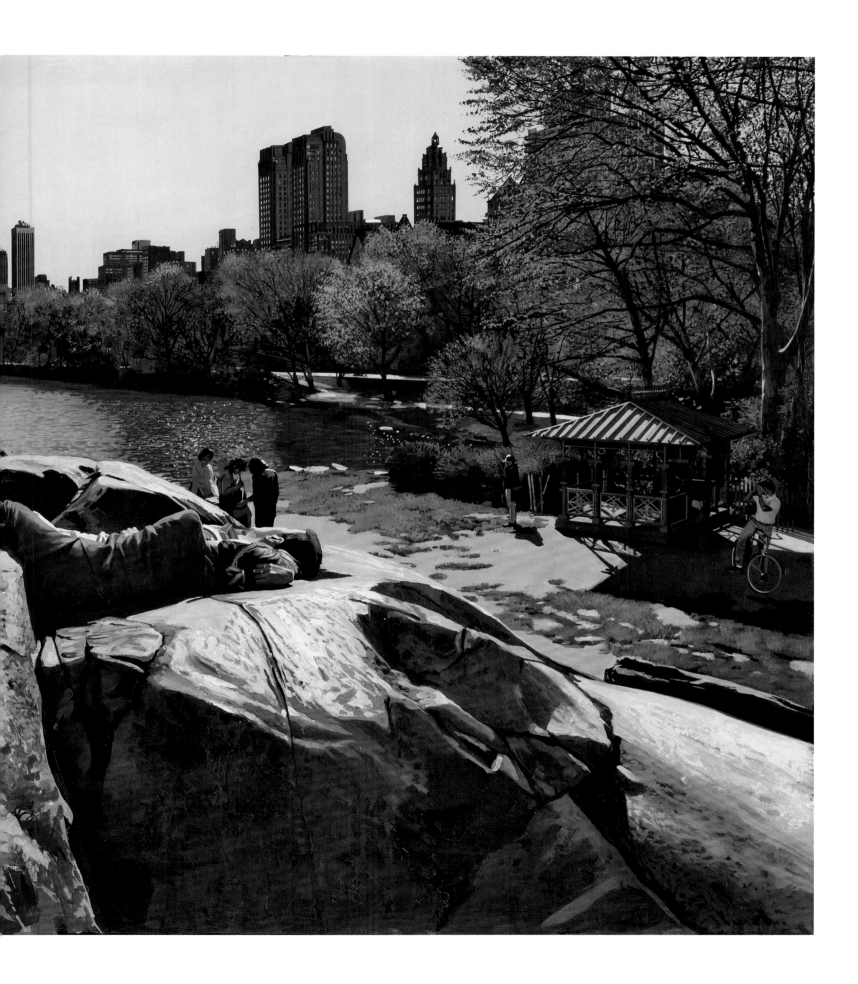

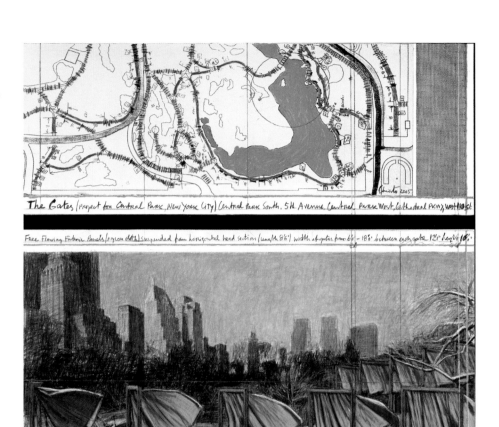

For anyone seeking time alone, Central Park has always been a refuge. On the coldest winter days, a walker may not see another soul. A 2005 collage (above) by Christo evokes both the needs and the rewards of such a walk. On a frigid day the jagged line of ziggurat-like buildings on Central Park South is in sharp contrast to the shrubs bent under snow and the banners moving in the wind and catching the sun—the hard angles of the city and the curving forms of nature. A solitary figure, seemingly absorbed in thought, walks by the frozen Pond. A metaphor for an artist, perhaps, but the collage has the practical purpose of showing how *The Gates* might appear around the Pond if there were snow during the two weeks they were to stand—February 12–27, 2005. On January 22–23, just before the 7,503 gates were to be installed, a blizzard struck New York. Fourteen inches of snow fell on the park. With everything else Christo had to do at that moment, he nevertheless found time for this collage. On February 21, another snowstorm created the scene Christo had anticipated. A week later, both the snow and *The Gates* were gone.

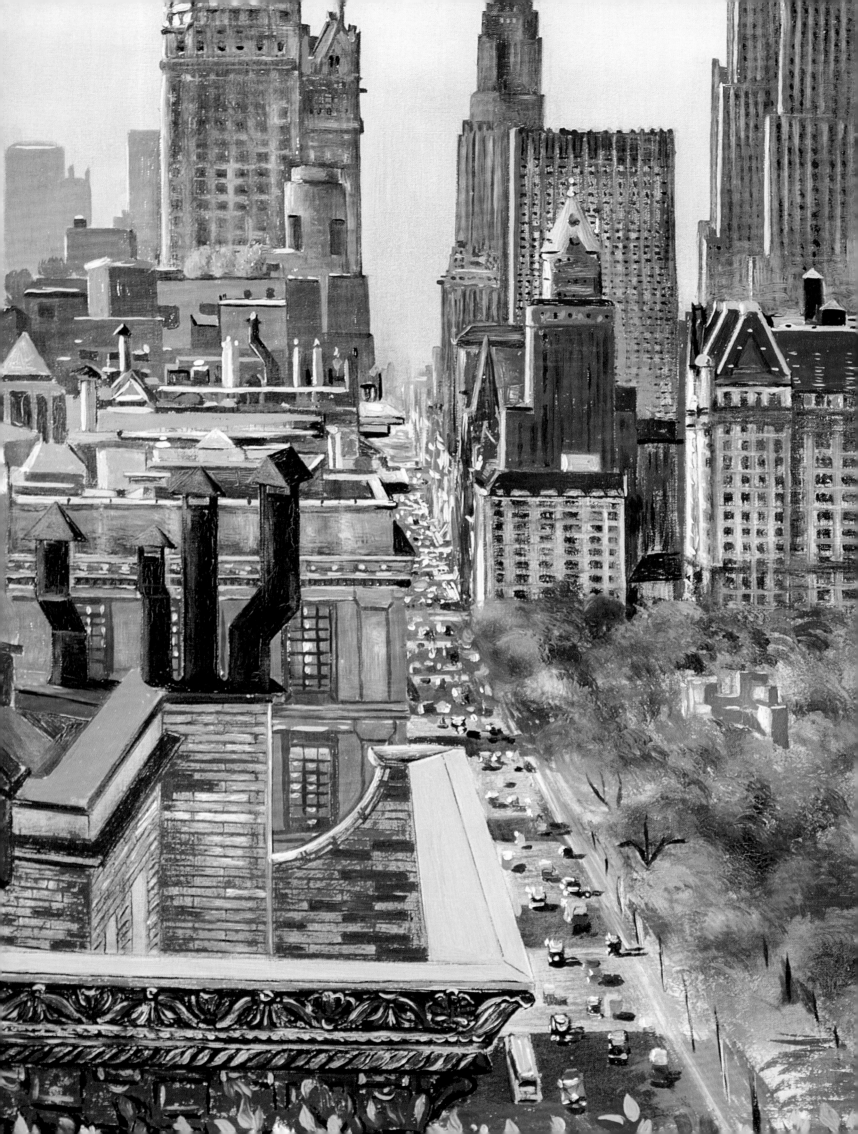

THE FRAME AROUND
THE PARK

When Central Park was created, most of the land surrounding it was vacant. But speculators and prescient home owners quickly recognized the attractions of living across from a park, prompting a building boom that ran from 59th Street to the northern edges of the park. On Fifth Avenue, the construction of houses for the very rich continued into the first decades of the twentieth century. The home of Henry Clay Frick, for example, at 70th Street, was completed in 1914. As can be seen from this and other extant Gilded Age houses, such as those on Fifth Avenue between 78th and 79th Streets, the buildings did not rise above the level of the trees across the street.

Moise Kisling
Rooftop View down Fifth Avenue,
1941 (detail)
See page 183

Childe Hassam
*The Hovel and the
Skyscraper*, 1904
Oil on canvas, 35 x 31 in.
(88.9 x 78.7 cm)
Pennsylvania Academy of
the Fine Arts, Philadelphia

The construction of much taller buildings was made possible by the development of steel-frame construction in the late 1880s and the invention of electric-powered elevators, patented in the United States in 1887. The first tall building to overlook the park was the renowned Dakota, on Central Park West at 72nd Street. Completed in 1884, it boasted the first elevators in a residential building in the country. The elevators were hydraulic. Whether the Dakota was named for its remoteness from the center of the city or, more likely, for its owner's fondness for the names of the new western territories, which he thought appropriate for the Upper West Side, its original neighbors were wooden shacks and plots given over to vegetables and goats. The name of the avenue, Central Park West, had been changed from Eighth Avenue only the year before. On Central Park South, then still called West 59th Street, the thirteen-story Navarro Flats residential complex, seen beyond the Sheep Meadow in William Merritt Chase's painting of 1889 (see page 53), barely cleared the line of trees. On the East Side, the first serious apartment building was twelve-story 998 Fifth Avenue, designed by McKim, Mead & White and completed in 1911. People who could afford a sixteen-room apartment on Fifth Avenue were skeptical about "communal" living. Only after the pioneer real estate broker Douglas Elliman persuaded Senator Elihu Root to rent an apartment in the building did others begin to consider a large apartment equivalent to a house in terms of comfort, security, and privacy. The boom in apartment houses and hotels on all sides of the park except the north took off before World War I and accelerated in the 1920s, with a few iconic buildings finished during the Depression. These buildings formed the new architectural frame of Central Park.

The taller buildings gave painters a new theme. Instead of the perhaps contorted perspective that in 1880 enabled Jasper Cropsey to show the spires of the Fifth Avenue Presbyterian Church, four blocks south of Central Park, looming over the Pond (see page 48), now there were interesting new structures at the very edges of the park. Some of the new buildings on Central Park South and Central Park West were designed as artists' studios, meeting the painters' needs for tall windows with ample, consistent natural light. These studios were also vantage points from which painters could portray the park at new angles. Now, from both the ground and high above, urban landscape painters had opportunities to depict distant perspectives and topographical features as dramatic in their own way as the scenery of the Hudson Valley, the Catskills, or the Rockies.

In 1903, Childe Hassam moved from the Sherwood Studios Building at 58 West 57th Street to 27 West 67th Street, a studio cooperative organized by a group of artists who wanted apartments in which they could both live and work. At the time, there were no other buildings blocking the view of the park from Hassam's windows. In 1904, he painted two views from his studio, one in spring, the other in winter. *Across the Park* (see page 9) depicts that brief period in spring when new leaves are still more yellow than green. The building in the foreground is the Sheepfold, designed by Jacob Wrey Mould and completed in 1871 to house the sheep that grazed on the Sheep Meadow, along with their shepherd. The sheep were considered useful or ornamental until 1934, when Robert Moses, the new parks commissioner, moved them to Prospect Park and soon thereafter eliminated them altogether. He converted the building into the

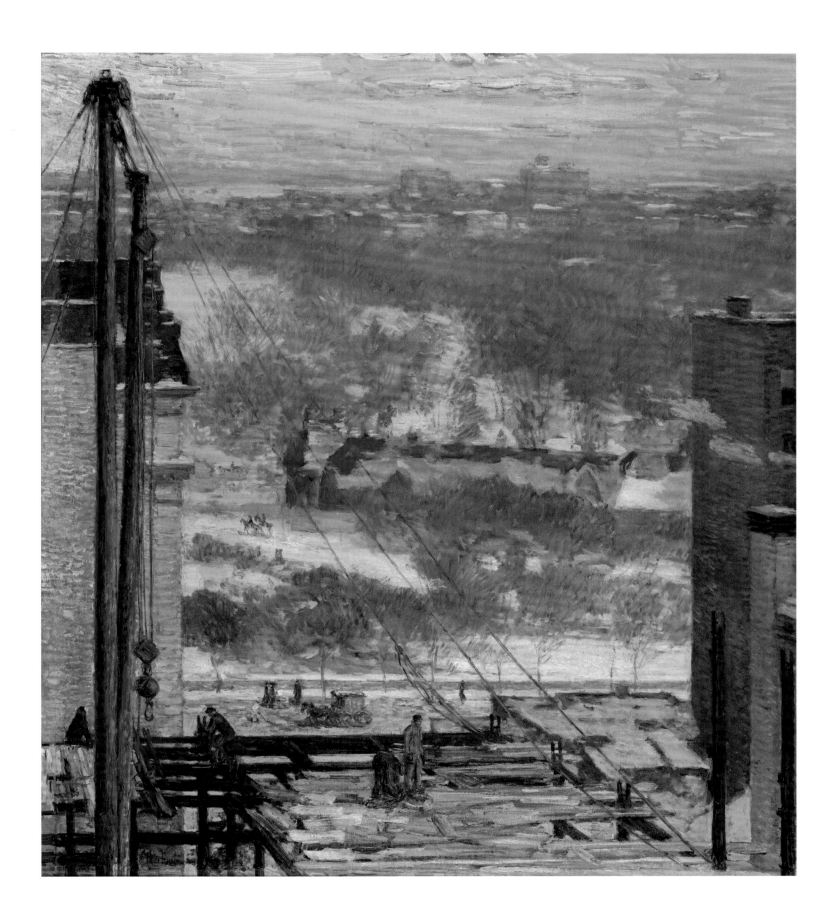

restaurant Tavern on the Green, which operated under various owners until 2009, when it became a visitor center run by the Department of Parks and Recreation for several years before reopening as a restaurant in 2014. There are no automobiles in the painting, but Hassam includes several horses—one pulling a working wagon, others being ridden or hitched to recreational carriages on the bridle path and West Drive. Using the height of the pedestrians as a scale, we can see how low the trees still were in 1904, and in the distance, on Fifth Avenue across the park, there were still very few tall buildings.

Hassam painted *The Hovel and the Skyscraper* (page 173) the following winter, when the park was covered in snow and his view was already changing. The "skyscraper" under construction directly outside Hassam's window was, in fact, a stable and the "hovel" in the park is the Sheepfold. In 1909, Hassam left his apartment with the diminishing park view for a studio at 130 West 57th Street.

Elmer Livingston MacRae (1875–1953) worked down the block in yet another 57th Street building popular with artists—Carnegie Hall, which had studios in the tower above the concert auditorium. From there, he painted *View of Central Park West from Carnegie Hall* (right) the same year Hassam moved back into the neighborhood. Construction was rapidly obscuring the visibility of the park. A palisade of buildings, today mostly replaced by taller ones, already lined Central Park West, and the Alwyn Court was going up at the corner of 58th Street and Seventh Avenue. Beyond is a stretch of the park where the snow, reflecting the blue of the sky, seems more intact than on building roofs and the street. Out of view slightly farther west was the Art Students League, today still located at 215 West 57th Street. Surely, many of the league's faculty and students took their easels and sketchbooks into the nearby park to hone their landscape-painting skills.

MacRae studied at the league from 1895 to 1898. One of his teachers was Carroll Beckwith. The league's summer school in Cos Cob, Connecticut, was run by John Henry Twachtman and J. Alden Weir, best known for their Impressionist landscapes of the Connecticut countryside. MacRae followed them there, staying at the Holley House Inn, where Childe Hassam also spent the summers. Other Central Park painters associated with the league and Cos Cob during those years include Ernest Lawson and Allen Tucker. MacRae married the daughter of the innkeeper and for the rest of his life painted Impressionist landscapes on the Connecticut shore. As his one Central Park painting indicates, he spent part of the winter in New York City, where, in 1911, he and three others began organizing the transformational 1913 International

Elmer Livingston MacRae
View of Central Park West from Carnegie Hall, 1909
Oil on canvas, 25 x 30 in.
(63.5 x 76.2 cm)
Private collection

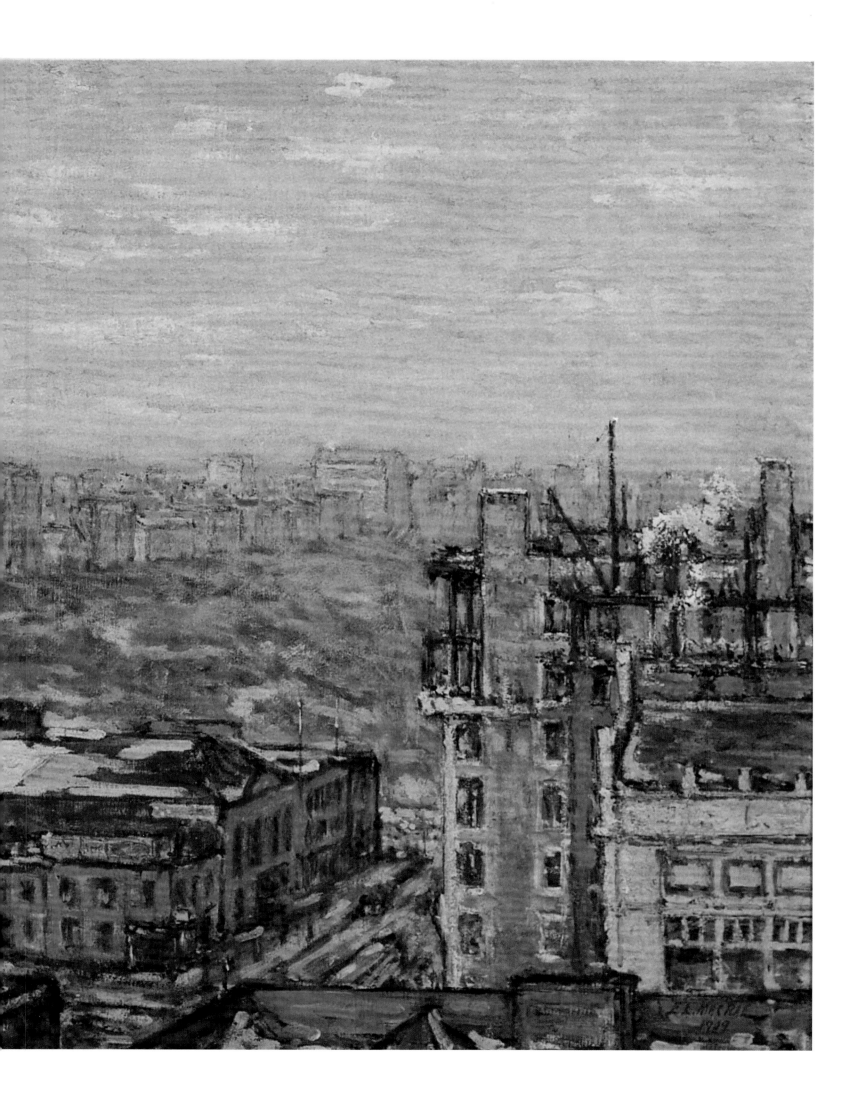

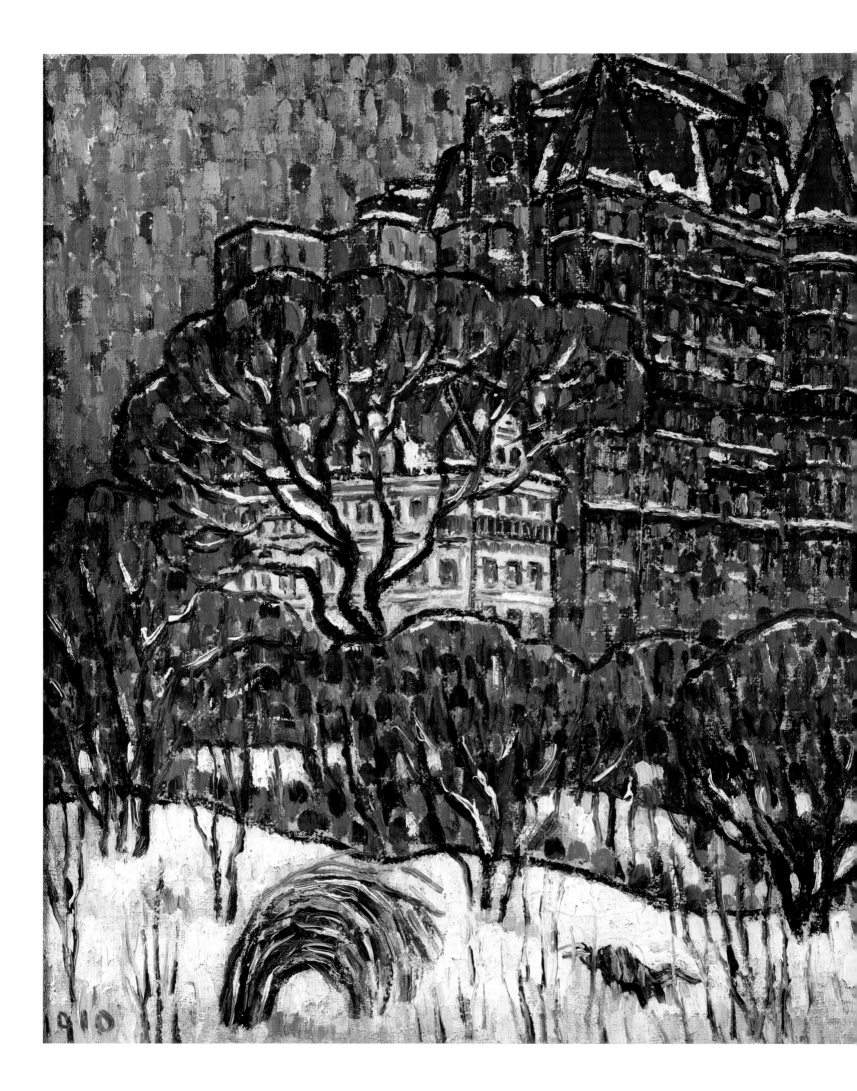

Exhibition of Modern Art, better known as the Armory Show. His orbit continued to overlap with that of other painters of the park, including Glackens, Prendergast, and Sheeler; their works were shown in a joint exhibition at a New York gallery in 1915.

Even before the Armory Show, New York painters were inspired by some of the French artists introduced to the American public at that exhibition. Middleton Manigault's *Across the Park* (1910; left) is the most intensely Fauvist of his four park paintings. His vantage point is inside the park at around 61st Street, looking across a snowy slope toward the distinctive apartment building then at the northeast corner of Fifth Avenue and 59th Street. In reality, it was a brown brick structure, as seen in Leon Kroll's *Sleep* (see pages 152–53). Its turrets and mansard roof were a sort of chocolate counterpoint to the larger, white Plaza Hotel (1907) just across Grand Army Plaza. Manigault's bold dabs of blue, green, and red tumbling from the sky over the buildings and into the trees evoke the exuberance New Yorkers feel when something as magical as snow transforms the man-made landscape.

Leon Kroll's *Central Park West* (1923; page 178) is another example of his penchant to shift natural and man-made features around to achieve the composition he desired. Here, he shows Mountcliff Arch, just south of Frederick Douglass Circle at 110th Street. It was built around 1890 to increase access to the West Drive from the north end of the park. Its rugged rock surface was intended to complement the nearby cliffs, which are covered with snow in the painting. The turreted, château-like building on Central Park West in the distance was then the New York Cancer Hospital, built between 1887 and 1890. Kroll's vantage point, actual or imagined, was from a building on the north side of West 110th Street overlooking the park. He shifted the exterior wall of the park closer to the curve of the bridle path beyond the arch and added a parallel wall in front of the buildings on the far side of the avenue.

Charles Sheeler's drawing *View of Central Park* (1932; page 179) is more faithful, providing documentation of a site that has since been transformed. Sheeler (1883–1965) was a professional photographer and Modernist painter whose work emphasized lines and planes, rather than embellishment. He did this depiction of the park at the request of Mrs. John D. Rockefeller Jr., his most significant patron. It was one of her favorite views of the park, looking across Central Park West at 77th Street to the Lake and the East Side. Mrs. Rockefeller, a founder of the Museum of Modern Art and a major collector, could only have seen this view from the

Edward Middleton Manigault
Across the Park, 1910
Oil on canvas, 12⅛ x 15 in.
(30.8 x 38.1 cm)
Private collection

Leon Kroll
Central Park West, 1923
Oil on canvas, 31 x 48 in.
(78.7 x 121.9 cm)
Private collection

windows of the American Museum of Natural History. Sheeler positioned himself in the sixth-floor rotunda at the southeast corner of the museum. He may also have worked from photographs; several shots he took from slightly different vantage points in the building survive. Sheeler shows the park in early April, when buds are creating a haze on the tree branches. Through them, the Naumburg Bandshell, the steps of the Bethesda Terrace, and even the *Angel of the Waters* (indicated by two pencil strokes) can be seen. There are three rowboats on the Lake, another sign of spring, and an elegant sedan moves north on the West Drive, which today only runs south. In the foreground, to the south of the Eaglevale Bridge, built around 1890, is the Ladies' Pond for women skaters. During a malaria epidemic in 1880, part of the pond was filled in, and the remainder was drained in 1934. Soon thereafter, a playground was installed, replaced in the 1990s by a lawn.

At about the same time Sheeler was observing the park from high up in the American Museum of Natural History, Milton Avery was perched a few blocks north painting another view of the park. *Central Park* (ca. 1930; pages 180–81) looks northward toward the same 90th Street entrance at Central Park West that Avery had painted from the ground in *Blue Horses, Central Park* (see page 117). His aerial view shows how the separate routes that Olmsted and Vaux had planned for pedestrians, vehicles, and riders curve through the landscape, sometimes paralleling one another, sometimes veering apart. Beyond, the distant line

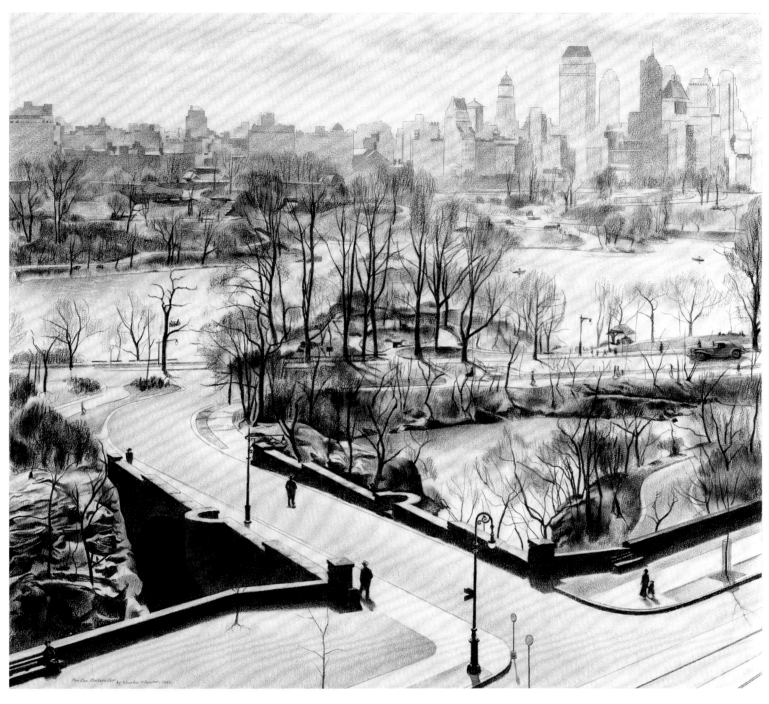

Charles Sheeler
View of Central Park, 1932
Conté crayon on paper,
17⅛ x 19⅛ in.
(45.4 x 48.6 cm)
Private collection

of buildings along Fifth Avenue are suffused with pink, suggesting the reflection of the late afternoon sun. In the foreground, the copper-sheathed dome and red slate mansard roof form the distinctive profile of the St. Urban, at 285 Central Park West. It was one of the early architecturally ambitious apartment buildings to rise on the Upper West Side. Designed in the Beaux-Arts style by Robert T. Lyons and completed in 1906, it featured a porte cochere at the entrance and an ice plant in the basement that delivered to tenants. When Avery painted his various scenes of Central Park, he was living in the West 70s. In the 1950s, he and his family moved to the Eldorado, one block north of the St. Urban; by then, however, his landscape interests lay beyond the city.

Even with their new, elevated viewpoints, few painters were inspired to show the park and the sky overhead in inclement weather. An exception is Allen Tucker (1866–1939), whose swirling brushwork and use of heavy impasto led

Milton Avery
Central Park, ca. 1930
Oil on board, 18 x 30 in.
45.7 x 76.2 cm)
Private collection

a contemporary critic to call him "the Van Gogh of America." Long before set-
ting his easel in Central Park, Tucker revealed a penchant for depicting nature's
drama in such works as *Storm in the Rockies* (1912), *Ice Storm* (ca. 1914), and
A March Gale (ca. 1919). About the same time that Tucker painted *Storm over
Central Park* (ca. 1930; above), he was developing an interest in an American
precursor with similar technique, Albert Pinkham Ryder. In 1932, Tucker did
his own version of Ryder's 1887 *The Flying Dutchman*, showing a sailing ship
maneuvering between powerful waves. Tucker lived at 121 West 79th Street and
must have seen or imagined this storm not far from there, looking south over
the Lake. A lone automobile seems to be hurrying out of the park as bolts of
lightning aim for the exaggeratedly tall buildings south of the park and sheets of
rain pour down. The lightning has momentarily cast both the sky and the surface
of the Lake in a fiery orange light, adding the emotional note Tucker thought
vital to painting. The distinctive silhouettes of the Chrysler Building, the Empire
State Building, and 30 Rockefeller Plaza are easily recognizable.

Some of the same buildings appear under a serene sky in Moïse Kisling's
Rooftop View down Fifth Avenue (1941; opposite), viewed from the penthouse
at 930 Fifth Avenue. Kisling (1891–1953) was a Polish-born French painter who

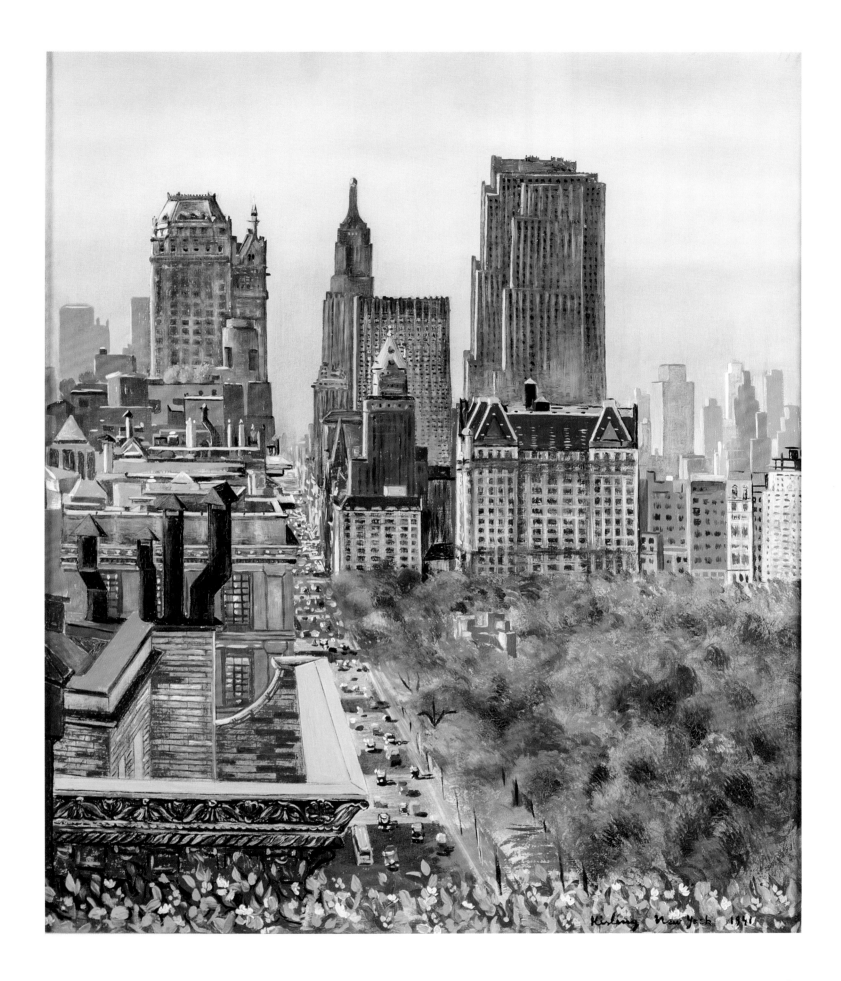

spent some of the war years in New York. Most of his paintings are richly colored depictions of large-eyed women, flowers, and landscapes in France. From 1943 to 1946, he lived at the Gainsborough Studios, 222 Central Park South, where he hosted gatherings of other French artists and intellectuals living in exile. He must have known the owner of the penthouse at 930 Fifth Avenue, which was designed by Emery Roth in 1940. Decades later, it was the home of Woody Allen. Much of the view down Fifth Avenue is still intact. Immediately to the south is 927 Fifth Avenue, designed in 1917 by Warren & Wetmore, one of the two firms that designed Grand Central Terminal. Its most famous residents are the Red-tailed Hawk Pale Male and a succession of mates, which since 1993 have nested and raised young on a lintel over the center window of the twelfth floor. The next building is 920 Fifth Avenue, designed by J. E. R. Carpenter in 1921. Igor Stravinsky once lived there. Kisling depicts the view on an October day, when the leaves have just started turning color in the park. He accentuates the perspectival axis down Fifth Avenue by eliminating the entrance to the park at 72nd Street and the transverse roads just north of the Arsenal.

When Kisling was painting at 930 Fifth Avenue, another naturalized French painter taking refuge from Vichy France lived just across the street at 4 East 74th Street—Marc Chagall. Born and initially trained in Russia, Chagall (1887–1985) moved to France in 1910 to further his artistic career free of the anti-Semitism that limited his opportunities in imperial Russia. He carried with him, however, a lifelong nostalgia for the Russian and Jewish folklore with which he had grown up, and he immortalized it in his intensely hued paintings. By the time he came to New York in 1941, Chagall was already acknowledged as one of the world's leading artists; the Pierre Matisse Gallery exhibited twenty-one of his paintings in 1941, and the Museum of Modern

Marc Chagall
Vue de la fenêtre sur Central Park, 1958
Pastel, colored pencils, and pencil on Japanese paper, 20 x 30 in. (50.8 x 76.3 cm)
Private collection

Marc Chagall N.Jo.

Art gave him an even larger show in 1946. Chagall returned to France in 1946 but made regular visits to the United States in later years. In 1958, he stayed at the Stanhope Hotel on Fifth Avenue at 81st Street. One bright day, he raised the windows to get a better view of Central Park, took out his pastels and colored pencils, and drew the swath of green. In the foreground of *Vue de la fenêtre sur Central Park* (pages 184–85) he shows part of the roof of the Metropolitan Museum, directly across Fifth Avenue from the hotel, and in the background, beyond the park, the line of buildings along Central Park West, including the Beresford and the Eldorado.

For visiting artists, hotel windows have continued to be an inspiring vantage point for painting the park and the uniquely New York palisade of buildings that surrounds it. In 2002, David Hockney was staying on Central Park West and 63rd Street. In *View from the Mayflower Hotel, New York (Evening)* (opposite) he used watercolors and colored crayons to depict the southwest corner of the park with the distinctive St. Moritz and Essex House hotels and the New York Athletic Club on Central Park South. Like Chagall, he includes the tassel of the rolled-up window shade, a charmingly homey detail underscoring his interior vantage point. Hockney (b. 1937) studied at the Bradford College of Art and the Royal College of Art in London. He first came to New York from England in July 1961. "I was taken by the sheer energy of the place," he later recalled. "It was amazingly sexy, and unbelievably easy. People were much more open, and I felt completely free. The city was a total twenty-four-hour city." Within a few years of that initial visit, Hockney was recognized for his distinctively intimate portraits and domestic scenes, colorful landscapes, and innovative photo collages.

The postwar period—roughly between Chagall's initial residency and Hockney's first visit—saw the rise of Abstract Expressionism, spearheaded by a number of New York painters. Others, however, continued to take the world around them as their inspiration. Fairfield Porter (1907–1975) is best known for his broad-brush oil landscapes of Southampton, Long Island, and Great Spruce Head Island, Maine. Before settling in Long Island in 1949, Porter lived in Manhattan, for a time as close to Central Park as 52nd Street. His city subjects, then and on subsequent visits, however, were mainly street scenes. In a 1969 letter to a friend describing his current project, Porter wrote of his attempt to show "what sometimes New York looks like in that beautiful light that is like the light in no other American or European city."

Porter painted at least one watercolor of the park, *New York City Skyline with Central Park* (page 188), which has an energy reminiscent of the work of John Marin, whose watercolors Porter collected and particularly admired. Though sketchily rendered, the buildings in this undated autumn scene look most like those between 88th and 90th Streets on Fifth Avenue. The circular form of the Guggenheim Museum (at 88th Street, completed in 1959) is indiscernible, but the distinctive roof of the Church of the Heavenly Rest one block north is a clue that the taller apartment buildings in the scene are not just generic. The reddish brown wash in the foreground is one of the pedestrian walks abutting the East Drive—the gray wash at the lower right. Porter must have been standing at the edge of the reservoir near 89th Street; there are few other places in the park where he could have gotten this perspective

David Hockney
View from the Mayflower Hotel, New York (Evening), 2002
Watercolor and crayon on paper, 23¾ x 18 in. (60.3 x 45.7 cm)
Private collection

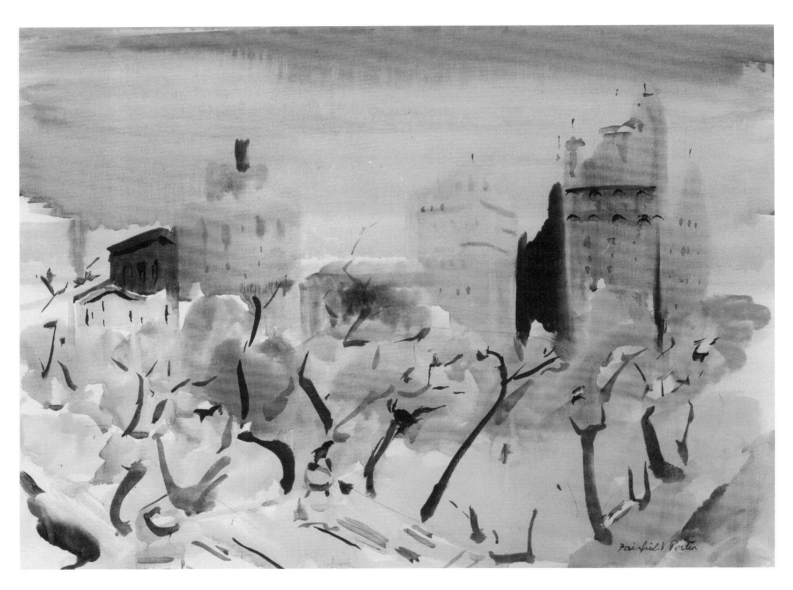

Fairfield Porter
New York City Skyline, with Central Park, n.d.
Watercolor with traces of pencil on paper, 19¾ x 26⅛ in. (50.2 x 66.4 cm)
Private collection

of the buildings beyond. The confidence with which he lays on the washes for the foliage, the stark contrast between deep shadow and bright sunlight on the buildings, and the punctuation of dots for windows and calligraphic strokes for tree trunks all demonstrate Porter's ability to direct his brush toward the edge of abstraction.

While Porter's style and sensibility, as well as his house in Southampton, kept him within the social orbit of the avant-garde New York School, another contemporary aggregation of painters in the city were staunch realists, including Edward Hopper, Reginald Marsh, Moses and Raphael Soyer, Leonard Baskin, and Edwin Dickinson. John Koch (1909–1978) was also part of this group. Some of his paintings depict gatherings of these artists with writers, critics, and musicians. They capture the cultivated atmosphere of Upper West Side mid-century intellectual social life. Raised in Michigan and essentially self-taught, with five years in Paris, Koch moved to New York in 1934. From 1954 until his death, he, like Milton Avery, lived in the Eldorado, at 300 Central Park West, the building that dominates Bowden's view across the reservoir (see page 89). His tenth-floor apartment, below the towers in the northeast corner of the building, was

OPPOSITE
John Koch
Rest Period, 1974
Oil on canvas, 36 x 30 in. (91.4 x 76.2 cm)
Private collection

OVERLEAF
Richard Haas
The Lake, Central Park, 1979
Acrylic on canvas, 92 x 186 in. (233.7 x 472.4 cm)
New York University School of Professional Studies, New York

Stephen Hannock
American City, 1993
Polished oil on canvas, 72 x
96 in. (182.9 x 243.8 cm)
Private collection

both home and studio, the setting in life and in art for the interactions among the cultural elite and between artists and models. Koch never painted from within the park but often worked close to his windows overlooking the park, and includes park views in many paintings. Some are essentially windowsill still lifes, others depict couples conversing or the artist himself at work. In *Rest Period* (1974; page 189), a model takes a break and studies the canvas on which Koch is working. The sculpture on the windowsill, of Prometheus and Hercules, is also by the artist. The contrast between the snowy park and frigid reservoir and the comfortable interior, warm enough for blooming cyclamen and an unclothed model, metaphorically and literally reinforces Koch's frequent theme of the artist at work—elevated from mundane concerns, sheltered in the studio with his muse, absorbed in his creativity.

Richard Haas (b. 1936) is best known for his trompe l'oeil architectural paintings on the exteriors of large city buildings. There are several in New York, mostly downtown, and they transform formerly blank walls into detailed architectural fantasies, often based on neighboring buildings, some of which no longer exist. Haas has also painted imaginative interior murals in houses and offices. At New York University's School of Professional Studies he did eight murals of city landmarks. Two are large vistas of Central Park, one of baseball fields with Central Park South in the distance, the other of the Lake and several iconic buildings on Central Park West (pages 190–91). In this 1979 painting, the light of the late afternoon summer sun bathes the lush crowns of the trees and casts long beams on the water and the few remaining rowboats, while the building facades are in shadow, obscuring most details of fenestration and decoration. What remains of the Majestic, Dakota, San Remo, and their neighbors is their stately monumentality, seemingly impassive witnesses to the changing seasons and activities of the park.

The same buildings are dwarfed in the perspective chosen by Stephen Hannock for *American City* (1993; pages 192–93), an aerial view of the park from its southeast corner. Hannock based this painting on smaller studies of the same view from a window in the General Motors Building. Hannock has said of his art, "I'm obsessed with light. I'm obsessed with everything light does. With how powerful it is and yet how fragile, how intense and yet how fleeting. One minute it's overwhelming, unbelievable, and the next minute, gone. The work is about what the paint can do to achieve the illusion of luminosity." This painting is about that final moment of light—or, more precisely, the moment of transition from natural to man-made light. The last rays of the sun, already set, are caught by the edges of clouds and the tallest buildings; below, the park's waters and the Hudson River reflect the sky. Lamps on the park drives and paths outline some of the park's features, and Cleopatra's Needle is illuminated by a dedicated spotlight.

Christo's drawing of the park as it might be seen from the tallest building south of Central Park on West 57th Street (1991; opposite) shows the entire eastern span, from the Pond to 110th Street, with the solid palisade of Fifth Avenue apartment buildings marking its sharp eastern boundary. The long, winding procession of banner-hung arches weaving around the zoo and encircling the reservoir highlights the sinuous curves of the park's paths, trees, and hills, reflected in the fluidity of the banners' response to every breeze.

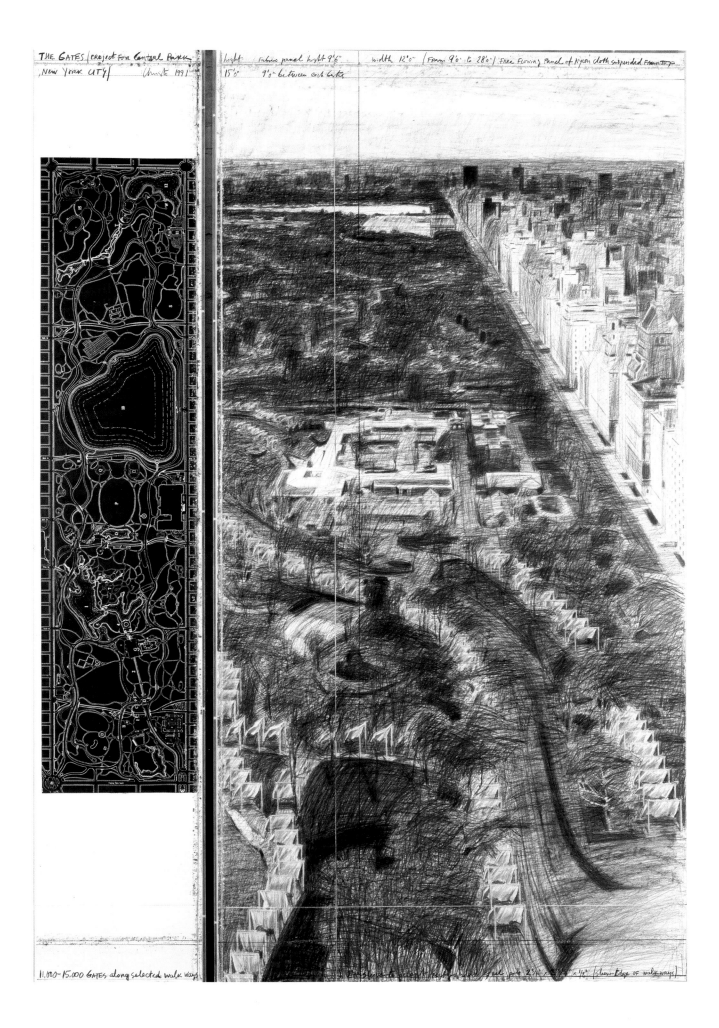

THE GATES (PROJECT FOR Central Park, New York City) Christo 1991

light Fabric panel hight 9'6" width 12'0" (From 9'0" to 28'0") Free Flowing Panel of Nylon cloth suspended From Top
15'0" 9'0" between each Gates

11,000-15,000 GATES along selected walk ways

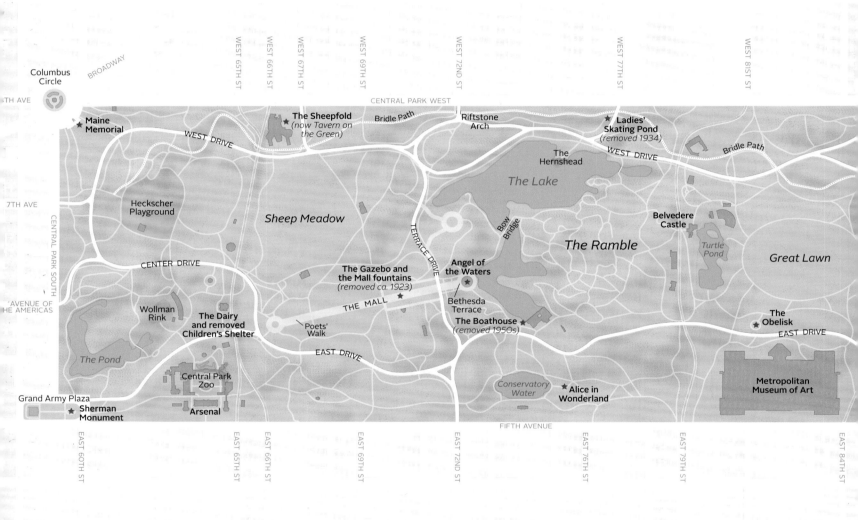

Columbus
Circle

BROADWAY

WEST 65TH ST
WEST 66TH ST
WEST 67TH ST
WEST 69TH ST
WEST 72ND ST
WEST 77TH ST
WEST 81ST ST

CENTRAL PARK WEST

★ Maine
Memorial

★ **The Sheepfold**
*(now Tavern on
the Green)*

Bridle Path

Riftstone
Arch

★ **Ladies'
Skating Pond**
(removed 1934)

WEST DRIVE

Bridle Path

WEST DRIVE

7TH AVE

CENTRAL PARK SOUTH

Heckscher
Playground

The
Hernshead

The Lake

Sheep Meadow

Belvedere
Castle

CENTER DRIVE

The Ramble

*Turtle
Pond*

Great Lawn

TERRACE DRIVE

AVENUE OF
HE AMERICAS

Wollman
Rink

**The Dairy
and removed
Children's Shelter**

**The Gazebo and
the Mall fountains**
(removed ca. 1923)

**Angel of
the Waters**
★

Bethesda
Terrace

THE MALL

Poets'
Walk

★ **The Obelisk**

EAST DRIVE

The Pond

The Boathouse
(removed 1950s) ★

EAST DRIVE

Central Park
Zoo

EAST DRIVE

Grand Army Plaza

*Conservatory
Water*

★ **Alice in
Wonderland**

**Metropolitan
Museum of Art**

★ **Sherman
Monument**

Arsenal

FIFTH AVENUE

EAST 60TH ST
EAST 65TH ST
EAST 66TH ST
EAST 69TH ST
EAST 72ND ST
EAST 76TH ST
EAST 79TH ST
EAST 84TH ST

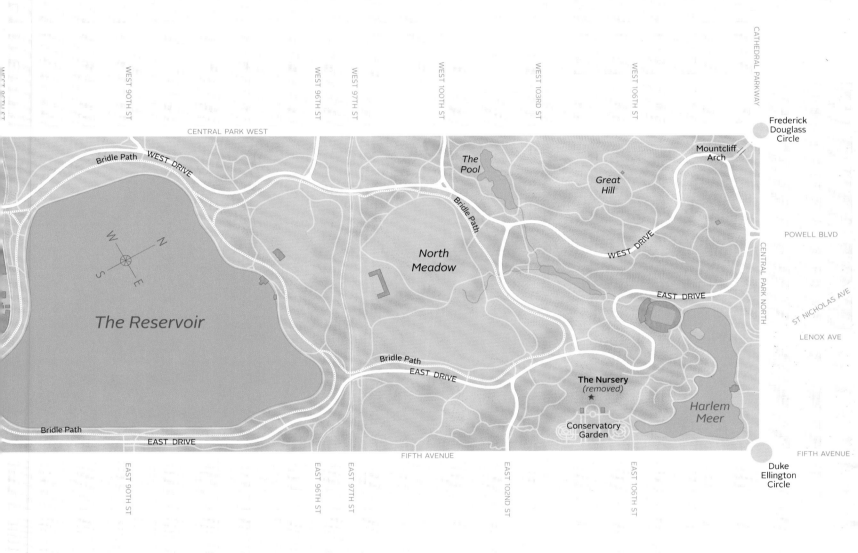

SELECTED BIBLIOGRAPHY

Alex, William, and George B. Tatum. *Calvert Vaux: Architect and Planner.* New York: Ink, Inc., 1994.

Berry-Hill, Henry, and Sidney Berry-Hill. *Ernest Lawson: American Impressionist, 1873–1939.* Leigh-on-Sea, UK: F. Lewis Publishers, 1968.

Campanile Galleries. Guy C. Wiggins: *American Impressionist.* Exhibition catalogue. Chicago: Campanile Galleries, 1970.

Christo and Jeanne-Claude. *The Gates: Central Park, New York City, 1979–2005.* Cologne, Germany: Taschen, 2005.

Clark, Carol, Nancy Mowll Mathews, and Gwendolyn Owens. *Maurice Brazil Prendergast, Charles Prendergast: A Catalogue Raisonné.* Munich: Williams College Museum of Art and Prestel, 1990.

Cox, Richard W. *Nature and Human Nature: The Art of Adolf Dehn.* Baton Rouge: Louisiana Arts and Science Center, 1995.

Cozzolino, Robert, Marshall N. Price, and M. Melissa Wolfe. *George Tooker.* London and New York: Merrell, 2008.

Elderfield, John. *Frankenthaler.* New York: Harry N. Abrams, 1989.

Gale Research Company. *Currier & Ives: A Catalogue Raisonné.* Detroit: Gale Research Company, 1984.

Gallati, Barbara Dayer. *William Merritt Chase: Modern American Landscapes 1886–1890.* Exhibition catalogue. New York: Brooklyn Museum of Art in association with Harry N. Abrams, 2000.

Gerdts, William H. *William Glackens.* New York, London, and Paris: Abbeville Press, 1996.

Goldberger, Paul. *Richard Haas: An Architecture of Illusion.* New York: Rizzoli, 1981.

Hale, Nancy, and Fredson Bowers, eds. *Leon Kroll: A Spoken Memoir.* Charlottesville: University of Virginia Press for the University of Virginia Art Museum, 1983.

Hannock, Stephen. *Luminosity: The Paintings of Stephen Hannock.* San Francisco: Chronicle Books, 2000.

Heckscher, Morrison H. *Creating Central Park.* New Haven, CT, and London: The Metropolitan Museum of Art and Yale University Press, 2008.

Hendricks, Gordon. *The Life and Work of Winslow Homer.* New York: Harry N. Abrams, 1979.

Hiesinger, Ulrich W. *Childe Hassam: American Impressionist.* Munich, London, and New York: Prestel, 1994.

Hollis Taggart Galleries. *Middleton Manigault: Visionary Modernist.* Exhibition catalogue. New York: Hollis Taggart Galleries, 2002.

Hoopes, Donelson F. *William Zorach: Paintings, Watercolors & Drawings, 1911–1922.* Exhibition catalogue. New York: Brooklyn Museum, 1968.

Kowsky, Francis R. *Country, Park & City: The Architecture and Life of Calvert Vaux.* New York and Oxford, UK: Oxford University Press, 1998.

Larkin, Susan G. *On Home Ground: Elmer Livingston MacRae at the Holley House.* Greenwich, CT: Bruce Museum, 1980.

Leigh, Ted, ed. *Material Witness: The Selected Letters of Fairfield Porter.* Ann Arbor: University of Michigan Press, 2005.

Levin, Gail. *Edward Hopper: The Art and the Artist.* New York and London: Whitney Museum of American Art and W. W. Norton & Company, 1980.

Lopate, Phillip, et al. *John Koch: Painting a New York Life.* London: Scala, 2001.

Mathews, Nancy Mowll. *Maurice Prendergast.* Munich: Prestel, 1990.

Miller, Sara Cedar. *Central Park: An American Masterpiece.* New York: Harry N. Abrams, 2003.

Moffatt, Frederick C. *The Life, Art, and Times of Joseph Delaney, 1904–1991.* Knoxville: University of Tennessee Press, 2009.

Peters, Lisa N. *Allen Tucker: The Force of Emotion—A Post-Impressionist Rediscovered.* Exhibition catalogue. New York: Spanierman Gallery, 2010.

Ramirez, Jan Seidler, ed. *Painting the Town: Cityscapes of New York.* New Haven, CT, and London: Museum of the City of New York and Yale University Press, 2000.

Rosenfeld, Jason, Martha Hoppin, and Garrett White. *Stephen Hannock.* New York and Manchester, VT: Hudson Hills Press, 2009.

Rosenzweig, Roy, and Elizabeth Blackmar. *The Park and the People: A History of Central Park.* Ithaca, NY, and London: Cornell University Press, 1992.

Sandler, Irving. *Alex Katz.* New York: Harry N. Abrams, 1979.

Schuyler, David. *Sanctified Landscape: Writers, Artists, and the Hudson River Valley, 1820–1909.* Ithaca, NY, and London: Cornell University Press, 2012.

Schwartz, Sanford, Robert Storr, and Rackstraw Downes. *Rackstraw Downes.* Princeton, NJ, and Oxford, UK: Princeton University Press, 2005.

Tottis, James W., et al. *Life's Pleasures: The Ashcan Artists' Brush with Leisure, 1895–1925.* London: Merrell, 2007.

Troyen, Carol, and Erica E. Hirshler. *Charles Sheeler: Paintings and Drawings.* Boston: New York Graphic Society and Little, Brown and Company, 1987.

Wilmerding, John. *Richard Estes.* New York: Rizzoli, 2006.

Wong, Janay. *Everett Shinn: The Spectacle of Life.* New York: Berry-Hill Galleries, 2000.

Zurier, Rebecca, Robert W. Snyder, and Virginia M. Mecklenburg. *Metropolitan Lives: The Ashcan Artists and Their New York.* New York and London: National Museum of American Art, Smithsonian Institution, and W. W. Norton & Company, 1995.

INDEX

PHOTOGRAPHY CREDITS

ENDPAPERS
Maurice Prendergast
Central Park, New York City, July 4, 1903
Watercolor, 14⅛ x 20⅞ in. (35.9 x 53 cm)
Private collection

PAGES 2–3
George Bellows
A Day in June, 1913
(detail)
See pages 146–47

PAGES 4–5
Edward Middleton Manigault
Across the Park, 1910
(detail)
See pages 176–77

PAGES 6–7
Leon Kroll
Scene in Central Park, 1922 (detail)
See page 49

First published in the United States of America in 2015 by
THE VENDOME PRESS
1334 York Avenue
New York, NY 10021
www.vendomepress.com

ISBN 978-0-86565-314-6

Editor: Jacqueline Decter
Production Coordinators: Irene Convey and Jim Spivey
Designer: Patricia Fabricant
Mapmaker: Beehive Mapping, with base data from Open Street

The publisher gratefully acknowledges the support of the Foundation for Landscape Studies, the Furthermore program of the J. M. Kaplan Fund, the Arthur Ross Foundation, and the Sansom Foundation.

Furthermore:
a program of the J. M. Kaplan Fund

Library of Congress Cataloging-in-Publication Data

Pasquier, Roger F., author.
 Painting Central Park / Roger F. Pasquier ; Foreword by Amanda M. Burden.
pages cm
 ISBN 978-0-86565-314-6 (hardback)
 1. Central Park (New York, N.Y.)--In art. 2. Art, American--Themes, motives. I. Burden, Amanda, writer of foreword. II. Title.
 N8214.5.U6P37 2015
 758.747--dc23
 2015006375

PRINTED IN ITALY
First printing